Published in Canada by General Publishing Company, Ltd., 30 Lesmill
Road, Don Mills, Toronto, Ontario.
Published in the United Kingdom by Constable and Company, Ltd., 10 Or-
ange Street, London WC2H 7EG.

The Complete Graphic Work of Jack Levine is a new work, first published by
Dover Publications, Inc., in 1984.

Manufactured in the United States of America
Dover Publications, Inc., 31 East 2nd Street, Mineola, NY 11501

Library of Congress Cataloging in Publication Data

Levine, Jack, 1915–
 The complete graphic work of Jack Levine.

 Bibliography: p.
 I. Levine, Jack, 1915– I. Prescott, Kenneth
Wade, 1920– II. Title.
NE539.L4A4 1984 769.92'4 82-18269
ISBN 0-486-24481-4

PREFACE

While serving as guest curator to The Jewish Museum in New York City and selecting works for its 1978 Jack Levine retrospective exhibition, I became aware of the need for a publication dealing with Levine's graphic work. No published reference material existed adequately covering his prints, which, then as now, were sought after by institutions and private collectors. As data were gathered with the cooperation of the artist, who examined individual works and discussed techniques, it was possible not only to make judicious selections for the exhibition but also to begin the assembly of a body of information which subsequently led to this book.

In the months following the New York opening, conversations with the artist and Mr. Lawrence Fleischman of Kennedy Galleries, who represents the artist, focused on the need and the feasibility of producing a book that would include all of Levine's prints and posters. The artist and Mr. Fleischman agreed with me that, time permitting, I should consummate my interest in Levine's graphic work with an appropriate publication.

A subsequent meeting with Mr. Hayward Cirker, President of Dover Publications, Inc., revealed a knowledgeable admirer of the artist's work. With the encouragement and cooperation of the artist and his gallery, and now with the blessing of a publisher, work could begin in earnest.

There is an obvious advantage to be derived from discussing works of art with the artist himself. It offers the opportunity to shed new light on individual works and to rectify mistakes that have crept into print and may make identification difficult. Jack Levine was generous with his time and shared many hours answering questions, recalling processes, examining prints and discussing the relationships of prints to paintings—something that could only be satisfactorily explained by the artist himself.

In the technical descriptions that follow, discriminating readers will detect some dates, media and titles that differ from those to be found in previous publications. In each case where discrepancies arose, the conflicting data were investigated at several sources. The final resolution came after discussion of the variables with the artist. Where differences existed in the order in which the prints were produced and printed, precedence was given to the date when the artist actually worked on the plate, or stone, even if the actual printing was delayed. The technical information ascribed here to each work was taken generally, but not invariably, from the actual print reproduced in the book.

There may be some differences within an edition. It is possible, for instance, that some examples were printed on a paper other than that listed. Not every print within an edition carries the printmaker's chop where it is so indicated in the description. And the artist's inscriptions vary within an edition and among the artist's proofs; the one given in the technical description is, however, as it was observed on a specific print. Moreover, Levine sometimes has used the term "state" where he might have used "trial proof." In this book, "state one" and "state two" appear with the titles in the three cases when the same key plate was used for two different editions. It is hoped that the technical data will assist collectors and students in identifying the body of works which, according to available information, comprise all Levine's known prints produced prior to the submission of this manuscript (end of 1982). The two portfolios of prints (see Bibliography) are published entities in themselves and are not included here.

The works are presented in the order of "published prints" (Nos. 1–66), "unpublished prints" (Nos. 67–73) and "posters" (Nos. 74–81), chronologically arranged within each grouping. Unpublished works are included because Levine's trial proofs have had a way of becoming editions; furthermore, as has happened, they fall in the hands of collectors and eventually find their way to the marketplace.

Most of the reproductions in this book were made by Dover directly from the original works, which were obtained primarily from the artist's collection and the Kennedy Galleries. One rare work was loaned by the collector, Philip Sills. Some reproductions of large works were made from photographs, courtesy of Kennedy Galleries; others, in the author's collection, were photographed by Mark Goodman, a faculty member at the Department of Art, University of Texas at Austin, and furnished to the publisher.

The essay in this book is intended to give the reader a general knowledge of the artist's background as well as to relate his graphic work to his oeuvre as a whole. Liberal use has been made of quotations taken from taped interviews with the artist which occurred from time to time as the manuscript progressed. For those readers interested in increasing their knowledge of Jack Levine and his career, the bibliography will be helpful, particularly the book written by Frank Getlein.

To read the criticism and reviews of his work in magazines and newspapers through all the years of Levine's artistic life is to get a minor overview of the history of criticism itself during this period, as well as a real sense of the changes in attitudes and tastes which took place.

One of the pleasures in preparing a book like this is coming to know the human being behind the works of art. With Jack Levine, basically shy and reticent, it has been a continuous joy to discover the breadth of his interests in such fields as history, religion, drama and music besides the greater enlightenment that has followed from discussions about the socio-political arenas.

No book as comprehensive as this could result from the efforts of one or two individuals. Hayward Cirker, President of Dover, and Clarence C. Strowbridge, a Senior Vice-President, were enthusiastic catalysts. Editor James Spero, himself an author, was helpful in many ways. Mr. Lawrence Fleischman, director and co-owner of Kennedy Galleries, his administrator Lillian Brenwasser, Frederick Bernaski, chief registrar, and Susan Sheehan of the Modern Prints Division responded cooperatively to all requests. Mary Jane Coughlin, my secretary at the Art Department, cheerfully typed several drafts of the work in progress. To all of these important contributors I am grateful. My wife, Emma-Stina, who has labored by my side in the writing of previous publications, has to my great pleasure agreed to be listed as co-author.

KENNETH W. PRESCOTT
Chairman, Department of Art
University of Texas at Austin

INTRODUCTION

"Out of the South End's squalid alleys and mean streets Painter Jack Levine has come brandishing brush and palette like lance and buckler at the ills of society. . . . You will see him as God's angry man but you will also see him as a kind of tenement troubadour, a poet, as it were, of pawnshops; you will see him from the angle of his inexhaustible humanity; you will see, indisputably, one of America's major artists."[1] So wrote Robert Taylor in 1952 on the opening of a retrospective exhibition of Levine's work organized by the Institute of Contemporary Art in Boston, which traveled widely before it closed at the Whitney Museum of American Art in 1955. The artist was 37 years old when it opened. In the 30 years that followed, his anger gradually mellowed by deeper insight and enriched by humor, Levine continued to paint incisive commentary on his time. In the mirror held up to him, the viewer observes a social drama in which he can laugh at the follies of mankind, cry at its ills, cringe at its greed and tawdriness and, perhaps, be jolted into a sudden self-realization. The view also offers sentiments of great tenderness and a joyful journey into a fairyland of line and color, where the artist has few peers.

To know Jack Levine is to know the painter whose skillful brush evokes memories of the great masters in the history of painting, and who has devoted a lifetime to study the means by which they achieved their magic. In his 1963 *Six Masters: A Devotion*, he pays tribute to Goya, Velázquez, Rembrandt, Titian, Rubens and El Greco, and his work has reflected the expressive force and colors of Rouault, Soutine and Kokoschka. He bows his head to tradition: "The problem of being an artist is the problem of pursuit of real knowledge and freedom." Without mastery of tradition, he has maintained, a successful pursuit is not possible. Picasso had it, he who could "draw like no artist since Leonardo."[2] Printmaking was a rather late interest in Levine's life, and when we consider his works in this field, we cannot divorce them from his paintings. Turning to music for an analogy, Levine thinks of prints as "four-handed versions of symphonies."[3] The narrative content of these "symphonies" and the "four-handed versions" thereof is the same. It originates in observation of life around the artist, but also reflects the films he has seen, the books he has read and a long-abiding interest in the biblical figures and Jewish philosophers who shaped the Jewish culture in which he grew up.

Jack Levine was born in Boston's South End in 1915, the youngest of eight children of Mary and Samuel Levine, a shoemaker who came from Lithuania in the late 1880s to settle in Boston. Many of Levine's earliest memories date from his life in this neighborhood, its streets crowded with the newly arrived immigrants who mixed with the local population—as well as with the drunks, vagrants, policemen and politicians who would later appear in his paintings. It was a life rich in color and variety. The storefronts, streetlights and cafés that served as background to this teeming humanity would retain their visual fascination for the artist in the years to come.

Even at this early stage, Levine, encouraged by his family, was busy recording what he saw around him:

> It was not so long after World War I. I have faint memories of the Great Boston Police Strike with the helmeted, bayonneted [*sic*] National Guard at every corner of the Washington-Dover Street intersection under the El. I would go to the shoe store on Harrison Avenue where my sister worked, and there on sheets of wrapping paper do drawings of the soldiers; taking pains with the detail of their wrap-around leggings and cartridge pockets.[4]

Jack Levine standing before *Texas Delegate,* ca. 1970.

Art was encouraged by his teachers too:

> In school we were issued shiny brass cups and hard oblongs of Milton Bradley watercolor. We were told not to use a pencil but to begin with color. On an orangey still watery tone I would set in the features of one of those epic childhood prototypes—jack-o-lantern, snowman, Raggedy Anne—watching the watery paper pull the features into radiating threads, blotting, puddling, striating, so that to my delight the expression of the face would change, now wrinkling, now smirking wonderfully. I am not over the thrill of it yet.[5]

A visit to a South Bay Union facility, run by the Cathedral of the Holy Cross, was not as exhilarating. There he was given charcoal and a large sheet of paper and told to interpret a pyramid. Young Jack got bored wrestling with the third dimension: "I turned the sheet over and drew with the charcoal something more to my liking—a huge battleship, her funnels belching charcoal smoke, all guns firing."[6]

In 1923, Jack moved with his family to Roxbury, then a quiet residential area of Boston. Homesick for the busy streets of his old neighborhood, he would console himself by drawing familiar characters whom he remembered from the South End. He also attended Saturday morning classes at the Boston Museum of Fine Arts, and then, with another talented young friend, Hyman Bloom, came under the tutelage of Harold Zimmerman at a Jewish center in Roxbury. Zimmerman was a student at the museum's school at the time and less than ten years their senior. Levine owes much to Zimmerman's unusual teaching and has reminisced about his method in later years:

> He never drew over my drawings. We followed what you would call imaginative drawing, never based on the use of a model. We developed our own art vocabulary from observation and from

study of what the great artists of the past had done, using what was needed from everything we saw and remembered. We did not copy—that's the important point. I never sketched at the circuses or symphonies that I attended, as you might think.... No, in his method of teaching, the idea was take it in and remember. If you don't remember, you go back or go see a piece of sculpture or some old master's drawings, but most often I would go back and look. Zimmerman taught drawing from the Alberti viewpoint. This is the knowledge of natural and scientific laws governing appearances; compositional drawing and an essentially analytical approach.[7]

Soon all three students came under the influence and guidance of Dr. Denman Ross, artist, collector and founder of Harvard's Art Department. Ross was impressed with the result of Zimmerman's unique teaching method and provided the means for him to set up a teaching studio. He also gave the two boys a weekly stipend of $12 each, enabling them to purchase art supplies. They were to continue their drawing lessons under Zimmerman at the same time as they received their introduction to painting from Dr. Ross, who wrote in 1930:

> These boys have already reached discrimination, appreciation and judgment.... [They] are able not only to draw from life as well or better than most graduates of the art schools but they are able at the ages of fifteen and seventeen respectively to produce imaginative compositions and designs of unquestionable merit. In other words, they are able to think in the terms of drawing and painting and able to express themselves as easily as they do in talking and writing.[8]

According to Ross, Zimmerman had also introduced the boys to the best drawings and paintings in the three museums of Boston and Cambridge, but Levine credits Ross for having shown him the world of the old masters. "He put me in touch with the European tradition and the great painting of the past at an early age, when I knew nothing about it. He gave me roots a long way back. Imagine, Ross taught [Arthur Wesley Dow] the teacher of Max Weber. I owe to Ross what I'm interested in—continuity. I don't want to lose it. I want to know what I'm doing."[9]

It was not long before Ross arranged a small exhibition of Levine's drawings at Harvard's Fogg Art Museum and then paid his student the ultimate compliment of purchasing some of the drawings. The eminent art collector and connoisseur Dr. Paul J. Sachs also collected some of these early drawings, which he subsequently presented to the museum, where they can be seen today in its permanent collection. During this time, Levine was also allowed "behind the scenes" access to the museum, where he examined at close range exhibitions being installed and visited the restoration laboratory. There he first encountered the mystery of the great masters' techniques, awakening an interest that was to remain through the years and increase with the refinement of his own skills.

Ross, who was about 80 years old when Levine studied with him, was a dogmatic and demanding teacher. He insisted on having his students draw from casts and models. Young Jack could not serve two masters, and soon he decided to leave Zimmerman's studio in order to devote full attention to Ross's instruction. In 1962 he spoke of his old teacher:

> Ross had all kinds of theories about the palette.... For the twelve dollars he gave me, he had the best toy he ever had. Consider it, at 14 I was a formidable draftsman, just ready to learn how to paint, and Ross had in me a perfect student to test his theories. He believed in controlling the color cycle—180 degrees from hot to cold colors. I informed myself about his theories but I did not adopt them.... He espoused the Impressionists' theories of light and color. I favored the old masters, but I have more respect now [1962] than ever for his science in art that seems so

neglected these days.... Ross is a person most worthy of study.... he was admired and looked up to by people as diverse as John Singer Sargent, Bernard Berenson, and Robert Henri. The notion persists that here was a man who had to complicate everything with theories; in fact I think he was not like that. His theories of design are broad and simple.... his color theories toward the end of his life became simpler and more workable. His systematic palettes were then organized scales of color with simple principles of warm and cool contrasts. My basic departure from Ross rests in my much stronger interest in the densities of paint (underpainting, glazings, scumblings, thick-and-thin applications, etc.), all matters that Ross and the Impressionist School, for the most part, did not really face.[10]

In the depth of the Depression, Ross withdrew his patronage, and Levine, who had dropped out of high school, now found himself without the means with which to buy art supplies. On his small stipend, which he had shared with his family, he had been able to devote his full energies to the creation of art. He now learned, for the first time, about the suffering and despair endured by the unemployed. His traumatic experiences from these days left indelible impressions, both visually and emotionally, which were to inform his art in future years.

In the meantime, President Franklin D. Roosevelt had responded to the urgings of his artist friends George Biddle, Edward Bruce and others and had inaugurated a public works program for artists. In 1935 Levine was employed as an artist in the Works Progress Administration's Federal Art Project. Once again he had enough money to devote his full time to his art. In 1937, however, he was found ineligible for government patronage because he lived with his parents. Reinstated the following year under a nonrelief quota, he again experienced a measure of security until 1939, when he was discharged for good. For the next few years, without a studio, he worked at home.

Levine's paintings from this time show a youthful anger and an emotional agony in their expressionistic fervor, which set them apart and which would not be reflected in his graphic art still to come. His affinity with European Expressionists at this period seems evident, although he has dismissed Expressionism on the grounds that it "puts too high a premium on subjective reactions."[11] Distortions were used, however, for emphasis and pathos in an extreme manner, which he later rejected.

In 1939 his paintings were exhibited at The Downtown Gallery with reviews that ran the gamut from "brilliant" and "dazzling" to "terrible." But even earlier, in 1936, the 21-year-old artist had been catapulted into national prominence, when his paintings *Conference* (also called *Brain Trust*) and *Card Game* were included in an exhibition, organized by The Museum of Modern Art that traveled to the Jeu de Paume in Paris. Soon thereafter, the Modern acquired *The Feast of Pure Reason,* dated 1937. It was rumored that the trustees debated at length before allowing the picture to be placed on exhibition. They feared that the three conniving characters could be construed to imply an illicit relationship between a capitalist and the worlds of politics and crime. The title alludes to a passage from James Joyce's *Ulysses,* but the genesis of the imagery is Boston, and represents a dramatization of what Levine imagined to be the unwritten laws that govern the relationships between lawbreakers and law enforcers, in which the end justifies the means and insures the survival of the most cunning. Levine later allowed that the painting was a youthful and simplistic view of man and society. *"The Feast of Pure Reason* depended for its motivation on the bitter assumptions of a boy of 22."[12] Reminded by the protesters of the Sixties of his own youthful anger, he produced a print with the same title in 1970 (No.

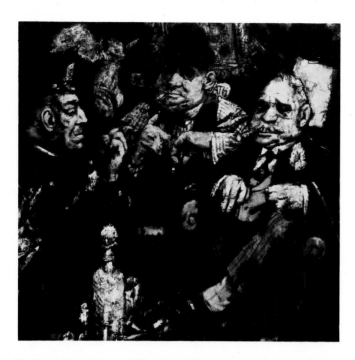

The Feast of Pure Reason, 1937. 42″ x 48″. Oil on canvas. Extended loan from the United States WPA Art Program to The Museum of Modern Art, New York.

56), which was a faithful replica of the painting. In both, three unsavory characters, policeman, ward heeler and prosperous-looking "gentleman," fill the compressed picture space with their massive forms. The elegant appointments enhance the ambience of corruption and exemplify the young artist's love of detail. In 1942 he wrote: "It is my privilege as an artist to put these gentlemen on trial, to give them every ingratiating characteristic they might normally have, and then present them . . . in my own terms . . . leaving it up to the spectator to judge the merits of the case."[13]

Levine's career as an artist was suddenly interrupted when he was drafted in 1942, but not before he had seen his paintings included in many prestigious exhibitions. Assigned to duties on the mainland and Ascension Island in the Atlantic, Levine was miserable in the three and one-half years he spent in the Army, his hands and his mind divorced from his encompassing interest. What little drawing and painting he did during his Army years was done on his own time—*Christ on the Cross* for an Army Chapel, a few oil sketches of army activities and some murals for a Women's Army Auxiliary Corps clubhouse. One bright moment came in 1942 with the news that his 1937 *String Quartette* had won a $3,000 prize at The Metropolitan Museum's exhibition *Artists for Victory*. A humorous print also dates from the war period, Levine's *Matisse and U.S. Servicemen* (No. 1). In Boston he observed the efforts made by civilian groups and organizations to entertain our country's men and women in uniform, who frequently found themselves far from home. The Boston Chapter of The Museum of Modern Art (later the Institute of Contemporary Art) offered its facilities for cultural and recreational purposes. Seeing the uneasiness of some servicemen in this unfamiliar milieu, Levine depicted a couple of puzzled boys in uniform being initiated into the mysteries of modern art.

Toward the end of the war, Levine was transferred to New York City. There he met the artist Ruth Gikow, whom he married when he was released from the Army. The Downtown Gallery had in the meantime sold many of his paintings; this gave him a sense of financial freedom and now, feeling the pulse of big-city life and occupying a studio of his own in New York, he was ready to make up for lost time. Productive decades lay ahead.

The death of his father in 1939 and the ensuing sense of loss that followed had caused Levine to reflect on his childhood and particularly his role as a son of Jewish parents. Had his all-consuming interest in art so removed him from the traditional celebrations of the Jewish faith that it had caused his parents unnecessary sorrow? *The Passing Scene* of 1941 and *The Old and the New* of 1942, painted before the artist left for the service, seem directly related to his melancholic state of mind. But he had also begun a series of miniature portrayals of Hebrew kings and sages, which he continued during the Forties and Fifties, and which together constitute a beautiful memorial to a father from his son. Levine bore in mind Persian miniatures and early Flemish paintings when he created these little jewels.

In his prefatory note to the 1959 *Teachers and Kings: Six Paintings by Jack Levine*, Paul J. Sachs wrote:

> To evaluate this complex, spectacularly talented artist properly, we need not only to know his satirical side . . . but also the group of paintings and drawings in which we are touched by a deep, gentle, tender side of the artist's nature as presented in . . . the series of beautifully painted Old Testament figures, small in scale. In them Jack Levine seems actually identified with his subjects. Knowing these figures we are satisfied that, unlike most of his contemporaries, he is heir to that ancient heritage compounded of religion and poetry, mythology and fable, which in the great epochs of the past supplied artists with subject matter.[14]

The six facsimile color reproductions of the paintings, printed by Roto-Sadag and published by the New York Graphic Society, are fine copies of the paintings, but should not be confused with Levine's fine prints. They are reproductions of *King David* (1940), *King Saul* (1948), *Maimonides* (1952), *King Asa* (1953), *Hillel* (1955) and *Yehudah* (1957).

Four intaglio prints executed in the Sixties relate to these paintings: *King David* (No. 10), seated at his harp; *Hillel* (No. 11), the saintly and gentle scholar; *The King* (No. 12), King Asa of Judah, known for his religious reforms; and *Maimonides I* (Nos. 14A and 14B), the scientist, philosopher and physician, whose countenance is also recognizable in the lithographs *Hebrew King* (No. 2) and *Maimonides II* (No. 42).

Related to this contemplative side of the artist are his lovely portrayals of pensive young women, appearing regularly through the decades. Many came about when Levine was captured by the looks of a model as she walked into his studio. This studio, while resounding with the best of recorded classical music, is not an epitome of good housekeeping and in "these messy surroundings" Levine often felt more comfortable to use the model for a character study than to have her pose in the nude. None of his prints of young women are portraits but are composites of memories evoked. In this category belong *Head of a Young Girl* (No. 23) and *Meditation* (No. 24). *Brechtiana* (No. 40), harking back to G. W. Pabst's film version of *Die Dreigroschenoper*, which Levine had seen in 1931, is also imbued with this meditative ambience.

One does not turn to Levine's work for landscapes or to find relief from human cares in the enjoyment of animals depicted in activity or repose. Cityborn, Levine feels at ease in the urban environment. Once, when he and his wife had been lured out into the country, she commented, "It makes him nervous to even look out the window and see all that inactive peace and quiet."[15] The one animal motif that keeps recurring from time to time is an old, work-worn horse pulling his heavy load, a familiar sight in any city in bygone days. It has been suggested that to Levine it is a symbol of victimized man.[16] The horse was already present in a childhood drawing and it has ap-

peared in mature works several times. It is not surprising then that, soon after he was released from the Army, feeling "rusty" after such a long time away from practicing his craft, he would again turn to the old motif, a friend as it were. In 1946 he painted *The White Horse,* with the faithful creature pictured in front of a grocery store whose front window offered all the architectural details and intricacies, absent in Army barracks, that the artist's facile brush had waited for so long to transcribe with dabs of color onto canvas. The same old horse served him well in one of his earliest prints, *The White Horse* (No. 5).

But anyone who thought that military life might have dulled Levine's penchant for satire was in for a surprise when his *Welcome Home* came on the scene in 1946. It depicts an overbearing general, whose return to the fold of his wealthy friends is celebrated at a ceremony in which the participants eat their way through a joyless meal in psychological isolation from each other. A cutting wit is here evident in contrast to the somewhat heavy-handed character depiction in *The Feast of Pure Reason.* A new treatment of space, a lighter palette and the use of an energizing white reflect his recent exposure to the Venetian masters. The painting caused a stir when it was included in an exhibition that traveled to Moscow in 1959. A rash of criticism arose, alleging that some of the artists represented had records of affiliations with Communist fronts and causes. In a press conference, President Eisenhower was asked specifically about *Welcome Home.* "It looks like a lampoon more than art as far as I am concerned," he remarked. "But I am not going to be the censor myself for the art that has already gone there."[17] In a later interview, Levine explained: " 'That painting actually isn't so much of an attack on the army as an expression of great joy at getting out of the army. You know Mr. Eisenhower and I were both in the army, and apparently we had different responses to that sort of life. . . .' In a word, this painting *Welcome Home* is a comic Valentine to the upper echelon of our armed forces."[18] Unfortunately, no print so far has come from this milestone in the artist's career.

In a lighter vein, but with a serious intent, Levine in 1948 painted *Reception in Miami,* which in vivid colors and electrifying brushwork renders the occasion at which the Duke and Duchess of Windsor are greeted by their admirers in Miami. In the artist's view, the fawning on the part of the Americans was foreign to the democratic principles of this country. In 1967, while in Paris, he returned to the subject and did a lithograph in color (No. 41).

In 1947 and 1948, Levine traveled in Europe on a Guggenheim Fellowship. The pain from the destruction he witnessed, he suffered in silence, but as we have already seen, upon his return home his canvases reflected the art on which he had feasted. For a short time he also flirted with Cubism, feeling his way in new directions. But then in 1951 he went abroad again: "When I . . . saw the Caravaggios in Italy and the Rembrandts in Holland, I knew that I had to paint volumes in light and shade."[19] And so he did, but evidence of his "fooling around" with Cubism enriched such paintings as his 1952–53 *Gangster's Funeral,* which many consider to be his greatest. If the attack on corruption and hypocrisy had been direct and hardhitting earlier in such works as *The Feast of Pure Reason* and *Conference,* and had been rendered in raw, brutal colors, it is here "embalmed" in the soft light of the funeral parlor and the respectful mien of the mourners. A faithful replica of this masterpiece is the artist's drypoint and engraving with the same name (No. 30). The content was carefully deliberated in advance, much as a dramatist would for a play:

Immediately questions arise such as what sort of dress shall be worn; what do people wear at a gangster funeral? This may seem

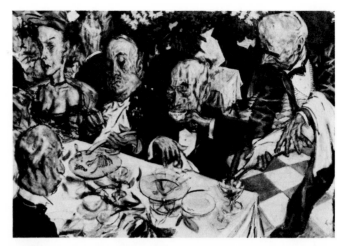

Welcome Home, 1946. 39¹⁵⁄₁₆″ x 59¹⁵⁄₁₆″. Oil on canvas. The Brooklyn Museum: John B. Woodward Memorial Fund.

a concern for a dramatist, a novelist. I envy them these interesting concerns.

If they be wearing street clothes instead of cutaways, it becomes possible to have the fat man show a broad mourning band on his thick little arm. It would be amusing to make it a heart instead of a band, but unfortunately that isn't possible.

A widow, in deep mourning, clad in rich furs. Better yet, two widows, one very very shapely. The chief of Police comes to pay his last respects—a face at once porcine and acute—under no circumstances off to one side as a watcher. This would suggest a thesis other than mine, a policeman's thesis. He must be in the line of mourners, filing past to view for the last time the earthly remains of his old associate. Who would, if he could, remonstrate with him for exposing himself in this manner.

If the chief's function is thus made clear it becomes possible to add a patrolman in a watchful capacity. I must now look for ways of establishing the identities of the mayor, the governor, et alia.

It may be said that the idea is more fit for a novel or a film. This is ridiculous. As far as the novel is concerned, a picture is still worth a thousand words; as far as a film is concerned, the Hays code requires it to show that crime does not pay, which is not my thesis either.

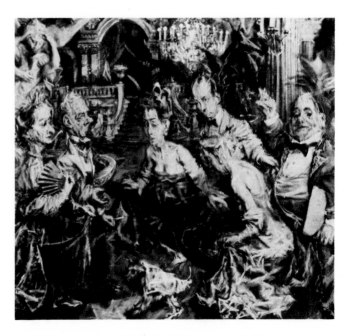

Reception in Miami, 1948. 50³⁄₈″ x 56⅛″. Oil on canvas. Hirshhorn Museum and Sculpture Garden, Smithsonian Institution.

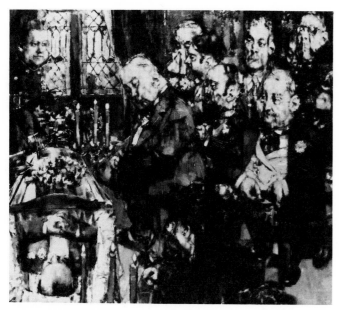

Gangster Funeral, 1952–53. 63″ x 72″. Collection of the Whitney Museum of American Art, New York.

This libretto in no way invalidates the possible creation of a work of art. On the contrary, it inflects it, enriches it, makes the project more complex. I see no harm in putting the conscious mind to work in this fashion.

Levine later added that he wanted no element of the macabre: "I want the painting as a comedy. It must not be a tragedy. I will show the corpse but the emphasis could be on the embalming."[20]

Through the years, Levine has kept up a steady commentary on American political life, and in 1954 his probing eye turned to political festivities in *Election Night.* It was included in the 1955 Whitney Museum retrospective exhibition and, later the same year, was shown at The Museum of Modern Art, where it was one of five new acquisitions (the others being by Cézanne, Miró, Klee and Matisse). It received enthusiastic reviews such as the one in *Time* magazine.

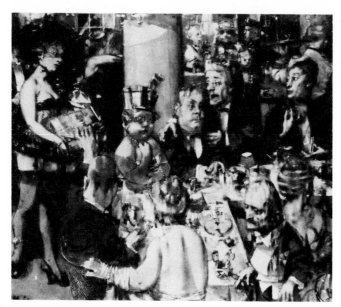

Election Night, 1954. 63⅛″ x 72½″. Oil on canvas. Collection, The Museum of Modern Art, New York. Gift of Joseph H. Hirshhorn.

An elaborate satire, coruscating with brilliant bits of still life, filled with unhappy specimens of real life and veiled in silvery, glancing lights, Levine's picture was designed to hold both the eye and the mind. As of the moment, almost no one places Levine among the "masters" of modern art. But at 40, Levine is not afraid to paint pictures that demand mastery; he has brilliance, seriousness and a sense of his own time which may have an even greater impact on museumgoers of the future."[21]

In 1969 he returned to the subject in a print with the same name (No. 55).

For a painstaking artist with a time-consuming technique, the Fifties proved to be a productive decade when the honors that had begun in the Forties continued to be granted. Levine's paintings, favorably received by the critics, sold well and many were purchased by prestigious museums and private collectors.

His gifted hand would continue this output in the Sixties but at a slightly slower pace. He now felt that he was suffering from public neglect and complained caustically about "the art brokers"—the curators and critics who showered their attention, first on Abstract Expressionism and then on the movements that followed. Never deviating from his lonely path in presenting contemporary subjects with human interest in ways that would evoke the names of the great masters, he had only contempt for those artists who abandoned what he considered serious pursuits to join the current fads. "I suppose I took it very hard," he said in 1972, "I saw so many painters I knew jumping on the bandwagon. I thought it was absolutely unscrupulous."[22] But the decisions that other artists made were not always easy, as evidenced in a quote by Mark Rothko: "It was with utmost reluctance that I found the figure could not serve my purposes. . . . But a time came when none of us could use the figure without mutilating it."[23] Looking back now, Levine admits that he was lucky "to have made it then" and therefore "never forced to choose."

It was in the early Sixties that printmaking became, if not a major, at least an important part of Levine's artistic life. His wife Ruth had earlier introduced him to Abe Lublin, then associated with the New York Graphic Society, which had published his *Teachers and Kings.* By now Lublin had founded his own firm and sought to arrange with Levine for the publication and distribution of graphics by the artist. Levine, a consummate draftsman who had long been an admirer of the prints of Rembrandt and Goya, welcomed the opportunity. Not long thereafter the sales of his prints became his main source of income. While continuing to paint, he withdrew his paintings from what he considered to be a hostile market. Of utmost importance had been his meeting with Emiliano Sorini, a talented printmaker living in New Jersey and operating a shop-studio close to Levine's studio. Sorini, a native of Urbino, Italy, provided the stimulus, which Levine characterizes as "infectious," by introducing him to intaglio printmaking. Levine gives full credit to Sorini as the one individual responsible for creating this new-found interest, for sustaining that interest and for teaching him the mastery of techniques heretofore unknown to him. Levine's interest, however, never went beyond the artistic rendition on the plate.

I never went to art school and never took a Cook's tour of all the media. I have a horror of acid and don't like to fool around with the stuff. I have never put a plate in acid, nor have I put a sheet of paper through a printing press. But there is a kind of therapy to be had from scraping the copper plate, in monkeying around with scrapers, polishers and burnishers. I work at home, not in the studio, and I am afraid that sometimes I work on this instead of answering letters and paying bills.

In the main, Levine approaches the plate directly with an

image he already has in mind, new or "out of repertoire," without preparatory sketches, all the while taking care to render on the plate or stone that which the medium is suited to convey. For anyone familiar with Levine's oeuvre, it is therefore not surprising to find in his graphic work subjects that are known from his paintings. Some of these have already been mentioned. Another is *The General* (No. 6), a translation into the print medium of his 1956 painting *The Turnkey*. Intended as a portrait of Generalissimo Franco, the print conveys the message of oppression and corruption as forcefully as the painting. Included in the scene is an exquisite still life, an ironic counterpoint to the prison setting. This is how one will find Levine's still lifes, as accessories to the main human event. The only known separate still life by this artist, *Flowers* (1962), called by Levine his "safe still life," was painted as a reaction to the criticism that arose following the 1959 exhibition that traveled to Moscow, in which Levine's *Welcome Home* was included.

If Levine's view of the American military is acerbic, it has the grace note of wit. His portrayals of European generals, however, are constrained to impart only the haughtiness and arrogance that made the subjects' use of oppression possible (see *Death's-Head Hussar*, No. 34, and *Prussian General*, No 38A and 38B). The victims of their cruelty are movingly depicted in *The Prisoner* (No. 8), based on the 1959–62 *Spanish Prison*, in which the foreground figure, overtly suffering deprivation of speech and freedom, is accompanied by his jailer, who, emerging out of the shadows, is equally shackled—if not physically, certainly in mind and spirit. In *The End of the Weimar Republic* (No. 44) a fair transcription of the 1959 painting *1932 (In Memory of George Grosz)*, Levine conjectured a situation in which President Hindenburg transfers the power of the state to Adolf Hitler. Always mindful of the masterpieces in the history of art, Levine was inspired in the format by Titian's *Paul III and His Grandsons*.

The gruesome consequences of Hitler's power is something that Levine has not dealt with in art.

> I think that an artist should paint his life, and I try to, and I am a social painter to the degree that the society or the body politic impinges on my life. The gas ovens were too horrible for me to face. Now with Hitler and Hindenburg—that was an aspect I *could* face. Somebody showed me a book about Germany . . . a line caught my eye about Hindenburg . . . and I was off![24]

The closest he came to depicting Nazi brutality was in *Warsaw Ghetto* (No. 54), in which its victims are seen fleeing their devastated homes.

A visit to Prague brought forth more gentle memories in the following years. Its charming City Hall appears as background to a rabbinical figure in *Rabbi of Prague* (No. 36). He returned to the subject in the 1974 painting *Rabbi from Prague* and also in the recent print *Lion of Prague* (No. 66). His interest in dignified rabbis, the religious leaders whose teachings he had spurned as a teenager, was manifested earlier in such prints as *Ashkenazi I* (No. 9) and *Ashkenazi II* (No. 16).

These still and serene studies of man are in great contrast to the active, even violent, situations encountered in *Cain and Abel I* (No. 21), *Cain and Abel II* (No. 52), *Sacrifice of Isaac* (No. 60) and *Torso of David* (No. 63). The prints bring to mind the question of what it is that motivates an artist in choosing his subjects. Levine suggests that many times, as in these works, he was simply looking for an artistic challenge. Levine wanted to render figures in action and arrested motion, and subjects from the Old Testament offered him the opportunity "to tackle the problems." In the past, artists have often turned to the classics for the same reason.

Jack Levine signing *The Prisoner* (No. 8), 1963.

In 1965, Levine went to Paris at the urging of Abe Lublin, who wanted him to work with the skilled Old World printmakers and particularly to experiment with color etching using the lift-ground technique. He arrived alone on a chilly Sunday morning, and although he had been to Paris a number of times before, "the idea of being there to be creative was a bit intimidating. I couldn't think of anything to do, but when I walked down the avenue and saw this muse with a kneeling figure in front, I had my topic!" The next day in the studio he started work on a self-portrait with muse, *American in Paris* (No. 25). Just recently he had explored, in drawings and prints, the presentation of characters from Ben Jonson's social comedy *Volpone, or the Fox* (see *Venetian Lady*, No. 18, *Volpone II*, No. 19, *Volpone III*, No. 20, the unpublished *Sketches for Volpone*, No. 68, and *Study for Volpone*, No. 69). He now returned to this play for his lady and her attendant dwarf in *La Toilette* (No. 27). Levine's last etching in Paris was the third in a series, *Rape of the Sabines (State Two)* (No. 29B), done in color (see also *L'Enlevement des Sabines*, No. 28, and *Rape of the Sabines [State One]*, No. 29A).

> The Rape of the Sabines is a persistent theme in Paris; you see it in reliefs and you see it in paintings. I don't know why it was on my agenda other than that it allowed me to work on nudes. When you think of the Sistine Chapel and the glorious use you see there of the human body, it seems irreverant to reduce it to Motif No.1 and Motif No.2. So, the Rape of the Sabines could be some kind of current commentary on women's rights, it could be a dissertation on the rather evil origin of the City of Rome, but mostly it's an excuse to do the nude and show off, or exult, or whatever . . . to test whether one as an artist can hack it.

By now, Levine had learned to handle the lift-ground technique well, but in the process of experimentation "many good things had been destroyed." While he had enjoyed the experience, he had no interest in "all the cookery involved" and had no intention of pursuing color etching. Before going home, he spent some time in a lithography atelier where he continued his homage to the masters in *Helene Fourment* (No. 31) and *Je Me Souviens de M. Watteau* (No. 32). Levine's continuous awe of the past masters as revealed in conversations is touching, but the obvious pleasure and total lack of self-consciousness with which he invades their stylistic territories is indicative of his own affinity with the great art of the past.

The joy of reveling in all the painterly means that in mysterious ways can transform a dull canvas into glowing flesh, gleaming satins and sparkling glass is much in evidence in

what Levine refers to as his "frivolous paintings," which he painted through the Fifties, Sixties and Seventies, finding his subjects in cafés, burlesque houses and theaters, as well as in the movies he saw and the books he read. Some of these are translated into prints that have to be appreciated on their own, less exuberant, terms and in a more intimate manner. *Careless Love* (No. 35), another memory from the film of *Die Dreigroschenoper,* mercilessly revealing some tawdry characters who can be seen in certain places of entertainment, is derived from the 1959 painting *Love, Oh Careless Love.* From one of Colette's novels comes *Boudoir* (No. 48), related to *Chéri,* painted the previous year and depicting a woman past her youth but not her desire for love. *The Great Society* (No. 49) and *At the Ball* (No. 50) are both related to the 1967 painting *The Great Society,* and present society at play rather than in the more serious pursuits that Lyndon Johnson had in mind when the term was coined.

A remarkable achievement is the lithograph *Thought* (No. 58), which shows a man familiar from the paintings *Opening Night—Man in Top Hat* (1970) and *For the Sake of Art—Avant-Garde* (1969–71). Its large size is impressive to begin with, but the sensuous, velvety black that covers most of the paper and sculpts the face as if by magic into an expression of total repose, has a tactile quality rare in a print. Levine has in the past had mixed feelings about lithography. "When I do an engraving or an aquatint, I have a real sense of making a plate from which impressions may be taken." But "I have always felt that there was something a little bit meretricious about lithography, unless you do what I did with the man wearing a top hat in *Thought* which is practically a piece of sculpture, the way I scratched the stone."[25] Subsequently, Levine has experienced satisfaction and pleasure in drawing on limestone and will travel some distance to be where the heavy stones are located (see *Requiem,* No. 64). For this artist, no transfer paper may come between him and the actual stone.

Among Levine's frivolous works must also be counted many of his allusions to the classics, which he often approaches tongue in cheek. In the early Sixties he did many drawings and paintings on the subject of The Judgment of Paris, of which there is also a print (see No. 22). Asked about his nudes, whose hefty shapes and stances are not unrelated to his burlesque queens, the artist explains:

> I am not the kind of artist that makes a Greek amphora, and while I admire the airfoil wing of a plane, I am not so much for these long, extended lines. The long-legged Harper's Bazaar model isn't really my thing, and so my figures are apt to be a little dumpy and a little clumsy, and moreover, that's the human body as I *do* it. I see it as everyone else sees it, but I don't *do* what I see. Physiognomists, and I'm one you see, never do as much with the body as they do with the head. This is true of people like Rembrandt or even Daumier, and in my small way, I think I'm like that too.[26]

In 1968, Levine accepted an assignment from *Time* magazine to cover the Democratic convention in Chicago. Never having done commercial work, it was a new experience for him. Out of the trauma that he witnessed came many drawings, some of which were reproduced with the story. Others were translated into such paintings as the *Texas Delegate* of 1968–71, who, with his lean, athletic body and good looks is, according to Levine, what a business tycoon looks like today. The delegate appears heavier and more like an old character out of Levine's stock in the print with the same name (No. 57). Observing Mayor Daley, Levine felt that he had invented him

as a character long ago and was reassured that the type was still around (see *The Daley Gesture,* No. 53).

After a decade during which his prints had sold well and been shown in galleries here and abroad, the pendulum had swung, and the art world was again interested in figurative painting. Levine had not shown his paintings in New York since his last exhibition at The Alan Gallery in 1966, although his work had been in many museum exhibitions around the country. He now chose the Kennedy Galleries to represent him; the faith of Lawrence Fleischman, its director, in Levine's work was rewarded when their inaugural exhibition opened in 1972 and elicited an enthusiastic response from public and collectors alike.

This brings us to the subject of the artist and his patrons. "I do have some deep misgivings about critics, art lovers and arbiters," says Levine. "I'm so deep into my work that I have to disparage appreciators." Looking for enlightenment in his *Art Lover,* painted in 1962, we find a youthful Louis XIV, seated with his magnifying glass in hand and gazing at a piece of art that has its existence outside the picture frame. He is magnificent in his gleaming satins and feathered hat against a background of heavenly gold that gives authority to his divine judgment. The painting was inspired by an engraving of the Sun King and his queen. Levine had originally meant to do a diptych but never finished the other half. One can only hope that it still exists in a dark corner of the studio and will be brought to life some day. In the lithograph that followed in 1967 (see No. 46), Louis has acquired heavy jowls and the pompous expression of a fool, but his attribute confirms that he is still the arbiter of what is good in art. For further illumination one may turn to the 1971 painting *Self-Portrait at Westchester Party,* in which the painter pokes fun at himself as he faces his patrons. (Unfortunately, there is no derivation from it among his prints.) Enthusiastically nudged forward by his genial host to shake hands with his fawning admirers, he is obviously in extreme discomfort, and we may safely surmise that he would much prefer to be back in the pungent atmosphere of his oil-stained studio.

A comprehensive retrospective exhibition, organized by The Jewish Museum in 1978, traveled from coast to coast and again brought Jack Levine's work to the attention of a wide public. It caused a flurry of writing about the artist's past and present history. In the course of events, he has been called an Expressionist and a romantic, a social commentator and a Social Realist, the latter term applied to those American artists who, particularly in the Thirties, tried to urge changes in society by depicting its ills. Through the years Levine himself has shunned labels. He insists that, in the main, he is not an activist and not very interested in politics and society as such. He thinks that art should be an expression of the artist's total experience of his time: "The ideas come from the process of daily living as things go by. It's a question of whether they catch in the elbow of the pipe and form a sludge." Those ideas that have stayed with him have consistently been of human interest.

Levine's energies and emotions were sorely tested for a long time during the illness of Ruth, his wife of 35 years and a talented artist. She died in the spring of 1982 and, at this writing, Levine, a devoted family man throughout their life together, is adjusting to his new circumstances. "Tradition is very precious," he said some years ago. "To paint is to be a keeper of the flame and to do something with it."[27] We are confident that Jack Levine will hold aloft that flame for a long time to come. It is in good hands.

NOTES

1. Robert Taylor, "A Major American Artist Emerges from the South End," *Boston Sunday Herald*, September 21, 1952.

2. Selden Rodman, *Conversations with Artists*, New York: Capricorn Books, 1961, p. 197.

3. In the beginning, Levine would send his "four-handed versions" as gifts to the people or institutions who had collected the paintings from which they derived. He was never thanked by, or even heard from, the recipients, and soon abandoned the practice.

4. Jack Levine, "My Early Boyhood," in *Paintings by Jack Levine—Sculpture by David von Schlegell: Paintings and Sculpture by Americans of Our Times*, Museum of Art of Ogunquit, Maine, 1964 (exh. cat.), n.p.

5. *Ibid.*

6. *Ibid.*

7. Jack Levine, "Jack Levine Talks about the Donation of 108 of His Drawings to the Archives," *Archives of American Art Bulletin*, vol. 2, March 1962, pp. 4–5.

8. Henry Freedman, *Jack Levine: Painter and Protester*, Baltimore, Md.: A dissertation submitted to The Johns Hopkins University in conformity with the requirements for the degree of Doctor of Philosophy, 1974, p. 111.

9. Quoted in Frederick S. Wight, "A Jack Levine Profile," *Art Digest*, vol. 26, September 15, 1952, p. 11.

10. Levine, "Levine Talks about the Donation." pp. 4–5.

11. Quoted in Wight, "A Jack Levine Profile," p. 10.

12. Rodman, *Conversations with Artists*, p. 203.

13. Jack Levine, "Jack Levine," in *Americans 1942—18 Artists from 9 States*, Dorothy C. Miller, ed., The Museum of Modern Art, New York, 1942 (exh. cat.), p. 87.

14. Paul J. Sachs, *Teachers and Kings*, Greenwich, Conn.: New York Graphic Society, 1958.

15. Rodman, *Conversations with Artists*, p. 194.

16. Freedman, *Jack Levine: Painter and Protester*, p. 82.

17. Robert J. Donovan, "President Is Critical of Art for Moscow," *New York Herald Tribune*, July 2, 1959, p. 10.

18. Clement Greenberg, "1930–1945," with quotes from an interview with the artist by Brian O'Doherty on a Boston Museum of Fine Arts program for station WGBH-TV, *Art in America*, August–September 1965, p. 107.

19. Rodman, *Conversations with Artists*, p. 202.

20. Quoted in Frederick S. Wight, "Under the L," in *Jack Levine*, The Institute of Contemporary Art, Boston, 1955 (exh. cat.), pp. 14–15.

21. "Splendid Handful," *Time*, vol. 66, August 8, 1955, p. 56.

22. Amei Wallach, "The Painter Who Came in from the Cold," *Newsday* (New York), April 25, 1972, p. 5A.

23. Quoted in Barbara Rose, *American Art Since 1900*, London: Thames and Hudson, 1967, p. 189.

24. Quoted in Kenneth W. Prescott, *Jack Levine*, The Jewish Museum, New York, 1978 (exh. cat.), p. 22.

25. *Ibid.*, p. 26.

26. *Ibid.*, p. 22.

27. Freedman, *Jack Levine: Painter and Protester*, p. 97.

BIOGRAPHICAL OUTLINE

1915 Born in Boston, Mass., 3 January.

1924–30 Studies drawing with Harold K. Zimmerman at Community Center, Roxbury, Mass.

1929–33 Studies painting with fellow student Hyman Bloom under tutelage of Dr. Denman W. Ross, Department of Art, Harvard University, Cambridge, Mass.

1935 Twenty Levine drawings bequeathed by Dr. Denman W. Ross to Fogg Art Museum, Harvard.

1935–40 Employed intermittently as an artist by the Easel Division, W.P.A. Art Project, Boston.

1936 Exhibits paintings for the first time in N.Y.C.: The Downtown Gallery; The Museum of Modern Art (*Card Game* and *Brain Trust*).

1937 First included in Whitney Museum of American Art's Annual Exhibition with *String Quartette. The Feast of Pure Reason* placed on indefinite loan to The Museum of Modern Art. Released from W.P.A. Art Project, vacates private studio and shares one with Hyman Bloom.

1938 Readmitted to Federal Art Project. *The Feast of Pure Reason* exhibited at Musée du Jeu de Paume, Paris. First included in Carnegie Institute's International Exhibition, Pittsburgh, Pa.

1939 First one-man exhibition held at The Downtown Gallery. *Night Scene*, exhibited at New York World's Fair, is purchased and presented to Addison Gallery of American Art, Andover, Mass.

1940 For the last time, dropped from the Federal Art Project. First included in Annual Exhibition of the Pennsylvania Academy of Art, Philadelphia, Pa. with *Street Scene, No. 2.*

1942–45 Drafted into U.S. Army; serves in the U.S. and on Ascension Island, South Atlantic Ocean; discharged as Technical Sergeant in 1945.

1942 Second Prize for *String Quartette* in *Artists for Victory* exhibition at The Metropolitan Museum of Art, N.Y.—painting subsequently purchased for permanent collection. First print, *Matisse and U.S. Servicemen*, published by the Boston Chapter of The Museum of Modern Art.

1943 First exhibits at Walker Art Center, Minneapolis, Minn. and Milwaukee Art Institute, Wis.

1945 Awarded John Simon Guggenheim Memorial Fellowship (May 1945–May 1946); travels to Europe and studies works by old masters. *The Syndicate* purchased for the Encyclopaedia Britannica Collection, Chicago, Ill. *Neighborhood Physician* purchased by Walker Art Center, Minneapolis.

1946 Marries painter Ruth Gikow. Second prize for *Welcome Home* from Carnegie Institute, Pittsburgh. Honorable Mention for *At Ease* (drawing) from National Academy of Design, N.Y. Grant Award from National Institute of Arts and Letters, N.Y. First exhibition at Tate Gallery, London. Guggenheim Fellowship renewed for one year (May 1946–May 1947); continues travels and studies in Europe.

1947 Third prize and bronze medal for *Apteka* from Corcoran Gallery of Art, Washington, D.C.

1948 Jennie Sesnan Gold Medal for *Apteka* from Pennsylvania Academy of Fine Arts. Chosen by *Look* as one of "Ten Best Painters."

1949 Second print, *Hebrew King*, published by The Downtown Gallery. Paints at Woodstock, N.Y. during summer.

1950 Teaches advanced painting at Cleveland Institute of Art, Cleveland, O.

1950–51 Fulbright grant for one year's study in Rome.

1951 Included in *I São Paulo Bienal*, Brazil.

1952 First retrospective exhibition, The Institute of Contemporary Art, Boston.

1953 First exhibition, paintings and drawings, The Alan Gallery, N.Y.; third print, *Woodstock Pastoral,* published by A. Lublin Inc.

1955 Retrospective exhibition, Whitney Museum of American Art, N.Y. (conclusion of 1952 Institute of Contemporary Art exhibition). *Solomon's Temple* included in American Wing of Israel National Art Museum, Jerusalem. Elected to American Academy of Arts and Sciences, Boston.

1956 Included in *XXVIII Venice Biennale*, Italy; elected member of National Institute of Arts and Letters, N.Y. Teaches summer school at Skowhegan School of Painting and Sculpture, Me.

1957 Awarded honorary D.F.A., Colby College, Waterville, Me.

1958 Grand Painting Prize, Instituto Nacional de Bellas Artes, Mexico City. Teaches painting at Pennsylvania Academy of Fine Arts, Philadelphia. Teaches summer school at Skowhegan School of Painting and Sculpture. New York City subway car display reproductions of works by Levine. New York Graphic Society publishes *Teachers and Kings*, facsimile reproductions of six portrait paintings of biblical and medieval characters.

1959 Second W. A. Clark Prize for *The Girls from Fleugel Street*, Corcoran Gallery of Art. Teaches summer school at Skowhegan School of Painting and Sculpture.

1960 Thirty paintings featured in a Sala de Honor of *II Bienal Interamericana*, Instituto Nacional de Bellas Artes, Mexico City.

1962 Purchases from dealer 108 student drawings which had been retained by his teacher Harold K. Zimmerman, and presents group to American Archives of Art. Elected member Board of Governors, Skowhegan School of Painting and Sculpture; resigns within year. With three intaglio prints, *Bearded Head*, *The White Horse* and *The General*, begins to focus seriously on printmaking.

1964 Walter Lippincott Prize for *The Last Waltz*, Pennsylvania Academy of the Fine Arts.

1966–69 Teaches painting at Pennsylvania Academy of the Fine Arts.

1967 *The Dreigroschenfilm* (The Threepenny Opera), a suite of 20 soft-ground etchings published by A. Lublin Inc./Touchstone Publishers, Ltd.

1968 Retrospective exhibition, De Cordova Museum, Lincoln, Mass.

1970 *Facing East*, limited-edition portfolio including four color lithographs, ten woodcuts and 54 pochoir and phototype reproductions, introduction by James Michener, published by Random House, Maecenas Press.

1972 First exhibition at Kennedy Galleries, Inc., N.Y.

1973 Elected member American Academy of Arts and Letters, N.Y. Travels to Israel and Spain. Honorable Mention for *Portrait of Harry*, The Butler Institute of Art, Youngstown, O. *Cain and Abel* painting added to the Collection of Modern Art, Borgia Apartment, Vatican Museum, Vatican City.

1975 Altman Prize for *The Perpetrator*, National Academy of Design.

1978–79 Retrospective exhibition, The Jewish Museum, N.Y.

EXHIBITIONS

One-Man Exhibitions (Selected)

1939 The Downtown Gallery, New York, N.Y., January 17–February 4, *Jack Levine*. Biographical notes by Jack Levine.

1948 The Downtown Gallery, New York, N.Y. May 4–29, *Jack Levine: Exhibition of New Paintings*.

1950 Boris Mirski Gallery, Boston, Mass., January 17–February 17, *Jack Levine*.

1952 The Downtown Gallery, New York, N.Y., January 29–February 16, *Jack Levine—Exhibition of Paintings*. The Institute of Contemporary Art, Boston, Mass., September 17–October 15, *Jack Levine*. Foreword by Lloyd Goodrich; essay by Frederick S. Wight. Circulated to: The Currier Gallery of Art, Manchester, N.H., November 5–30; Colorado Springs Fine Arts Center, Colorado Springs, Colo., February 3–28, 1953; Akron Art Institute, Akron, O., March 17–April 19, 1953; The Phillips Collection, Washington, D.C., May 3–June 1, 1953; Whitney Museum of American Art, New York, N.Y., February 23–April 3, 1955.

1953 The Alan Gallery, New York, N.Y., October 26–November 21, *Gangster Funeral; Related Paintings and Drawings by Jack Levine*. Text by Jack Levine.

1955 For the "Whitney Retrospective," see circulation of exhibition organized by The Institute of Contemporary Art, Boston, 1952. Gallery of Art Interpretation, The Art Institute of Chicago, Ill., April 15–September 15, *The Trial and Preliminary Drawings*. The Philadelphia Art Alliance, Philadelphia, Pa., October 26–November 27, *Jack Levine: Drawings*.

1956 Colby College (Miller Library), Waterville, Me., April 3–20, *Jack Levine*.

1957 The Alan Gallery, New York, N.Y., May 7–25, *Jack Levine: Paintings and Drawings*.

1959 The Alan Gallery, New York, N.Y., December 29, 1959–January 16, 1960, *Jack Levine*.

1960 Randolph-Macon Woman's College, Lynchburg, Va., March 5–23, *49th Annual Exhibition: Paintings by Jack Levine*. Instituto Nacional de Bellas Artes, Mexico, September 5–November 5, *II Bienal Interamericana*.

1962 The New Art Center, Detroit, Mich., September 25–October 10, *Jack Levine: Childhood Drawings*.

1963 The Alan Gallery, New York, N.Y., April 8–27, *Jack Levine*. Berkshire Museum, Pittsfield, Mass., July 2–31, *Paintings by Jack Levine*. The Alan Gallery, New York, N.Y. December 9–28, *Jack Levine: Etchings and Aquatints 1963*.

1965 Klutznick Exhibit Hall, B'nai B'rith Building, Washington, D.C., November 1–30, *Jack Levine Graphics*.

1966 The Alan Gallery, New York, N.Y., April 19–May 7, *Jack Levine: Recent Paintings and Drawings*. Kovler Gallery, Chicago, Ill., May 11–June 4, *Jack Levine: Drawings and Graphics*.

1967 Athena Gallery, New Haven, Conn., January 15–February 18, *The Complete Graphic Works of Jack Levine*. Graphis Inc., New York N.Y., June 15–30, *Jack Levine: Dreigroschenfilm*. George Washington University Art Gallery, Washington, D.C., November–December, *Jack Levine: Dreigroschenfilm*.

1968 Galería Colibrí, San Juan, Puerto Rico, January 19–February 3, *Jack Levine: Dreigroschenfilm*. De Cordova Museum, Lincoln, Mass., February 4–March 24, *Jack Levine: Paintings and Prints*. Text by John D. McLaughlin. Galleria d'Arte il Gabbiano, Rome, Italy, March 20–April 4, *Jack Levine: Opera Grafica*. Muggleton Art Gallery, Auburn, N.Y., *Jack Levine, Graphics, 1968*.

1970 Art Harris Art Gallery, Los Angeles, Calif., March 17–31, *Jack Levine: Etchings and Lithographs*.

1971 Long Beach Museum of Art, Long Beach, Calif., January 20–February 7, *Jack Levine: Graphic Retrospective*.

1972 Kennedy Galleries, Inc., New York, N.Y., April 12–May 6, *Jack Levine: Recent Paintings*. Text by Mahonri Sharp Young.

1973 Kennedy Graphics, New York, N.Y., February 1–March 17, *Jack Levine Graphics*.

1975 Kennedy Galleries, Inc., New York, N.Y., November 8–29, *Jack Levine—Recent Work*.

1977 Kennedy Graphics, New York, N.Y., October 12–November 19, *Levine—Prints and Drawings*.

1978 Rodman Hall Arts Centre, St. Catherines, Ontario, Canada, April 4–30, *Jack Levine*. Kennedy Graphics, New York, N.Y., November 8–December 2, *Jack Levine—Graphic Works*. The Jewish Museum, New York, N.Y., November 8, 1978–January 28, 1979, *Jack Levine: Retrospective Exhibition—Paintings, Drawings, Graphics*. Foreword and Essay by Kenneth W. Prescott. Circulated to: Norton Gallery and School of Art, West Palm Beach, Fla., February 17–April 8; Brooks Memorial Art Gallery, Memphis, Tenn., April 30–June17; Montgomery Museum of Fine Arts, Montgomery, Ala., July 9–August 26; Portland Art Museum, Portland, Ore., September 17–November 4; Minnesota Museum of Art, St. Paul, Minn., November 26, 1979–January 13, 1980.

1979 Kennedy Graphics, New York, N.Y., September 17–October 27, *Jack Levine: Chicago, 1968*. Robert I. Kahn Gallery, Temple Emanu-El, Houston, Tex., September 13–October 10, *Jack Levine—Modern Day Master*. Kennedy Graphics, New York, N.Y., October, *Jack Levine—Graphic Work*.

1981 Kennedy Graphics, New York, N.Y., April, *Jack Levine—Prints*.

1982 Kennedy Graphics, New York, N.Y., January, *Jack Levine—Graphic Work*.

Group Exhibitions (Selected)

1936 The Museum of Modern Art, New York, N.Y., September 14–October 12, *New Horizons in American Art*.

1937 Addison Gallery, Phillips Academy, Andover, Mass., May–June 23, *Four Years of Federal Art in New England*. The Downtown Gallery, New York, N.Y., October, *Twelve Young American Painters*. Whitney Museum of American Art, New York, N.Y., November 10–December 12. *Annual Exhibition of Contemporary American Painting*.

1938 *Three Centuries of American Art*, organized by The Museum of Modern Art, New York, N.Y., exhibited at Musée du Jeu de Paume, Paris, May 24–July 31. The Downtown Gallery, New York, N.Y., October 4–October 22, *Americans at Home*. Carnegie Institute, Pittsburgh, Pa., October 13–December 4, *International Exhibition of Paintings*. Whitney Museum of American Art, New York, N.Y., November 2–December 11, *Annual Exhibition of Contemporary American Painting*.

1939 New York World's Fair, New York, N.Y., *American Art Today*. The Museum of Modern Art, New York, N.Y., May 10–September 30, *Tenth Anniversary Exhibition: Art in Our Time*. The Downtown Gallery, New York, N.Y., June 7–30, *American Art Past and Present*. Carnegie Insti-

tute, Pittsburgh, Pa., October 19–December 10, *International Exhibition of Paintings*. The Downtown Gallery, New York, N.Y., November 7–25, *Contemporary American Genre*.

1940 Whitney Museum of American Art, New York, N.Y., January 10–February 18, *Annual Exhibition of Contemporary American Painting*. Pennsylvania Academy of Fine Arts, Philadelphia, Pa., January 28–March 3, *135th Annual Exhibition of Painting and Sculpture*. The Museum of Modern Art, New York, N.Y., April 3–May 1, *Four American Travelling Shows* and *Thirty-Five under Thirty-Five*, circulated to eight institutions. Carnegie Institute, Pittsburgh, Pa. October 24–December 15, *Survey of American Painting*.

1941 The Downtown Gallery, New York, N.Y., January 7–February 1, *The Painter Looks at Music*; June exhibition; October 7–November 1, *Fall 1941: New Examples by Leading American Artists*. Pennsylvania Academy of Fine Arts, Philadelphia, Pa., January 26–March 2, *136th Annual Exhibition of Painting and Sculpture*. Whitney Museum of American Art, New York, November 12–December 30, *Annual Exhibition of Paintings by Artists under Forty*.

1942 The Museum of Modern Art, New York, N.Y., January 21–March 8, *Americans 1942: 18 Artists from 9 States*. Circulated to: The Institute of Modern Art, Boston, Mass. City Art Museum, St. Louis, Mo., January 25–February 28, *Thirty-sixth Annual American Exhibition: Trends in American Painting of Today*. Pennsylvania Academy of Fine Arts, Philadelphia, Pa., January 25–March 1, *137th Annual Exhibition of Painting and Sculpture*. The Downtown Gallery, New York, N.Y., September 22–October 10, *Opening Exhibition*. Whitney Museum of American Art, New York, N.Y., November 24, 1942–January 6, 1943, *Annual Exhibition of Contemporary American Art*. The Metropolitan Museum of Art, New York, N.Y., December 7, 1942–February 22, 1943, *Artists for Victory: An Exhibition of Contemporary American Art*. Circulated to: The Institute of Modern Art, Boston, May–June 1943.

1943 Pennsylvania Academy of the Fine Arts, Philadelphia, Pa., January 24–February 28, *138th Annual Exhibition of Painting and Sculpture*. Milwaukee Art Institute, Milwaukee, Wis., March 5–28, *Masters of Contemporary American Painting*. Corcoran Gallery of Art, Washington, D.C., March 21–May 2, *18th Biennial Exhibition of Contemporary American Oil Paintings*. The Downtown Gallery, New York, N.Y., October 5–30, *18th Annual Exhibition*.

1944 Pennsylvania Academy of the Fine Arts, Philadelphia, Pa., January 23–February 27, *139th Annual Exhibition of Painting and Sculpture*. The Downtown Gallery, New York, N.Y., April 11–May 6, *Spring 1944: New Important Paintings and Sculptures by Leading Americans*. The Downtown Gallery, New York, N.Y., October 3–28, *19th Annual Exhibition*.

1945 Whitney Museum of American Art, New York, N.Y., January 3–February 8, *Annual Exhibition of American Sculpture, Watercolors and Drawings*. *Encyclopaedia Britannica Collection of Contemporary American Painting*, organized by Encyclopaedia Britannica, Inc., Chicago, Ill., Opened at The Art Institute of Chicago, Ill., April 12, and circulated to 36 United States cities. Carnegie Institute, Pittsburgh, Pa., October 11–Decmber 9, *Painting in the United States*. The Downtown Gallery, New York, N.Y., October 15–November 3, *Loan Exhibition*; November 6–December 1, *20th Annual Exhibition*. Whitney Museum of American Art, New York, N.Y., November 27, 1945–January 10, 1946, *Annual Exhibition of Contemporary American Painting*.

1946 National Academy of Design, New York, N.Y., January 3–23, *Second Annual Exhibition of Contemporary American Drawing*. The Downtown Gallery, New York, N.Y., May 7–25, *New Post-War Paintings by Important Americans*; June 4–28, *June 1946: New Important Paintings by Leading Americans*; September 24–October 19, *21st Annual Exhibition*. Tate Gallery, London, England, June–July, *American Painting from the Eighteenth Century to the Present Day*. Carnegie Institute, Pittsburgh, Pa., October 10–December 8, *Painting in the United States*.

1947 Riverside Museum, New York, N.Y., January 25–February 8, *La Tausca Art Competition*; circulated to nine institutions. The Downtown Gallery, New York, N.Y., February 4–March 1, *Important New Drawings*; The Brooklyn Museum, Brooklyn, N.Y., February, *Anniversary Exhibition*. Whitney Museum of American Art, New York, N.Y., March 11–April 17, *Contemporary American Sculpture, Watercolors and Drawings*; December 6, 1947–January 25, 1948, *Annual Exhibition of American Painting*. Corcoran Gallery of Art, Washington, D.C., March 30–May 11, *Twentieth Biennial Exhibition of Contemporary American Oil Paintings*. Carnegie Institute, Pittsburgh, Pa., October 9–December 7, *Painting in the United States, 1947*. The Institute of Contemporary Art, Boston, Mass., November 7–December 21, *30 Massachusetts Painters in 1947*. *American Industry Sponsors Art*, organized by the United States Department of State and circulated in Europe.

1948 The Downtown Gallery, New York, N.Y., January–February 7, *Five Americans*; September 28–October 23, *23rd Annual Exhibition*. Pennsylvania Academy of Fine Arts, Philadelphia, Pa., January 25–February 29, *143rd Annual Exhibition of Painting and Sculpture*. Whitney Museum of American Art, New York, N.Y., January 31–March 31, *Contemporary American Sculpture, Watercolors and Drawings*; November 13, 1948–January 2, 1949, *Annual Exhibition of Contemporary Painting*. Carnegie Institute, Pittsburgh, Pa., October 14–December 12, *Painting in the United States*.

1949 Institute of Contemporary Art, Boston, Mass., January 1–December 31, *American Painting in Our Century*. Circulated to five institutions. Pennsylvania Academy of Fine Arts, Philadelphia, Pa., January 23–February 27, *144th Annual Exhibition of Painting and Sculpture*. University of Illinois, Urbana, Ill., February 26–April 13, *Contemporary American Painting*. Whitney Museum of American Art, New York, N.Y., April 2–May 8, *Contemporary American Sculpture, Watercolors and Drawings*. December 16, 1949–February 5, 1950, *Annual Exhibition of Contemporary American Painting*. The Downtown Gallery, New York, N.Y., April 15–April 23, *The Artist Speaks*; October 3–October 22, *24th Annual Exhibition*. Carnegie Institute, Pittsburgh, Pa., October 13–December 11, *Painting in the United States, 1949*.

1950 Pennsylvania Academy of Fine Arts, Philadelphia, Pa., January 22–February 21, *145th Annual Watercolor Exhibition*. *145th Annual Exhibition of Painting and Sculpture*. Whitney Museum of American Art, New York, N.Y., April 1–May 28, *Contemporary American Sculpture, Watercolors and Drawings*; November 10–December 31, *Annual Exhibition of Contemporary American Painting*. Carnegie Institute, Pittsburgh, Pa., October 19–December 21, *Pittsburgh International Exhibition of Paintings*. The Metropolitan Museum of Art, New York, N.Y., opened

December 8, *American Painting Today, 1950.*

1951 Pennsylvania Academy of Fine Arts, Philadelphia, Pa., January 21–February 25, *146th Annual Exhibition of Painting and Sculpture.* De Cordova Museum, Lincoln, Mass., April 8–May 13, *Moods and Movements, Boston—1951.* The Art Institute of Chicago, Chicago, Ill., October 25–December 16, *60th Annual Exhibition: Paintings and Sculpture.* Museu de Arte Moderna de São Paulo, Brazil, October–December, *I São Paulo Bienal.* Whitney Museum of American Art, New York, N.Y., November 8, 1951–January 6, 1952, *Annual Exhibition of Contemporary American Painting.*

1952 Pennsylvania Academy of Fine Arts, Philadelphia, Pa., January 20–February 24, *147th Annual Exhibition of Painting and Sculpture.* Whitney Museum of American Art, New York, N.Y., October 1–November 2, *Edith and Milton Lowenthal Collection* (circulated to: Walker Art Center, Minneapolis, Minn., November 20–January 17, 1953); November 6, 1952–January 4, 1953, *Annual Exhibition of Contemporary American Painting.*

1953 Whitney Museum of American Art, New York, N.Y., October 15–December 6, *Annual Exhibition of Contemporary American Painting.* Seattle Art Museum, Seattle, Wash., November 5, 1953–April 5, 1954, *Contemporary American Painting and Sculpture.*

1954 Pennsylvania Academy of Fine Arts, Philadelphia, Pa., January 24–February 28, *149th Annual Exhibition of Contemporary American Painting and Sculpture.* The Art Institute of Chicago, Chicago, Ill., October 21–December 5, *61st American Exhibition: Paintings and Sculptures.* The Museum of Modern Art, New York, N.Y., October 19, 1954–January 2, 1955, *Twenty-fifth Anniversary Exhibition: Paintings from the Museum Collection.*

1955 The Butler Institute of American Art, Youngstown, O., March 6–April 2, *The American Jew in Art. Modern Art in the U.S.A.,* organized by The Museum of Modern Art, New York, N.Y., circulated to: Musée National d'Art Moderne, Paris, France, March 30–May 15; Kunsthaus, Zurich, Switzerland, July 16–August 28; Museo del Arte Moderno, Barcelona, Spain, September 24–October 24; Haus des Deutschen Kunsthandwerks, Frankfurt, Germany, November 13–December 11; The Tate Gallery, London, England, January 5, 1956–February

12, 1956; Gemeentemuseum, The Hague, Netherlands, March 2–April 15, 1956; Neue Gallerie in der Stallburg, Vienna, Austria, May 5–June 2, 1956; Kalemagdan Pavilion, Belgrade, Yugoslavia, July 6–August 6, 1956. William Rockhill Nelson Gallery of Art and The Mary Atkins Museum of Fine Arts, Kansas City, Mo., April 17–May 8, *Contemporary American Painting in Honor of the American Jewish Tercentenary.* The Museum of Modern Art, New York, N.Y., May 31–September 5, *Paintings from Private Collections.* Milwaukee Art Institute, Milwaukee, Wis., September 9–October 23, *55 Americans.* Detroit Institute of Arts, Detroit, Mich., September 23–October 30, *Collection in Progress: Selections from the Lawrence and Barbara Fleischman Collection of American Art.* Carnegie Institute, Pittsburgh, Pa., October 13–December 18, *The 1955 Pittsburgh International Exhibition of Contemporary Painting.* Whitney Museum of American Art, New York, N.Y., November 9, 1955–January 8, 1956, *Annual Exhibition of Contemporary American Painting.*

1956 Pennsylvania Academy of the Fine Arts, Philadelphia, Pa., January 22–February 26, *151st Annual Exhibition of Painting and Sculpture.* Whitney Museum of American Art, New York, N.Y., April 18–June 10, *Annual Exhibition of Contemporary American Sculpture, Watercolors and Drawings;* November 14, 1956–January 6, 1957, *Annual Exhibition: Sculpture, Paintings, Watercolors and Drawings.* Venice, Italy, June 16–October 21, *XXVIII Biennale di Venezia.*

1957 Solomon R. Guggenheim Museum, New York, N.Y., March 27–June 7, *First Annual Guggenheim International Award Exhibition.* Whitney Museum of American Art, New York, N.Y., November 20, 1957–January 12, 1958, *Annual Exhibition: Sculpture, Paintings and Watercolors.* Pennsylvania Academy of the Fine Arts, Philadelphia, Pa., *152nd Annual Exhibition of Paintings and Sculpture.*

1958 Pennsylvania Academy of the Fine Arts, Philadelphia, Pa., January 26–February 23, *153rd Annual Exhibition of Paintings and Sculpture.* Instituto Nacional de Bellas Artes, Mexico City, Mexico, June 6–August 20, *I Bienal Interamericana de Pintura y Grabado. Fulbright Painters,* organized by The Smithsonian Institution, Washington, D.C. Circulated to: Whitney Museum of American Art, New York, N.Y., September

16–October 5, and to 19 other U.S. cities. Pennsylvania Academy of the Fine Arts, Philadelphia, Pa., October 25-November 20, *20th Century Painting and Sculpture from Philadelphia Private Collections.*

1959 The Corcoran Gallery of Art, Washington, D.C., January 17–March 8, *The 26th Biennial Exhibition.* Whitney Museum of American Art, New York, N.Y., March 5–April 12, *The Museum and Its Friends: Eighteen Living American Artists Selected by the Friends of the Whitney Museum. American Painting and Sculpture,* organized by the United States Department of State; opened in Moscow, U.S.S.R., July 25. The Art Institute of Chicago, Chicago, Ill., December 2, 1959–January 31, 1960, *63rd American Exhibition: Paintings, Sculpture.* Association of Museums in Israel, Jerusalem, Israel, *18 American Artists,* sponsored by the Whitney Museum of American Art, New York, N.Y., and American Federation of Arts, New York, N.Y.

1960 The Metropolitan Museum of Art, New York, N.Y., March 23–June 19, *The Nate and Frances Spingold Collection.* Museo Nacional de Arte Moderno, Mexico City, Mexico, September 5–November 5, *II Bienal Interamericana de Mexico.* Whitney Museum of American Art, New York, N.Y., December 1, 1960–January 22, 1961, *Annual Exhibition: Sculptures and Drawings.*

1961 Whitney Museum of American Art, New York, N.Y., April 10–May 16, *The Theatre Collects American Art.* The Alan Gallery, New York, N.Y., September 12–30, *61–62: Opening Exhibition.* Whitney Museum of American Art, New York, N.Y., December 13, 1961–February 4, 1962, *Annual Exhibition: Contemporary American Painting.*

1962 Pennsylvania Academy of the Fine Arts, Philadelphia, Pa., January 12–February 25, *157th Annual Exhibition of Painting and Sculpture.* The Alan Gallery, New York, N.Y., June 4–29, *Sculpture, Drawings, Watercolors, Prints of Three Centuries;* September 25–October 13, *62–63: Tenth Anniversary Season. ART:USA: NOW: The Johnson Collection of Contemporary American Paintings,* organized by S. C. Johnson and Son, Inc. Circulated to: Milwaukee Art Center, Milwaukee, Wis., September 21–October 31 and to Europe, U.S. and Japan for five years. Whitney Museum of American Art, New York, N.Y., December 12, 1962–February 3, 1963, *Annual Exhibition; Sculpture and Drawings.*

1963 Washington Gallery of American Art, Washington, D.C., July–August, *U.S. Government Art Projects: Some Distinguished Alumni.* The Beaverbrook Art Gallery, Fredericton, England, September 7–October 6, *The Dunn International: An Exhibition of Contemporary Painting.* Circulated to: The Tate Gallery, London, England, November 15–December 14. The Minneapolis Art Institute, Minneapolis, Minn., November 27, 1963–January 19, 1964, *Four Centuries of American Art.* Whitney Museum of American Art, New York, N.Y., December 11, 1963–February 2, 1964, *Annual Exhibition: Contemporary American Painting.* National Gallery of Art, Washington, D.C., December 17, 1963–March 1, 1964, *Paintings from The Museum of Modern Art, New York.*

1964 Pennsylvania Academy of the Fine Arts, Philadelphia, Pa., January 15–March 1, *159th Annual Exhibition of American Painting and Sculpture.* October 3–25, *Recent Acquisitions.* The Art Institute of Chicago, Ill., February 28–April 12, *Directions in Contemporary Painting and Sculpture, 67th American Exhibition.* Galleria George Lester, Rome, Italy, May 11–30, *Paintings, Jack Levine, The Judgment of Paris: Collages, Nathan Oliveira.* The Alan Gallery, New York, N.Y., September 8–26, *64–65: Opening Exhibition.*

1965 The Metropolitan Museum of Art, New York, N.Y., April 9–October 17, *Three Centuries of American Painting.* The Brooklyn Museum, Brooklyn, N.Y., June 15–September 12, *The Herbert A. Goldstone Collection of American Art.* The Alan Gallery, New York, N.Y., September 8–October 2, *65–66: Opening Exhibition.* Whitney Museum of American Art, New York, N.Y., December 8, 1965–January 30, 1966, *Annual Exhibition: Contemporary American Paintings.*

1966 Pennsylvania Academy of the Fine Arts, Philadelphia, Pa., January 21–March 6, *161st Annual Exhibition of Painting and Sculpture;* November 3–December 11, *An Exhibition by Former Chairmen of Juries for Annual Exhibitions.* Corcoran Gallery of Art, Washington, D.C., April–Septem-

ber, *Two Hundred and Fifty Years of American Art.* Cleveland Museum of Art, Cleveland, O., June 6–July 31, *Four Centuries of American Art.* Whitney Museum of American Art, New York, N.Y., September 28–November 27, *Art in the United States: 1670–1966.*

1967 Vatican Museum, Rome, Italy, July, *American Graphics Exhibited at the Museum of Contemporary Art, Vatican Museum.* Whitney Museum of American Art, New York, N.Y., December 13, 1967–February 4, 1968, *Annual Exhibition of Contemporary American Painting.* Pennsylvania Academy of the Fine Arts, Philadelphia, Pa., *162nd Annual Exhibition of Painting and Sculpture.*

1968 Pennsylvania Academy of the Fine Arts, Philadelphia, Pa., January 19–March 3, *163rd Annual Exhibition of Painting and Sculpture;* September 19–October 27, *Art Collecting, Philadelphia Style: Selected Works from Private Collectors.* Galleries of the National Academy of Design, Skowhegan School of Painting and Sculpture, New York, N.Y., October 4–13, *Annual Art Exhibition and Sale.* Whitney Museum of American Art, New York, N.Y., October 15–December 1, *The 1930's: Painting and Sculpture in America.*

1969 ACA Galleries, New York, N.Y., September 17–October 11, *Major Acquisitions Including the Lester Avnet Collection of American Paintings.*

1971 Kennedy Galleries, Inc., New York, Summer, *Summer Exhibition.* The Museum of Modern Art, New York, N.Y., Summer, *The Artist as Adversary.* Joslyn Art Museum, Omaha, Neb., October 10–November 28, *The Thirties Decade: American Artists and Their European Contemporaries.*

1973 The Butler Institute of American Art, Youngstown, O., July 1–September 3, *37th Annual Midyear Show.*

1974 The American Academy of Arts and Letters and The National Institute of Arts and Letters, New York, N.Y., June 30–September 2, *Annual Ceremonial and Exhibitions of Works by Newly Elected Members.*

1975 Jack O'Grady Galleries, Chicago, Ill., October, *Tribune's Bicentennial*

Collection. The Jewish Museum, New York, N.Y., October 16–January 25, 1976, *Jewish Experience in the Art of the Twentieth Century.*

1977 Kennedy Galleries, Inc., New York, N.Y., February 23–March 12, *Seventy-Five Years of American Painting;* Summer, *Living With Painting and Sculpture;* November 16–December 3, *The City as a Source.* December 8–21, *Artists Salute Skowhegan. Representations of America,* co-organized by The Metropolitan Museum of Art, New York, N.Y., and The Fine Arts Museums of San Francisco, Calif. Circulated in the U.S.S.R. to: Pushkin Museum, Moscow, December 15–February 15, 1978; Hermitage Museum, Leningrad, March 18–May 15, 1978; Palace of Art, Minsk, June 15–August 16, 1978.

1978 Montgomery Museum of Fine Arts, Montgomery, Ala., April 26–June 11, *American Art 1934–1956: Selections From the Whitney Museum of American Art.* Circulated to: Brooks Memorial Art Gallery, Memphis, Tenn., June 30–August 6; Mississippi Museum of Art, Jackson, Miss., August 21–October 1. Kennedy Galleries, Inc., New York, N.Y., December 6, 1978–January 6, 1979, *The American View—Art from 1770-1978.*

1979 Kennedy Galleries, Inc., New York, N.Y., December 4–January 5, 1980, *Selected American Masterworks;* May 1–May 26, *The Eyes of America: Art from 1792–1979.*

1980 Kennedy Galleries, Inc., New York, N.Y., November 5, 1980–January 9, 1981, *People, Places and Things, American Painting 1750–1980;* April 17–May 23, *Sixty American Paintings.*

1981 Kennedy Galleries, Inc., New York, N.Y., November 11, 1981–January 15, 1982, *Art of America—Selected Painting and Sculpture;* April 14–May 29, *Kennedy Galleries Selections of American Art from Public and Private Collections.*

1982 Oklahoma Art Center, Oklahoma City, Okla., May 7–June 20, *American Masters of the Twentieth Century.* Circulated to: Terra Museum of American Art, Evanston, Ill., July 11–September 15.

BIBLIOGRAPHY

WRITINGS BY LEVINE (arranged chronologically)

Statement on String Quartet in "Notes," *The Metropolitan Museum of Art Bulletin*, vol. 7, February 1949, p. 148.

"Jack Levine" in *Americans 1942—18 Artists From 9 States*, Dorothy C. Miller, ed., The Museum of Modern Art, New York, 1942 (exh cat.).

"Homage to Vincent," *Art News*, vol. 47, December 1948, pp. 26–29f.

"Form and Content," *College Art Journal*, vol. 9, Autumn 1949, pp. 57–58.

"Man is the Center," *Reality; A Journal of Artists' Opinions* (New York), vol. 1, Spring 1953, pp. 5–6 (abridged from a speech delivered in a symposium, "Modern Artists on Artists of the Past," held at The Museum of Modern Art, April 22, 1952).

Teachers and Kings: Six Paintings by Jack Levine; Greenwich, Connecticut: New York Graphic Society, 1959 (Introduction by Paul J. Sachs).

"Jack Levine Talks about the Donation of 108 of His Drawings to the Archives," *Archives of American Art Bulletin*, vol. 2, March 1962, pp. 4–5.

"My Early Boyhood," in *Paintings by Jack Levine—Sculpture by David von Schlegell: Paintings and Sculpture by Americans of Our Times*, Museum of Art of Ogunquit, Maine, 1964 (exh. cat.).

"In Praise of Knowledge," in *The Influence of Spiritual Inspiration on American Art*, Musei Vaticani and The Smithsonian Institution, Rome, Libreria Editrice Vaticana, 1977, pp. 55–60.

"Marvin Cherney 1925–1967," Kennedy Galleries, New York, 1980 (exh. cat.).

MONOGRAPH

GETLEIN, FRANK. *Jack Levine*, New York: Harry N. Abrams, Inc., 1966.

SELECTED PERIODICALS (arranged chronologically)
Indicates that article is an exhibition review

The Art Digest, vol. XI, October 1, 1936, cover.

*DAVIDSON, MARTHA, "The Government as a Patron of Art," *Art News*, vol. 35, October 10, 1936, pp. 11–12.

*MUMFORD, LEWIS, "The Art Galleries," *New Yorker*, vol. 10, October 10, 1936.

*"Twelve," *Time*, vol. 30, October 18, 1937.

*D[AVIDSON], M[ARTHA]. "Levine: Epic Painting in a First One-man Showing," *Art News*, vol. 37, January 1939, p. 12.

*BIRD, PAUL. "The Fortnight in New York," *Art Digest*, vol. 13, February 1, 1939, pp. 18–19.

Parnassus, vol. XIII, February 1941, p. 92.

*"Downtown Group," *Art Digest*, vol. 15, June 1, 1941, p. 24.

CROWNINSHIELD, FRANK. "Six American discoveries—A great museum goes to the artists," *Vogue*, vol. 99, May 15, 1942.

*FARBER, M. "Artists for Victory; Metropolitan Museum of Art Opens Great Exhibition for American Artists," *Magazine of Art*, vol. 35, December 1942, pp. 274–280.

"No More K.P.," *Art Digest*, vol. 17, January 1, 1943, p. 12.

*"Britannica Collection Fulfills Promise," *Art Digest*, vol. 19, September 15, 1945, pp. 5f.

*BREUNING, MARGARET. "This is Their Best," *Art Digest*, vol. 20, November 15, 1945, p. 31.

"Angry Artist," *Time*, vol. 47, May 20, 1946, p. 64.

*"The Found and the Lost," *Newsweek*, vol. 27, May 20, 1946.

*"The American Taste," *Time*, vol. 47, June 24, 1946.

*"The Big Show," *Time*, vol. 48, October 21, 1946.

*"Carnegie Goes Abstract," *Newsweek*, vol. 28, October 21, 1946, p. 106.

FRANKFURTER, ALFRED M. "American Art Abroad," *Art News*, vol. 45, October 1946, p. 26.

Magazine of Art, October 1946.

*LOUCHHEIM, ALINE B. "One More Carnegie," *Art News*, vol. 45, November 1946, p. 40.

*THWAITES, JOHN ANTHONY. "London Letter; The Tate Show: Misrepresenting American Art," *Magazine of Art*, vol. 39, December 1946, pp. 382–383.

*BOSWELL, PEYTON. "Review of the Year," *Art Digest*, vol. 21, January 1, 1947, pp. 18f.

"Americans Abroad," *Magazine of Art*, vol. 40, January 1947, pp. 21–25.

*"Corcoran Biennial Opens in Washington—Menkes Places First," *Art Digest*, vol. 21, April 1, 1947, pp. 12f.

"*Welcome Home* Acquired by the Museum," *Brooklyn Institute of Arts and Sciences. Bulletin*, vol. 8, March 1947, p. 2.

SUMMERS, MARION. "From the Sketchbook of Jack Levine," *Mainstream* (New York, N.Y.), vol. 1, Spring 1947, pp. 213–216.

McCAUSLAND, ELIZABETH. "The Caustic Art of Jack Levine," *'47 Magazine of the Year* (New York, N.Y.), vol. 1, September 1947.

*DAME, LAWRENCE. "Regarding Boston," *Art Digest*, vol. 22, January 1, 1948, p. 14f.

*BREUNING, MARGARET. "Five of the Best," *Art Digest*, vol. 22, February 1, 1948, p. 10.

*"Reviews and Previews: Five Americans," *Art News*, vol. 46, February 1948, p. 58.

"The School of Boston," *Newsweek*, vol. 31, May 5, 1948.

*LANSFORD, ALONZO. "Jack Levine Shows Post-War Paintings," *Art Digest*, vol. 22, May 15, 1948.

*"Exhibition, Downtown Gallery," *Pictures on Exhibit*, vol. 10, May 1948, pp. 18–19ff.

*"Spotlight on: Levine, Berman, Friedman, Arnest, Lam," *Art News*, vol. 47, May 1948, pp. 36f.

*DAME, LAWRENCE. "Boston Institute Surveys American Painting," *Art Digest*, vol. 23, February 1, 1949, pp. 12f.

*"Handful of Fire," *Time*, vol. 55, December 26, 1949.

"The Image of Man, the Artist has Shattered It, but He Cannot Forget It," *Life*, vol. 27, January 23, 1950.

*"City Boy," *Time*, vol. 55, January 30, 1950, p. 51.

"Itinerant General: Levine's *Welcome Home*," *Brooklyn Institute of Arts and Sciences. Bulletin*, vol. 12, Fall 1950, p. 4.

MEYERS, BERNARD. "Jack Levine, One of the Most Versatile Painters in the World Today," *American Artist*, vol. 15, Summer 1951, pp. 36–41.

*"Reviews and Previews: Jack Levine," *Art News*, vol. 50, February 1952, pp. 42–43.

*"Crises and Dilemma: Retrospective Show at Boston's Institute of Contemporary Art," *Time*, vol. 60, September 8, 1952, pp. 82–83.

*WIGHT, FREDERICK S. "A Jack Levine Profile," *Art Digest*, vol. 26, September 15, 1952, pp. 10–11f.

*"Reviews and Previews: Jack Levine," *Art News*, vol. 52, no. 7, November 1953, pp. 41–42.

*"Breakthroughs," *Time*, vol. 62, November 16, 1953, p. 84.

SOBY, JAMES THRALL. "Gangster's Funeral," *Saturday Review* (Washington, D.C.), vol. 36, December 5, 1953, pp. 57–58.

WERNER, ALFRED, "Art and Artists," *Congress Weekly*, December 7, 1953, pp. 14–15.

*"Bucking the Trend," *Time*, vol. 64, October 18, 1954.

*COATES, ROBERT M. "The Art Galleries: Retrospective Works of Hyman Bloom and Jack Levine at the Whitney," *New Yorker*, vol. 31, March 12, 1955, pp. 100–102.

*"Fortnight in Review: Hyman Bloom and Jack Levine," *Art Digest*, vol. 29, no. 12, March 15, 1955, p. 22.

"The Angry Art of the Thirties," *Fortune*, vol. 51, March 1955.

*"Major Work by an American Artist Shown with Preliminary Drawings," *The Art Institute of Chicago Quarterly*, vol. 49, April 1, 1955, pp. 23ff.

*SCHACK, WILLIAM. "Genesis and Kings," *The Reconstructionist* (New York), vol. 21, June 24, 1955.

*KRAMER, HILTON. "Bloom and Levine: The Hazards of Modern Painting," *Commentary*, vol. 19, June 1955, pp. 583–587.

*"Splendid Handful," *Time*, vol. 66, August 8, 1955, p. 56.

JOHNSON, UNA E. "Contemporary American Drawings," *Perspectives USA*, no. 13, October 1955, p. 94.

"The Trial," *University of Chicago Magazine*, vol. 48, March 1956.

*"Poison in the Sky," *Time*, vol. 68, September 24, 1956, p. 74.

"*String Quartette* by Jack Levine," *Etude* (Philadelphia, Pa.) vol. 74, October 1956.

*COATES, ROBERT M. "Art Galleries: Male and Female," *New Yorker*, vol. 33, May 18, 1957, pp. 129–130.

*"In the Galleries: Jack Levine," *Arts*, vol. 31, June 1957, p. 53.

*Reviews and Previews: Jack Levine," *Art News*. vol. 56, Summer 1957, p. 22.

GETLEIN, FRANK. "Jack Levine: The Degrees of Corruption," *The New Republic*, October 6, 1958, p. 20.

GROSSMAN, EMERY. "Jack Levine: Young Dean of American Artists," *Temple Israel Light* (Great Neck, N.Y.), vol. 5, January 1959.

*"The Corcoran's Century," *Time*, vol. 73, February 2, 1959, pp. 50–51.

WERNER, ALFRED. "The Peopled World of Jack Levine," *The Painter and Sculptor* (London), vol. 2, Summer 1959, pp. 24–29.

WERNER, ALFRED. "Jack Levine's Feast of Colour," *Jewish Affairs* (Johannesburg, S.A.), October 1959, pp. 13–15.

*"New Work at The Alan Gallery," *Apollo*, vol. 70, October 1959, p. 106.

"U.S. Art to Russia; the State Department Changes Policy," *Art News*, November 1959, p. 301.

*"Easier Levine," *Time*, vol. 75, January 11, 1960, p. 56.

*"Reviews and Previews: Jack Levine," *Art News* vol. 59, March 1960, pp. 12–13.

RIVAS, GUILLERMO. "Paintings in the Second Biennial," *Mexican Life* (Mexico City), October 1960.

GENAUER, EMILY. "On the Defensive," *Art Digest,* vol. 26, October 1, 1961, p. 34.

"Precocious Pencil," *Time,* vol. 79. February 9, 1962, p. 56.

*GETLEIN, FRANK. "The Whitney: What's New?," *The New Republic*, vol. 146, February 12, 1962, pp. 30–31.

*GETLEIN, FRANK. "Art Against the Grain," *Horizons*, vol. 4, July 1962, p. 16.

*"In the Galleries: Jack Levine, Hyman Bloom," *Arts,* vol. 37, November 1962, p. 42.

*"Reviews and Previews: Jack Levine," *Art News*, vol. 62, Summer 1963, p. 16.

*"In the Galleries: Jack Levine, " *Arts*, vol. 37, September 1963, p. 63.

GETLEIN, FRANK, "Printmaking and the Painter," *The New Republic*, vol. 149, October 5, 1963, pp. 31–33.

*OLIVEIRA, NATHAN. "Alla galleria Lester di Roma, mostra di Levine e Oliveira/Levine espone una serie di opere sul 'Giudizio di Paride,' " *Arte Oggi* (Rome), May 20, 1964.

WERNER, ALFRED. "The Art of Jack Levine," *The Chicago Jewish Forum*, vol. 23, Winter 1964–65.

GREENBERG, CLEMENT. "Part VI—America Takes the Lead," *Art in America*, vol. 53, August–September 1965, pp. 108–129.

McCOY, GARNETT. "The Artist Speaks: Part V," *Art in America* , vol. 53, August–September 1965, pp. 88–107.

WERNER, ALFRED. "On Jack Levine, Upon the Occasion of his Appearance at The Herzl Institute," *Herzl Institute Bulletin* (New York, N.Y.), vol. 2, October 24, 1965.

*"In the Galleries: Jack Levine," *Arts*, vol. 40, June 1966, p. 52.

KAY, JANE. "Portrait of the Artist—Jack Levine, Paintings and Prints at De Cordova Museum," *Boston Arts*, March 1968, pp. 19–21.

CARRIERE, RAFFAELE. "Jack Levine: un americano affamato di immagini," *Epoca*, vol. 19, June 1968, pp. 139–141.

"The Democrats After Chicago," *Time*, vol. 92, September 6, 1968.

HAVERSTOCK, MARY SAYRE. "An American Bestiary," *Art in America*, vol. 58, July–August 1970, pp. 38–71.

MICHENER, JAMES. "The social critic and somber witness on an enchanted holiday," *Orientations* (Hong Kong), vol. 1, October 1970, pp. 24ff.

*"Reviews and Previews: Jack Levine," *Art News*, vol. 71, April 1972, p. 54.

*HANCOCK, MARIANNE. "Review: Jack Levine," *Arts*, vol. 46, Summer 1972, p. 65.

YOUNG, MAHONRI SHARP. "Jack Levine: an appreciation," *Northlight* (Westport, Conn.), vol. 4, November–December 1972, pp. 10–15.

*"Reviews and Previews: Jack Levine," *Art News*, vol. 72, March 1973, p. 84.

BALDWIN, C. "Le Penchant des peintres américains pour le réalisme," *Connaissance des Arts*, no. 254, April 1973, p. 119.

*TANNENBAUM, JUDITH. "Reviews, New York," *Arts*, vol. 47, April 1973, p. 87.

WERNER, ALFRED. "Ghetto Graduates: Jewish Immigrant Artists in America," *American Art Journal,* vol. 5, November 1973, p. 81.

*WEISSMAN, JULIAN. "New York Reviews: Jack Levine," *Art News*, vol. 75, January 1976, p. 120.

GLUECK, GRACE. "The 20th Century Artists Most Admired by Other Artists," *Art News*, vol. 76, November 1977, pp. 78–103.

SELECTED NEWSPAPER ARTICLES (arranged chronologically)

*Indicates that article is an exhibition review

*"The Federal Art Show," *Christian Science Monitor*, April 27, 1937.

*JEWELL, EDWARD ALDEN, "Lively Americans at the Whitney," *New York Times*, November 14, 1937.

*"Paintings by Whorf and Levine Chosen for Paris Exhibition," *Boston Evening Transcript*, April 30, 1938.

*GENAUER, EMILY. "Downtown Exhibits Bitter Protests of Jack Levine," *New York World-Telegram*, January 21, 1939.

*"Exhibition, The Downtown Gallery," *New York Times*, January 22, 1939.

*"Contemporary American Art Put on Display," *New York Herald Tribune*, January 2, 1942.

*ADLOW, DOROTHY. "Artists for Victory Show Under Art Institute Auspices," *Christian Science Monitor*, June 1, 1943.

*GENAUER, EMILY. "Changes in Technique," *New York World-Telegram*, December 1, 1945.

"Institute of Arts adds 13 Members," *New York Times*, February 7, 1946.

*CRANE, JANE WATSON. "Corcoran Biennial Offers a Key to 'What is American Art?' Big Post War Exhibit Conservative at Core," *Washington Post*, March 3, 1947.

BROOKS, NED. "Modern Art Banned As Official Export," *New York World-Telegram*, May 19, 1947.

*GENAUER, EMILY. "Vital Works on View by Levine," *New York World-Telegram,* May 11, 1948.

*GENAUER, EMILY, "*Welcome Home* Gets Reception at Denver Show," *New York World-Telegram*, August 24, 1948.

DeVREE, HOWARD. "Purchases" [*Reception in Miami* . . . Among Recent Museum Acquisitions], *New York Times*, January 2, 1949.

*DRISCOLL, EDGAR J., JR. "Levine's One-Man Show Stimulating Exhibit," *Boston Sunday Globe*, January 22, 1950.

*LOUCHHEIN, ALINE B. "Boston sees Levine in Retrospect," *New York Times*, September 21, 1952.

*TAYLOR, ROBERT. "A Major American Artist Emerges From the South End," *Boston Sunday Herald*, September 21, 1952.

*DRISCOLL, EDGAR J., JR. "Levine Show Highlights New Boston Art Season," *Boston Sunday Globe*, September 28, 1952.

*WERNER, ALFRED. "Art and Artists," *Congress Weekly* (New York, N.Y.), October 13, 1952.

*GENAUER, EMILY. "Art and Artist: Paintings by Moderns, Trend of Whitney Annual Show Swings Away from Abstract," *New York Herald Tribune*, November 4, 1952.

*GENAUER, EMILY. "Humanist with Bite," *New York Herald Tribune*, May 31, 1953.

*DeVREE, HOWARD. "From Old Masters to American Moderns Range the Week's Exhibitions," *New York Times*, October 4, 1953.

*"Levine Work Monumental," *New York Herald Tribune*, October 31, 1953.

WERNER, ALFRED. "Art and Artists," *Congress Weekly* (New York, N.Y.), December 7, 1953.

*DeVREE, HOWARD. "Whitney Museum Opens Retrospective Shows of Work by Levine and Bloom," *New York Times*, February 24, 1955.

*GENAUER, EMILY. "Two Realists at the Whitney," *New York Herald Tribune*, February 27, 1955.

*Driscoll, Edgar J., Jr. "Three Flights Up But Worth Climb," *Boston Sunday Globe*, December 14, 1958.

Donovan, Robert J. "President is Critical of Art for Moscow," *New York Herald Tribune*, July 2, 1959.

*Canaday, John. "Two American Painters," *New York Times*, January 3, 1960.

*Genauer, Emily. "The Future in Art? A Critic's Answers," *New York Herald Tribune*, January 3, 1960.

*Burrows, Carlyle. "Style Change Best for Guston Status Quo Good for Levine," *New York Herald Tribune*, January 3, 1960.

*Levin, Meyer and Eli. "Painter Levine Retains Critical, Social Perspective," *Philadelphia Inquirer*, February 14, 1960.

*Vargas, Carlos. "Exposición Retrospectiva de Obras del Pintor J. Levine," *El Universal* (Mexico City), July 24, 1960.

*Porcel, Gonzales, "Habla Jack Levine Acerca de la Pintura y de la Política," *Últimas Noticias* (Mexico City), September 14, 1960.

Ronnen, Meir. "Look Back in Anger—on Canvas," *Jerusalem Post Weekly* (Israel), June 17, 1962.

*Culhane, David M. "Londoners Get A Look At 'Art: USA: Now,'" *Sun* (Baltimore), March 3, 1963.

*Genauer, Emily. "Reassuring Show by Jack Levine," *New York Herald Tribune*, April 14, 1963.

*Preston, Stuart. "Old Hands and New in Pursuit of the Image," *New York Times*, April 14, 1963.

Getlein, Frank. "Prints in the Great Tradition," *Sunday Star* (Washington, D.C.), August 11, 1963.

*Genauer, Emily. "The Whitney Annual," *New York Herald Tribune*, December 15, 1963.

Canaday, John. "Art: Debutante and a Grand Old Man," *New York Times*, January 16, 1964.

Carver, Mabel MacDonald. "An Hour with Jack Levine in His Studio," *Villager* (New York, N.Y.), January 16, 1964.

*"Il Mito del Sesso visto da Levine," *L'Unità* (Milan), May 30, 1964.

*Banks, Harold. "Jack is Quick on the Draw," *Record American* (Boston, Mass.), September 4, 1964.

Wilson, Patricia Boyd, "String Quartette," *Christian Science Monitor*, December 6, 1965.

*Genauer, Emily. "The Facts Up to Date at the Whitney Annual," *New York Herald Tribune*, December 12, 1965.

*Getlein, Frank, "Impressive Panorama of American Art at Corcoran," *Sunday Star* (Washington, D.C.), April 17, 1966.

Carr, Jane, "Levine: Man Behind The Mask," *New Haven Register*, February 5, 1967.

Getlein, Frank. "Art: The Summertime Boom in Graphics is Here Again," *Washington Star*, August 1967.

*"Call Him 'Jack the Brush,' Threepenny Opera Inspires Portfolio of Prints," *Washington Post* (Washington, D.C.), November 30, 1967.

Werner, Alfred. "Views and Visions," *Jewish News* (Newark, N.J.), January 5, 1968.

*"Pintor Levine Ofrecería Charla," *El Mundo* (San Juan, P.R.), January 23, 1968.

*"Jack Levine Works at De Cordova," *Jewish Advocate* (Boston), February 1, 1968.

*Ruiz de la Mata, Ernesto J. "Jack Levine," *San Juan Star Magazine* (Puerto Rico), February 4, 1968.

*Driscoll, Edgar J., Jr. "Jack Levine's Acid Works of Art, Alas the human touch," *Boston Globe*, February 11, 1968.

*LeBrun, Caron. "At Last—A Tribute to Jack Levine," *Herald Traveler* (Boston), March 17, 1968.

"Americani del dissenso," *L'Unità* (Milan), April 5, 1968.

*"L'arte polemica di Jack Levine," *Paese Sera* (Rome), April 5, 1968.

Berkman, Florence, " 'Non-Artists have Called the Shots,' Says Levine," *Hartford Times* (Conn.), March 18, 1969.

Kenny, Herbert A., "Jack Levine, satirist in paint, to publish $600 sketch book," *Boston Globe,* June 10, 1970.

*Wallach, Amei. "The Painter Who Came in From the Cold," *Newsday* (New York, N.Y.), April 25, 1972.

Genauer, Emily. "Art and the Artist," *New York Post*, April 29, 1972.

*"Realist Art Master Returns," *Times-News* (Erie, Pa.), May 29, 1972.

*Winship, Frederick M. "Critics hostile but Levine oils back in vogue," *Boston Globe*, May 31, 1972.

Chapin, Louis. "Humane American Satirist," *Christian Science Monitor*, July 13, 1972.

*Kramer, Hilton. "Jack Levine," *New York Times*, February 3, 1973.

Werner, Alfred. "Jack Levine: A Social Realist," *Jewish News* (Newark, N.J.), February 6, 1975.

*Glueck, Grace. "Paintings by Levine Defy Abstract Trend," *New York Times*, November 11, 1975.

Spencer, Charles. "Artists with a Social Conscience, Jack Levine: Painter of American Life," *Jewish Chronicle Literary Supplement* (New York, N.Y.), December 5, 1975.

*Mosher, Charlotte. "Jewish Art Exhibition Offers Memorable Work," *Houston Chronicle*, March 5, 1976.

*"Jack Levine: Retrospective Exhibit," *Jewish Advocate* (New York, N.Y.), November 2, 1978.

*Russell, John S. "A Retrospective Show of Radical Art of Jack Levine," *New York Times*, November 11, 1978.

*Shenker, Israel. Jack Levine Paintings at the Jewish Museum," *New York Times*, November 18, 1978.

*Tallmer, Jerry. "Graphics brood into the savage," *New York Post*, November 25, 1978.

*Werner, Alfred. "Levine Retrospective Praised as MOMA Features Matisse," *The Jewish News* (New Jersey), December 7, 1978.

*Szonyi, David. "I Swing A Heavy Brush," *Baltimore Jewish Times* (Md.), January 5, 1979.

*Taylor, Robert. "Boston Expressionists: They marched to the beat of a different drummer," *Boston Sunday Globe*, January 14, 1979.

*Holmes, Ann. "Levine loves being 'singular in my time,' " *Houston Chronicle*, September 17, 1979.

COMMENTARY

1. Matisse and U.S. Servicemen. Alternative titles: At the U.S.O.; U.S.O. at Boston Chapter. **Date:** 1942. **Medium:** lithograph in black. **Image size:** 10¼ x 8½". **Sheet size:** 12 x 16". **Paper:** Machine made. **Printer:** Joseph Butera, Boston, Mass. **Publisher:** Boston Chapter of the Museum of Modern Art (later Institute of Contemporary Art). **Edition:** Unknown, probably in excess of 100. **Signature:** "J Levine" l.r. center, on the stone; ca. six signed by the artist "J Levine '42," l.l., in pencil.

Early in World War II, the Boston Chapter of New York's Museum of Modern Art opened its doors as a recreational center for U.S. servicemen and women. Levine donated this print for fund-raising purposes. It shows two bewildered servicemen confronted with a version of Matisse's dancing figures. A rotund gentleman with an uncanny likeness to the master himself serves as docent.

2. Hebrew King. Alternative title: The King. **Date:** 1949. **Medium:** lithograph in black. **Image size:** ca. 13¾ x 9¾". **Sheet size:** 18 x 13" **Paper:** Basingwerk parchment. **Printer:** John Muench, N.Y. **Publisher:** The Downtown Gallery, N.Y. **Edition:** 50; A.P. unknown. **Signature:** "47/50," l.l.; "J Levine," l.r. in pencil; "J Levine," l.l., on stone.

In the Forties, Levine had painted a series of portrayals of Hebrew sages and kings. Thus when one day he tried his hand on a stone in John Muench's lithography shop on 14th Street, the image of a turbaned man took form quite naturally. Muench was struck with the drawing and, instead of removing it from the stone as Levine has expected, pulled the print. It was subsequently offered for sale as a small edition by The Downtown Gallery. The somber figure we see in this print may be considered a forerunner to the 1952 painting, *Maimonides* (10 x 8"; see also Nos. 14A, 14B and 42).

3. Woodstock Pastoral. Alternative title: Satyr and Girls. **Date:** 1952 (printed in 1969). **Medium:** etching on copper in black. **Plate size:** 8¼ x 8¾". **Sheet size:** 16 x 9¼". **Paper:** B. F. K. Rives. **Printer:** Emiliano Sorini, N.Y. **Publisher:** A. Lublin Inc., N.Y. **Edition:** 120; ca. 10–20 A.P. **Signature:** "Artist's Proof," l.l.; "J Levine," l.r., in pencil.

In 1949 Levine spent about a month at the artists' colony in Woodstock, N.Y., where he began work on a painting, *Woodstock Pastoral* (25 x 31"). "The painting was an experiment in the Rubens technique," he recalls. "I was interested in flesh tonalities and figures in motion." The rather ponderous humor evident in the painting was intended as a joke on the colony, which Levine regarded as "the antithesis of anything as pagan" as the scene with frolicking figures which he composed. In 1952, Ernest Jones, an elderly printmaker in the neighborhood, urged Levine to try his hand at etching. The artist was not enthusiastic and "had to be led to it." Jones provided a varnished plate, and Levine quickly made a drawing, "a spin-off on a bit of Woodstock." The plate lay forgotten until 1969, when Sorini etched it.

4. Bearded Head. Alternative title: The Bearded Man. **Date:** 1962. **Medium:** etching, drypoint and aquatint on zinc in black. **Plate size:** 9¾ x 7⅞". **Sheet size:** 22¼ x 15". **Paper:** Arches. **Printer:** Emiliano Sorini, N.Y. **Publisher:** A. Lublin Inc., N.Y. **Edition:** 50; one known A.P. **Signature:** "Artist's Proof," l.l.; "J Levine," l.r., in pencil.

Although Levine considers *Bearded Head* the result of a "work plate," he also regards it as the beginning of his career in printmaking. It was under the guidance of Emiliano Sorini, a skilled technician, that Levine was introduced to the varied techniques of intaglio printing. He began this print by doing all kinds of "doodles" on the plate. After Sorini had put it in acid, he guided the artist in further preparation of the plate by the use of drypoint and aquatints in different tones, burying some of the first sketches in the process. However, a close examination will reveal a turbaned man (at the bottom, upsidedown) and a woman adorned with pearls (upper left).

5. The White Horse. **Date:** 1962. **Medium:** etching on zinc in black. **Plate size:** 7¾ x 9¾". **Sheet size:** 15 x 22". **Paper:** Arches.

Printer: Emiliano Sorini, N.Y. **Publisher:** A. Lublin Inc., N.Y. **Edition:** 50; A.P. unknown. **Signature:** "1/50," l.l.; "J Levine," l.r., in pencil.

Animals, where present in Levine's work, are generally treated as peripheral elements. This work-worn horse, a generic image drawn from memory, is, however, a recurring motif. The print relates to an early 1946 painting *The White Horse* (30 x 36"). The artist is here feeling his way in the use of crosshatching.

6. The General. Alternative titles: The Spanish General; The Jailer. **Date:** 1962–63. **Medium:** etching and aquatint on zinc in Van Dyke brown. **Plate size:** 14¾ x 17½" **Sheet size:** 19¾ x 25¾". **Paper:** B. F. K. Rives. **Printer:** Emiliano Sorini, N.Y.; ⬚ES, l.r. **Publisher:** A. Lublin Inc., N.Y. **Edition:** 100; ca. 10–20 A.P. **Signature:** "Artist's Proof," l.l.; "J Levine," l.r.; "General," l.c., in pencil.

The 1956 painting *The Turnkey* (54 x 60⅛"), from which this print is derived, was intended to portray General Franco, "the consummate fascist enemy, the one who was left that the war didn't erase." But as Levine recalls, "the portrait got away from me," and the finished portrayal is that of a fat and pompous little man, "full of ego and nastiness." The ink chosen for this print is a Van Dyke brown, which Levine found very versatile. He is pleased with the paler values which seem to "warm up in a nearly magic way," reminiscent of the oil painting, which is mostly in shades of brown. The warm glow of the chapel setting, with its allusions to devotion, civility and pleasures, is in deep contrast to the use of the building, which is indicated by the dark prison entrance in the background.

7. Adam and Eve. **Date:** 1963. **Medium:** etching on zinc in Van Dyke brown. **Plate size:** 9¾ x 7⅞". **Sheet size:** 22 x 14⅝." **Paper:** B. F. K. Rives. **Printer:** Emiliano Sorini, N.Y. **Publisher:** Associated American Artists, N.Y. **Edition:** 100; ca. 10–20 A.P. **Signature:** "Artist's Proof," l.l.; "J Levine," l.r., in pencil.

Two paintings, both titled *Adam and Eve*, one of 1951 (11¾ x 7¾") and the other of 1959 (48 x 42"), preceded this print. The figures in the paintings have little resemblance to those in the print.

8. The Prisoner. **Date:** 1963. **Medium:** aquatint on zinc in Van Dyke brown. **Plate size:** 12¾ x 17¾". **Sheet size:** 20½ x 29½". **Paper:** B. F .K. Rives. **Printer:** Emiliano Sorini, N.Y. **Publisher:** A. Lublin Inc., N.Y. **Edition:** 100; ca. 10–20 A.P. **Signature:** "Artist's Proof," l.l.; "J Levine," l.r., in pencil.

The imagery in this print tells a story of repression and social evil. Based on a painting of 1959–62, *The Spanish Prison* (28 x 32"), it is a commentary on Franco's Spain. The black hat, familiar emblem of the brutal *guardia civil*, combined with a hangman's mask and prisoner's gag, leave little to the imagination. Levine had seen and admired Goya's aquatints. Here he inked the whole area of the plate, which was put in acid and burnt until it would print black. By "scrubbing, scratching and scraping" the imagery was then brought out.

9. Ashkenazi I. **Date:** 1963. **Medium:** etching on zinc in black. **Plate size:** 9¾ x 7¾". **Sheet size:** 20⅝ x 14¾". **Paper:** B. F .K. Rives. **Printer:** Emiliano Sorini, N.Y. **Publisher:** A. Lublin Inc., N.Y. **Edition:** 100; ca. 10–20 A.P. **Signature:** "Trial Proof," l.l.; "J Levine," l.r., in pencil.

The earliest Jewish settlers in the United States were Sephardic (Spanish-Portuguese) Jews coming from Brazil. This print holds the memory of a visit to a Portuguese synagogue in Newport, R.I. With references to old Portuguese chandeliers and New England architecture the artist has captured the essence of its ambience. The room, however, is occupied by an Ashkenazic (Eastern European) Jew, whose mores and rituals are more familiar to Levine.

10. King David. **Date:** 1963. **Medium:** etching and drypoint on zinc in black. **Plate size:** 9¾ x 7¾". **Sheet size:** 20⅝ x 14⅝". **Paper:** B. F .K. Rives. **Printer:** Emiliano Sorini, N.Y.; ⬚ES, l.r. **Publisher:** Asso-

ciated American Artists, N.Y. **Edition:** 100; ca. 10–20 A.P. **Signature:** "Artists Proof," l.l.; "J Levine," l.r., in pencil.

Although there is an earlier 1940 painting, *King David* (10 x 8″), it has no particular relationship to this print, which is simply another version of David playing the harp. The subject matter was at this point only of secondary interest to technique. Levine had studied Rembrandt's prints, and here he attempted to combine etching and drypoint in order to arrive at the qualities of light and shade for which he was striving (see also *Torso of David*, No. 63).

11. Hillel. Date: 1963. **Medium:** etching on zinc in black. **Plate size:** 9¾ x 7⅞″. **Sheet size:** 20½ x 14¾″. **Paper:** B. F. K. Rives. **Printer:** Emiliano Sorini, N.Y.; ES, l.r. **Publisher:** A. Lublin Inc., N.Y. **Edition:** 100; ca. 10–20 A.P. **Signature:** "Artists Proof," l.l.; "J Levine," l.r., in pencil.

The antecedent of this print is the 1955 miniature painting *Hillel* (9⅞ x 7⅞″), to which the print is quite faithful. Hillel was a Jewish scholar whose teachings were close to those of Christ. He flourished ca. 30 B.C.–9 A.D., the time that saw the birth of the Christ Child. Hillel fills the foreground, as in the painting, occupied with his quill and ink pot. Architectural details, unrelated to his time and place, impart the universality and timelessness of his thoughts. In this print the artist experimented with using sandpaper on the varnished surface to get a desired halftone, but he never used the technique again.

12. The King. Alternative title: King Asa. **Date:** 1963. **Medium:** etching on zinc in black. **Plate size:** 9½ x 7¾″. **Sheet size:** 20½ x 14¾″. **Paper:** Japanese rice affixed on Arches. **Printer:** Emiliano Sorini, N.Y.; ES, l.r. **Publisher:** A. Lublin Inc., N.Y. **Edition:** 100; ca. 10–20 A.P. **Signature:** "Artists Proof," l.l.; "J Levine," l.r., in pencil.

The King was done," says Levine, "like so many things—to keep my hand in it. Started without a specific idea in mind, it began as a kind of improvisation and is, you might say, out of repertoire." Looking through Levine's "repertoire," a miniature painting of 1945 also titled *The King* (10 x 7″) shows an affinity. The print is also related to the later (10 x 8″) painting (1953) which portrays *King Asa*, king of Judah in the ninth century B.C. who was known for his religious reforms. The printer Sorini produced the print on a very fine rice paper, which was affixed to heavier Arches paper resulting in a seemingly tinted background to the printed image (see also Nos. 13 and 15).

13. Apollo and Daphne. Date: 1963–64. **Medium:** etching on zinc in black. **Plate size:** 7¾ x 9¾″. **Sheet size:** 14⅝ x 20½″. **Paper:** Japanese rice affixed on B. F. K. Rives. **Printer:** Emiliano Sorini, N.Y.; ES, l.r. **Publisher:** A. Lublin Inc., N.Y. **Edition:** 100; ca. 10–20 A.P. **Signature:** "Artists Proof," l.l.; "J Levine," l.r., in pencil; "Apollo and Daphne," l.c., on plate.

Jack Levine's sense of humor definitely leans toward satire. Here the classic ideal of beauty is irreverently, if good-naturedly, spoofed. A modern Apollo, rotund and fully dressed, chases a corseted little Daphne, who flees to preserve her virtue. "What kind of a tree will she grow into?" muses the artist. Levine feels that sometimes we "get too intense about human beauty." As with the preceding and following prints (Nos. 12 and 15), this print is on thin rice paper, affixed to heavier stock.

14A. Maimonides I (State One). Alternative title: Moses Maimonides. **Date:** 1963. **Medium:** etching and aquatint on zinc in black. **Plate size:** 9⅝ x 7¾″. **Sheet size:** 20⅝ x 14⅝″. **Paper:** B. F. K. Rives. **Printer:** Emiliano Sorini, N.Y.; ES, l.r. **Publisher:** A. Lublin Inc., N.Y. **Edition:** none; ca. 15 A.P. **Signature:** "Artists Proof," l.l.; "J Levine," l.r., in pencil.

The image in the two states of *Maimonides I* (Nos. 14A and 14B) is based on the 1952 painting *Maimonides* (10 x 8″). This first state was printed by Sorini. Experiencing some trouble with the plate when pulling the proofs, he decided not to print an edition. Levine was pleased with the aquatint in this state and prefers it to the edition subsequently issued (No. 14B). Maimonides was a great twelfth-century scholar. In 1967 Levine returned to the subject in his lithograph *Maimonides II* (No. 42; see also No. 2).

14B. Maimonides I (State Two). Alternative title: Moses Maimonides. **Date:** 1964. **Medium:** etching and aquatint on zinc in Van Dyke brown. **Plate size:** 9⅝ x 7¾″. **Sheet size:** 19¼ x 13″. **Paper:** B. F. K. Rives. **Printer:** Letterio Calapai, N.Y.; (imp), l.r. **Publisher:** Associated American Artists, N.Y. **Edition:** 100; ca. 10–20 A.P. **Signature:** "Artists Proof," l.l.; "J Levine," l.r., in pencil.

This second state was printed and issued as an edition. Lighter in tone, in the artist's mind it is not as successful as the proofs previously pulled (No. 14A).

15. Judas Maccabeus. Alternative title: The Warrior. **Date:** 1963–64. **Medium:** etching on zinc in black. **Plate size:** 9¾ x 7¾″. **Sheet size:** 20½ x 14¾″. **Paper:** Japanese rice affixed on B. F. K. Rives. **Printer:** Emiliano Sorini, N.Y.; ES, l.r. **Publisher:** A. Lublin Inc., N.Y. **Edition:** 100; ca. 10–20 A.P. **Signature:** "Artists Proof," l.l.; "J Levine," l.r., in pencil.

In this print, Levine is feeling his way toward a heroic type of figure—not Greco-Roman, but one with a muscular power which the artist could assign to ancient Hebrew figures such as Cain and Abel (Nos. 21 and 52). At an early stage he felt that the thorax and arm read well in light and shade and he liked the economy of means which produced this effect. "There was something in it that I wanted to keep as a memo and not bring any further." Done about the same time as the preceding two prints (Nos. 12 and 13), this was also printed on thin rice paper and affixed to heavier stock.

16. Ashkenazi II. Alternative title: Rabbi in His Study. **Date:** 1964. **Medium:** etching and drypoint on zinc in black. **Plate size:** 9⅝ x 7⅞″. **Sheet size:** 20½ x 14¾″. **Paper:** B. F. K. Rives. **Printer:** Emiliano Sorini, N.Y.; ES, l.r. **Publisher:** A. Lublin Inc., N.Y. **Edition:** 100; ca. 10–20 A.P. **Signature:** "Artists Proof," l.l.; "J Levine," l.r., in pencil.

Ashkenazi II should not be confused with *Ashkenazi I* (No. 9). Here there is no suggestion of a synagogue interior in the architectural setting, and the rabbi's physiognomy and dress are quite distinct from the 1963 print.

17. Studies of Heads. Alternative title: Character Studies. **Date:** 1964. **Medium:** etching, drypoint and engraving on zinc in black. **Plate size:** 9⅞ x 7⅞″. **Sheet size:** 17⅞ x 12¼″. **Paper:** Japan. **Printer:** Emiliano Sorini, N.Y.; ES, l.r. **Publisher:** A. Lublin Inc., N.Y. **Edition:** 75; ca. 10–15 A.P. **Signature:** "Artists Proof," l.l.; "J Levine," l.r., in pencil.

After seeing a trial proof of this print, Levine here turned to engraving for the first time, refining and adding details on the etched plate.

18. Venetian Lady. Alternative title: Volpone I. **Date:** 1964. **Medium:** engraving on copper in black. **Plate size:** 7¾ x 9¾″. **Sheet size:** 14¾ x 20½″. **Paper:** B. F. K. Rives. **Printer:** Emiliano Sorini, N.Y.; ES, l.r. **Publisher:** A. Lublin Inc., N.Y. **Edition:** 100; ca. 10–20 A.P. **Signature:** "Artists Proof," l.l.; "J Levine," l.r., in pencil.

Levine once saw a production of Ben Jonson's play *Volpone, or the Fox*, and for years he toyed with the idea of making a series based on its characters. A comedy on the evil of avarice, it seemed to Levine to be a forerunner of *The Threepenny Opera*. In 1964 he produced *Venetian Lady*, but "the series never came off," as he puts it (see Nos. 19, 20, 27, 68 and 69). On reflection, he wished he had given the characters in this print modern dress to offset its Venetian locale.

19. Volpone II. Date: 1964. **Medium:** etching on zinc in burnt umber. **Plate size:** 8 x 9¾″. **Sheet size:** 14¾ x 20⅝″. **Paper:** Arches. **Printer:** Emiliano Sorini, N.Y.; ES, l.r. **Publisher:** A. Lublin Inc., N.Y. **Edition:** 100; ca. 10–20 A.P. **Signature:** "93/100," l.l.; "J Levine," l.r., in pencil.

The second in the *Volpone* series (see Nos. 18, 20, 27, 68 and 69) shows some quick character sketches from the play. Volpone is seen in a flowered dressing gown with his back turned to Lady Would-be. Being a study, the plate was worked "every which way," and miserly old Corbaccio can be seen upside-down below the main character. Sorini ran the plate through an extra time to produce the thin tonal value, reminiscent of the effect he had earlier achieved with rice paper (see Nos. 12, 13 and 15).

20. Volpone III. Date: 1964–65. **Medium:** etching on zinc in black. **Plate size:** 9¾ x 8″. **Sheet size:** 20⅝ x 14⅞″. **Paper:** Arches. **Printer:** Emiliano Sorini, N.Y. ⒠S, l.r. **Publisher:** A. Lublin Inc., N.Y. **Edition:** 100; ca. 10–10 A.P. **Signature:** "13/100," l.l.; "J Levine," l.r., in pencil.

In *Volpone III,* Levine continues his depiction of characters from the play (see Nos. 18, 19, 27, 68 and 69). Some are identified by their Italian names.

21. Cain and Abel I. Date: 1964. **Medium:** etching and drypoint on copper in black. **Plate size:** 9¾ x 7¾″. **Sheet size:** 19¼ x 14¾″. **Paper:** B. F. K. Rives. **Printer:** Emiliano Sorini, N.Y.; ⒠S, l.r. **Publisher:** A. Lublin Inc., N.Y. **Edition:** 80; ca. 10–15 A.P. **Signature:** "Artists Proof," l.l.; "J Levine," l.r., in pencil.

Levine turned to Cain and Abel as a subject that would enable him "to capture the male mood in action" and allow him "to deal with the male body and its relationships of bone, muscle and tendon as an ultimate image, expressing energy and motivation" (see Nos. 15 and 52). He had already explored the violent encounter in his 1961 painting *Cain and Abel* (64 x 48″).

22. Judgment of Paris. Date: 1964. **Medium:** etching on copper in burnt umber. **Plate size:** 5⅞ x 8⅞″. **Sheet size:** 13 x 15¼″. **Paper:** B. F. K. Rives. **Printer:** Emiliano Sorini, N.Y.; ⒠S, l.r. **Publisher:** A. Lublin Inc., N.Y. **Edition:** 100; ca. 10–20 A.P. **Signature:** "Artists Proof," l.l.; "J Levine," l.r., in pencil.

Here again we find the artist in one of his humorous moods, doing a "split-second improvisation" on a well-known subject. Some faint memory of Rubens prompted the rural setting, but while the vanity is the same, the down-to-earth proportions of Levine's nudes have little resemblance to the ideal beauty of Grecian goddesses. Nevertheless, the fate of poor Paris is still to make his choice. Behind the tree, the caduceus reveals the presence of Mercury. As early as 1959 Levine had painted this subject. In 1964 and 1965 there emerged a whole series of paintings and drawings in contemporary settings with a modern-day Paris facing the same old predicament.

23. Head of a Young Girl. Alternative titles: Little Engraving; Portrait of a Young Girl. **Date:** 1964. **Medium:** engraving on copper in black (one known trial proof in Van Dyke brown). **Plate size:** 3 x 1⅞″. **Sheet size:** 15 x 11″. **Paper:** B. F. K. Rives. **Printer:** Emiliano Sorini, N.Y.; ⒠S, l.r. **Publisher:** A. Lublin Inc., N.Y. **Edition:** 250; 10–20 A.P. **Signature:** "Artists Proof II," l.l.; "J Levine," l.r., in pencil.

Head of a Young Girl is Levine's preferred title for this evocation of youthful physiognomy. There was no model. Preparing halftones on a copper plate requires an infinite number of lines, and in this print the artist experimented with a tool with multiple points that had been used by engravers in the past to produce the shaded effects in such areas as skies. Levine did not care for the idea of "such a mechanical tool for multiple lines" or for the effect which it produced. He never used it again.

24. Meditation. Date: 1964. **Medium:** etching and drypoint on copper in black. **Plate size:** 7¼ x 4⅞″. **Sheet size:** 14¾ x 9½″. **Paper:** B. F. K. Rives. **Printer:** Emiliano Sorini, N.Y.; ⒠S, l.r. **Publisher:** A. Lublin Inc., N.Y. **Edition:** 250; ca. 10–20 A.P. **Signature:** "Artists Proof," l.l.; "J Levine," l.r., in pencil.

The pensive face of a young girl again emerged (see No. 23) when next the artist picked up a blackened copper plate. As before, he had no special person in mind, and the name was given the print by someone else. This image relates to a number of exquisite renderings of young women painted by Levine in the Fifties and Sixties. The use of drypoint to produce abrupt and inky blacks was new to Levine, and while finding the technique interesting, he was not enthusiastic about the result.

25. American in Paris. Date: 1965. **Medium:** etching and lift-ground on copper in bistre, blue green, Venetian red and warm black. **Plate size:** 3⅞ x 3″. **Sheet size:** 13 x 9¾″. **Paper:** Arches. **Printer:** Atelier Le Blanc et Cie., Paris, France. **Publisher:** A. Lublin Inc., N.Y. **Edition:** 100; ca. 10–20 A.P. **Signature:** "51/100," l.l.; "J Levine," l.r., in pencil.

Strolling down a boulevard in Paris, where he had just arrived, Levine found his attention caught by a sculpture of a man kneeling before the Goddess of the Arts. On reaching the print studio, he felt inspired to pay homage in a similar fashion and turned out this little self-portrait with the muse holding a palette. The Eiffel Tower in the background serves to give the scene a sense of place and balance. The print began as a black etching, but the key plate was then replaced and the imagery we see was done in lift-ground technique. When the young technician in the studio pulled the print, he exclaimed: "Ha! American in Paris," having George Gershwin on his mind, and thus the print was named. When telling the story, Levine added with a wry smile: "I was pleased to receive any kind of favor from a Frenchman."

26. Italian General. Date: 1965. **Medium:** etching and lift-ground on copper in black, blue and bistre. **Plate size:** 3⅞ x 3″. **Sheet size:** 11⅛ x 7⅜″. **Paper:** B. F. K. Rives. **Printer:** Atelier Le Blanc et Cie., Paris, France. **Publisher:** A. Lublin Inc., N.Y. **Edition:** 120; ca. 10–20 A.P. **Signature:** "Artists Proof," l.l.; "J Levine," l.r., in pencil.

For this print a key plate was first prepared and the drawing submitted to straight etching. Later, colors were added by lift-ground technique. "It was a trial plate," says the artist. "My trial plates have a way of becoming editions."

27. La Toilette. Alternative title: Volpone IV. **Date:** 1965. **Medium:** etching and lift-ground on copper in black. **Plate size:** 3⅞ x 2⅞″. **Sheet size:** 13 x 9¾″. **Paper:** Arches. **Printer:** Atelier Le Blanc et Cie., Paris, France. **Publisher:** A. Lublin Inc., N.Y. **Edition:** 120; ca. 10–20 A.P. **Signature:** "Artist's Proof," l.l.; "J Levine," l.r., in pencil.

Even though Levine was in Paris at this time and many years had elapsed since he first encountered Ben Jonson's comedy, *Volpone, or the Fox,* its characters still played on his imagination (see Nos. 18, 19, 20, 68, and 69). Here the artist fancied a lady at her toilette assisted by a dwarf. This was Levine's first attempt at lift-ground before he got into color.

28. L'Enlevement des Sabines. Alternative title: Rape of the Sabines III. **Date:** 1965. **Medium:** drypoint on copper in black. **Plate size:** 3⅞ x 2⅞″. **Sheet size:** 13 x 9⅞″. **Paper:** Arches. **Printer:** Atelier Le Blanc et Cie., Paris, France. **Publisher:** A. Lublin Inc., N.Y. **Edition:** 250; ca. 10–20 A.P. **Signature:** "96/250," l.l.; "J Levine," l.r., in pencil; "L'Enlevement des Sabines," l.c., on plate.

"Talk about the American in Paris!" Levine smiled as he recalled how again and again he had encountered the theme of the Rape of the Sabines in paintings and reliefs and reacted by turning to the same subject in this quickly rendered drawing in drypoint. He saw in it an opportunity to celebrate the nude and was to stay with the subject in the two following prints (see Nos. 29A and 29B). The alternative title incorrectly suggests that this is the third in the series.

29A. Rape of the Sabines (State One). Alternative title: Rape of the Sabines I. **Date:** 1965. **Medium:** lift-ground and etching on copper in bistre. **Plate size:** 8 x 10¾″. **Sheet size:** 13 x 9⅝″. **Paper:** B. F. K. Rives. **Printer:** Atelier Le Blanc et Cie., Paris, France. **Publisher:** A. Lublin Inc., N.Y. **Edition:** 100; ca. 10–20 A.P. **Signature:** none.

Levine, always attuned to the art of the great masters, was vaguely conscious of Poussin's pen-and-brush drawings as he executed this monochrome print. He had come to like bistre, a dark, brownish yellow, as used in Rembrandt's drawings, and preferred it to the more reddish sepia. The same key plate was utilized for this and the following print (see No. 29B).

29B. Rape of the Sabines (State Two). Alternative title: Rape of the Sabines II. **Date:** 1965. **Medium:** lift-ground and etching on copper in bistre, blue and red. **Plate size:** 8 x 10¾″. **Sheet size:** 13 x 19⅝″. **Paper:** B. F. K. Rives. **Printer:** Atelier Le Blanc et Cie., Paris, France. **Publisher:** A. Lublin Inc., N.Y. **Edition:** 100; ca. 10–20 A.P. **Signature:** "Artist's Proof," l.l.; "J Levine," l.r., in pencil.

The same key plate was used for this print as for the previous version (see No. 29A). The additional colors were superimposed from other plates.

30. Gangster's Funeral. Date: 1965. **Medium:** drypoint and engraving on copper in black. **Plate size:** 19¼ x 25⅜″. **Sheet size:** 25 x 35¼″. **Paper:** Arches. **Printer:** Atelier Le Blanc et Cie., Paris, France. **Publisher:** A. Lublin, Inc., N.Y. **Edition:** 120; ca. 10–20 A.P. **Signature:** "Artist's Proof," l.l.; "J Levine," l.r., in pencil.

This print derives from a 1952–53 painting (63 x 72″) with the same title and subject matter. Levine drew on the plate without reversing the scene, so the print is in mirror image. It was done from memory, even though the close resemblance to the painting might suggest that he had a reproduction of it close at hand for reference. He recalls that he had taken the engraved plate with him to Paris where it was printed by Le Blanc under his supervision. Various publications have erroneously dated this print 1968.

31. Helene Fourment. Date: 1965. **Medium:** lithograph in black. **Image size:** ca. 15¾ x 11½″. **Sheet size:** 26 x 19¾″. **Paper:** Arches. **Printer:** Ateliers Guillard, Gourdon et Cie., Paris, France. **Publisher:** A. Lublin Inc., N.Y. **Edition:** 35; 1 A.P. known. **Signature:** "J Levine," l.r., on stone; "Artist's Proof," l.l.; "J Levine," l.r., in pencil.

This image stems from Levine's wish to draw a "big lush Rubenesque woman" and, in homage to the master, he named her after Rubens' second wife, Hélène Fourment. Midway through printing, the stone broke, which accounts for the small edition.

32. Je Me Souviens de M. Watteau. Alternative title: Homage to Watteau. **Date:** 1965. **Medium:** lithograph in reddish brown, brownish black and white. **Image size:** ca. 17 x 22½″. **Sheet size:** 19¾ x 26″. **Paper:** Arches (tinted). **Printer:** Ateliers Guillard, Gourdon et Cie., Paris, France. **Publisher:** A. Lublin Inc., N.Y. **Edition:** 100; ca. 10–20 A.P. **Signature:** "Artist's Proof," l.l.; "J Levine," l.r., in white conté crayon.

"Watteau did some of the most delicious drawings that the human mind can conceive, and I did this print in praise of him." While the sheet seems to hold a series of studies, "they are studies for nothing," says Levine. He was trying to simulate, in lithography, the effect of the technique "à trois crayons," drawings in red, white and black or bistre on tinted paper. On the stone the white had to be "subtracted," and it was an East Indian named "Muti" whose skill enabled Levine to achieve the chalklike effect he wanted.

33. Nymph and Warlock. Date: 1965. **Medium:** etching and drypoint on zinc in burnt umber. **Plate size:** 9⅝ x 7⅜″. **Sheet size:** 17¾ x 13⅞″. **Paper:** Rives. **Printer:** Emiliano Sorini, N.Y. **Publisher:** Associated American Artists, N.Y. **Edition:** 100; ca. 10 A.P. **Signature:** "Artists Proof I," l.l.; "J Levine," l.r., in pencil.

At the time Levine made this print, he was painting the 1965 *Three Graces* (72 x 63″). The nymph here refers to one of the Graces in that painting. The artist intended the warlock (male witch) "to emerge from the confusion and murkiness of the background as something like a double exposure." Levine exploited the possibilities of combining etching and drypoint to achieve this effect.

34. Death's-Head Hussar. Date: 1965. **Medium:** engraving on copper in black. **Plate size:** 11⅝ x 8⅞″. **Sheet size:** 22⅛ x 14⅞″. **Paper:** B. F. K. Rives. **Printer:** Emiliano Sorini, N.Y.; ⒔, l.r. **Publisher:** Associated American Artists. **Edition:** 100; ca. 10–20 A.P. **Signature:** "82/100," l.l.; "J Levine," l.r., in pencil.

This haughty military man, bedecked in a fur hat emblazoned with a silver skull, harks back to a photograph that Levine had seen of a well-known World War I German field marshal. He is also present in the 1966 painting *Military Symphony* (63 x 72″). Adopting the three-quarter view reminiscent of imposing portraiture of the past, Levine is giving us his view of the prototype of a German officer.

35. Careless Love. Alternative titles: Love, Careless Love; Love O Careless Love. **Date:** 1965. **Medium:** etching and aquatint on zinc in burnt umber. **Plate size:** 17⅜ x 22″. **Sheet size:** 22 x 29⅞″. **Paper:** B. F. K. Rives. **Printer:** Emiliano Sorini, N.Y.; ⒔, l.r. **Publisher:** A. Lublin, Inc., N.Y. **Edition:** 100, ca. 10–20 A.P. **Signature:** "Artist's Proof," l.l.; "J Levine," l.r., in pencil.

Although labeled differently from time to time, *Careless Love* is the title preferred by the artist. The imagery, another memory evoked from the *Threepenny Opera*, was taken from a 1959 painting, *Love, Oh Careless Love* (56 x 64″), named for a perennially popular American folksong. Levine still remembers the tune well enough from his childhood to be able to give it a fair vocal rendition.

36. Rabbi of Prague. Date: 1965–66. **Medium:** drypoint and some etching on copper in burnt umber. **Plate size:** 8¾ x 6″. **Sheet size:** 14¾ x 11¼″. **Paper:** B. F. K. Rives. **Printer:** Emiliano Sorini, N.Y.; ⒔, l.r. **Publisher:** unknown. **Edition:** 100; ca. 10–20 A.P. **Signature:** "Artists Proof," l.l.; "J Levine," l.r., in pencil.

"Ever since a visit to Prague's ghetto, I seem to have a repeated desire to do a figure of a rabbinical type with the tower of the City Hall in the background." Here Levine has a rabbi seated next to an arched window. Outside is seen the City Hall's belfry with its two clocks which had so charmed Levine, one with Roman numerals and the other with Hebrew characters. The Gothic structure farther back is a synagogue, the oldest in Europe according to Levine. Subsequently, in 1974, Levine painted a small miniature, *Rabbi from Prague* (16¾ x 13⅞″), followed by another print, the 1982 *Lion of Prague* (No. 66), both on the same theme.

37. Self-Portrait with Muse. Alternative title: Artist with Muse. **Date:** 1966. **Medium:** mezzotint on zinc in raw umber. **Plate size:** 9⅞ x 12⅝″. **Sheet size:** 18½ x 22″. **Paper:** B. F. K. Rives. **Printer:** Emiliano Sorini, N.Y. **Publisher:** A. Lublin Inc., N.Y. **Edition:** 100; ca. 10–20 A.P. **Signature:** "Trial Proof," l.l.; "J Levine," l.r., in pencil.

Meant as a lampoon on himself, this print portrays Levine as a youthful-looking artist at his easel. A gigantic muse hovers in mid-air, about to adorn him with a laurel wreath. The enlarged head of the artist, a device used more sparingly in his prints than in his paintings, may here have a self-deprecating significance. The print is based on a 1960 painting of the same name (21 x 24″). Sorini patiently prepared this plate by repeatedly working a serrated rocker over it in all directions, until it would print a uniform, velvety black. Only then was Levine ready to begin "the scraping and the polishing" that eventually produced this image.

38A. Prussian General (State One). Date: 1966. **Medium:** etching with some lines reinforced with aquatint on copper in black. **Plate size:** 9¾ x 7⅝″. **Sheet size:** 22⅛ x 14⅞″. **Paper:** B. F. K. Rives. **Printer:** Emiliano Sorini, N.Y. **Publisher:** Harry Abrams, N.Y. **Edition:** 100; ca. 10–20 A.P. **Signature:** "Artists Proof," l.l.; "J Levine," l.r., in pencil.

While not unmindful of the Prussians as depicted by George Grosz, Levine did not need any prompting in his uncompromising view of the German officers in general, whom he found intolerable (see also Nos. 34 and 38B), and the Nazi generals in particular, whom he viewed as "monsters of history." Because some lines in the drawing were too wide and would have resulted in a "false bite" —white showing where there should have been shadow—they were held in place with an aquatint coating over the drawing.

38B. Prussian General (State Two). Alternative title: Double Eagle Prussian General. **Date:** 1966. **Medium:** etching and aquatint on copper in black. **Plate size:** 9¾ x 7⅝″. **Sheet size:** 17½ x 11¼″. **Paper:** B. F. K. Rives. **Printer:** Emiliano Sorini, N.Y. **Publisher:** A. Lublin Inc., N.Y. **Edition:** unknown, perhaps 100; 10–20 proofs. **Signature:** "Artist's Proof," l.l.; "J Levine," l.r., in pencil.

The double eagle was added in aquatint to the key image as it appears in the previous version (No. 38A). Levine does not recall the size of the edition or if the whole edition was actually pulled.

39. El Greco. Date: 1966. **Medium:** etching, drypoint and mezzotint on copper in black. **Plate size:** 11¾ x 7⅞″. **Sheet size:** 20 x 13¾″. **Paper:** Italia. **Printer:** Emiliano Sorini, N.Y.; ⒔, l.r. **Publisher:** A. Lublin Inc., N.Y., **Edition:** 100; ca. 10–20 A.P. **Signature:** "Artists Proof," l.l.; "J Levine," l.r., in pencil.

Although this print is remotely based on a portrait by El Greco at the Metropolitan Museum, Levine had a number of such portraits by the master in mind as he constructed this image from memory.

40. Brechtiana. Date: 1966. **Medium:** lithograph in black. **Image size:** ca. 14¾ x 16¾". **Sheet size:** 19¾ x 25¾". **Paper:·** B. F. K. Rives. **Printer:** Edmond et Jacques des Jobert, Paris, France. **Publisher:** A. Lublin Inc., N.Y. **Edition:** 100; ca. 10–20 A.P. **Signature:** "Artists Proof," l.l.; "J Levine," l.r., in pencil.

Levine's first exposure to Brecht was back in 1931 when he saw a German film version of the *Threepenny Opera*. He later did a portfolio embracing the many characters and happenings of the play. By his own admission, Levine has never done justice to Brecht. The bittersweet ambience of the film so captured his attention that his own work conveyed its particular mood rather than Brecht's as he understands it. In this print, Jenny and Mack the Knife are seen with a couple of minor characters. (See also Nos. 70 and 71.) The drawing was quickly done on the stone in the Paris studio where it was printed.

41. Reception in Miami. Date: 1967. **Medium:** lithograph in Van Dyke brown, dark red, yellow ochre and raw sienna. **Image size:** ca. 21 x 28¼". **Sheet size:** 21⅝ x 29¾". **Paper:** Arches. **Printer:** Atelier Mourlot, Paris, France. **Publisher:** A. Lublin Inc., N.Y. **Edition:** 120; ca. 10–20 A.P. **Signature:** "Bon à Tirer (Hand Press)," l.l.; "J Levine," l.r., in pencil; some signed "J Levine," l.c., in gold-yellow chalk.

This print is based on the 1948 painting (50⅜ x 56⅛") of the same name. The imagery, reversed in the print, stems from a visit to Miami by the Duke and Duchess of Windsor, as reported by columnist Earl Wilson. Levine was moved to action by the way "our co-nationals began to scrape and bow" as they greeted the honored guests. He felt "it was a kind of violation of everything that the Declaration of Independence and Constitution stand for." A somewhat mellowed artist now admits reluctantly that perhaps there is room for such courtesy in this world.

42. Maimonides II. Date: 1967. **Medium:** lithograph in burnt umber. **Image size:** ca. 26 x 18". **Sheet size:** 26⅝ x 21". **Paper:** Arches. **Printer:** Atelier Mourlot, Paris, France. **Publisher:** A. Lublin Inc., N.Y. **Edition:** 100; ca. 10–20 A.P. **Signature:** "Artists Proof," l.l.; "J Levine," l.r., in pencil.

Surrounded by people in the print studio, Levine, who prefers to work alone, made this transcription from the 1952 painting *Maimonides* (10 x 8") in only a few minutes. Medium, color and details in clothing and architecture distinguish this version from the earlier *Maimonides I* (Nos. 14A and 14B; see also *Hebrew King*, No. 2).

43. Blue Angel. Date: 1967. **Medium:** lithograph with color separations from zinc plates in raw umber, burnt umber, dark red, blue and orange. **Image size:** ca. 19¾ x 25½". **Sheet size:** 21¼ x 27⅜". **Paper:** B. F. K. Rives. **Printer:** Atelier Mourlot, Paris, France, and N.Y. **Publisher:** A. Lublin Inc., N.Y. **Edition:** 120; ca. 10–20 A.P. **Signature:** "Artists Proof," l.l.; "J Levine," l.r., in pencil.

One of Marlene Dietrich's early movies was *The Blue Angel*, based on a novel by Heinrich Mann, in which she played a cheap cabaret entertainer. Wanting to paint an interior, Levine used the topic for his 1961 painting *Blue Angel* (26 x 32"). The print, in reverse, retains some of the painting's intimate details. The woman is portrayed with an angry and defiant look. Prints from the keystone were pulled in Paris and then shipped to the atelier in New York, where Levine had color separations done from zinc plates.

44. The End of the Weimar Republic. Date: 1967. **Medium:** etching and mezzotint on zinc in black. **Plate size:** 17¾ x 14¾". **Sheet size:** 29¾ x 22". **Paper:** B. F. K.. Rives. **Printer:** Emiliano Sorini, N.Y. **Publisher:** A. Lublin Inc., N.Y. **Edition:** 100; ca. 10–20 A.P. **Signature:** "Artists Proof," l.l.; "J Levine," l.r., in pencil.

Prior to U.S. entry into World War II, Levine had contemplated a series of paintings dealing with the rise of Hitler's Germany. He started several pictures, but completed none before he joined the army. One painting, *1932 (In Memory of George Grosz)*, 1959 (56 x 49"), and this closely related print, drawn on the plate without reversing the scene, subsequently did materialize. Inspired by a photograph and William L. Shirer's description of Hindenburg, Levine conceived of a historical moment, when a huge, senile Field Marshal/President hands

over the fate of his nation, and a baton as a symbol, to the power-hungry fascist Hitler.

45. Vernissage. Date: 1967. **Medium:** lithograph in black. **Image size:** ca. 16¾ x 22". **Sheet size:** 17⅞ x 22⅛". **Paper:** Arches. **Printer:** Atelier Mourlot, N.Y. **Publisher:** A. Lublin Inc., N.Y. **Edition:** 125; ca. 10–20 A.P. **Signature:** "Artists Proof," l.r.; "J Levine," l.r., in pencil.

"Varnishing day" traditionally preceded an exhibition and was set aside for the artist to apply finishing touches and a final coat of varnish. The French word *vernissage* has come to be used for the opening itself. This print celebrates the housewarming at Atelier Mourlot in New York, a branch of the famous Atelier Mourlot of Paris, where Levine had recently been working on lithographs. A man and a woman are seen, their arms interlocked in a "fraternal" toast. In the background one of the technicians is busy at his printing press. Levine had been commissioned to do a poster for the occasion. This and the following print, *The Art Lover* (No. 46), were designed with this in mind. A larger print, *Atelier Mourlot—Marianne and the Goddess of Liberty Poster* (see Nos. 47 and 74), was eventually chosen for the purpose.

46. The Art Lover. Date: 1967. **Medium:** lithograph in black, blue and yellow ochre. **Image size:** ca. 22 x 17½". **Sheet size:** 26 x 19" **Paper:** Arches. **Printer:** Atelier Mourlot, N.Y. **Publisher:** A. Lublin Inc., N.Y. **Edition:** 100; ca. 10–20 A.P. **Signature:** "30/100" in pencil, l.l.; "J Levine," l.r., in black conté crayon.

Like the preceding print (No.45), *The Art Lover* was conceived to serve as a poster for the opening of Atelier Mourlot in New York (see No. 47) but was considered too small for the purpose. The image relates to a 1962 painting of the same name (56 x 49"). Although Levine's Louis XIV had in the intervening years acquired heavy jowls, we nevertheless recognize him from other Levine portrayals. Levine's attitude toward "the art lover" is at best ambiguous; an intensely private person, he shudders at having his most intimate labors exposed to the casual judgment of others. As background for the figure, Levine had originally wanted to have a stained-glass window in diaper pattern with fleurs-de-lis and had planned to use a photographic collage to achieve the desired effect. The traditionally trained technician demurred, however, and instead collaborated to produce the fleur-de-lis background we see in the published edition.

47. Marianne and the Goddess of Liberty. Alternative title: Bien Venue. **Date:** 1967. **Medium:** lithograph in black. **Image size:** ca. 27 x 21". **Sheet size:** 29⅞ x 22¾". **Paper:** Arches. **Printer:** Atelier Mourlot, N.Y. **Publisher:** A. Lublin Inc., N.Y. **Edition:** 125; ca. 10–20 A.P. **Signature:** "Artists Proof," l.l.; "J Levine," l.r., in pencil.

Faced with the opportunity to celebrate visually the New York opening of the French Atelier Mourlot, Levine looked to history for appropriate symbols. He pictured America as the Goddess of Liberty (the Statue of Liberty was given by the French to the American people in 1884 to commemorate their alliance during the American Revolution), welcoming France in the symbolic rendering of Marianne, bedecked in her liberty cap (the *bonnet rouge*, the Phrygian cap, having been adopted by the French revolutionists as an emblem of their freedom from royal authority). Working with a hard lithographic crayon, Levine composed as the drawing progressed. This black-and-white version was printed in a limited edition. (See also *Atelier Mourlot—Marianne and the Goddess of Liberty Poster*; No. 74).

48. Boudoir. Alternative title: La Toilette. **Date:** 1968. **Medium:** etching and drypoint on zinc in burnt umber. **Plate size:** 7¾ x 9¾". **Sheet size:** 15 x 22". **Paper:** Arches. **Printer:** Emiliano Sorini, N.Y. **Publisher:** A. Lublin Inc., N.Y. **Edition:** 50; ca. 10 A.P. **Signature:** "First State," l.l.; "J Levine," l.r., in pencil.

Boudoir is the title chosen by the artist for this print, which has been incorrectly labeled *La Toilette* and should not be confused with the print of that name from the Volpone series (No. 27). *Boudoir* and the related 1967 painting, *Chéri* (28 x 32"), were inspired by Colette's 1926 novel *La Fin de Chéri*.

49. The Great Society. Date: 1968. **Medium:** etching on copper in black. **Plate size:** 8⅞ x 11⅛". **Sheet size:** 13⅞ x 19⅝". **Paper:**

B. F. K. Rives. **Printer:** Emiliano Sorini, N.Y. **Publisher:** A. Lublin Inc., N.Y. **Edition:** 100; ca. 10–20 A.P. **Signature:** "Artists Proof," l.l.; "J Levine," l.r., in pencil.

Although the term "The Great Society," coined during Lyndon Johnson's regime, caught Levine's attention, the artist did not focus on President Johnson's vision in this work. He instead turned his attention to "the beautiful people" as they played and acted to impress themselves and each other. The print relates to the fully realized painting of 1967, *The Great Society* (63 x 56").

50. At the Ball. Date: 1968. **Medium:** drypoint on copper in black. **Plate size:** 4⅞ x 6⅞". **Sheet size:** 11⅛ x 14¼". **Paper:** B. F. K. Rives. **Printer:** Emiliano Sorini, N.Y. **Publisher:** Skowhegan School of Painting and Sculpture, N.Y. **Edition:** 100; ca. 10–20 A.P. **Signature:** "Artist's Proof," l.l.; "J Levine," l.r., in pencil.

As was the case in the preceding print (No. 49), some of the ideas in this work derived from the 1967 painting *The Great Society*. The strutting couple in the foreground and the miniskirted girl behind are also seen in the painting.

51. On the Convention Floor. Date: 1968. **Medium:** lithograph in black. **Image size:** ca. 18½ x 24½". **Sheet size:** 19½ x 25⅛". **Paper:** B. F. K. Rives. **Printer:** Atelier Mourlot, N.Y. **Publisher:** A. Lublin Inc., N.Y. **Edition:** 100; ca. 10–20 A.P. **Signature:** "On the Convention Floor," l.c., on stone; "Artists Proof," l.l.; "J Levine," l.r., in pencil.

In 1968 Levine was commissioned by *Time* magazine to cover the National Democratic Convention in Chicago, a new experience for the artist. This loosely executed drawing on the stone captures the hubbub and circus atmosphere of the proceedings. (See also Nos. 53 and 57.)

52. Cain and Abel II. Date: 1969. **Medium:** lithograph in black. **Image size:** ca. 18¾ x 16¾". **Sheet size:** 29¾ x 22⅝". **Paper:** B. F. K. Rives. **Printer:** Atelier Mourlot, N.Y. **Publisher:** Anti-Defamation League of N.Y. **Edition:** 125; ca. 10–20 A.P. **Signature:** "97/125," l.l.; "J Levine, " l.r., in pencil.

Here Levine returns to the subject of Cain and Abel (see No. 21), which afforded him the opportunity of rendering figures that are interrelated and in considerable motion. The artist found the challenge intriguing. "It's a Renaissance problem, not a modern one, and much more interesting than anything that Cubism has to offer." The configuration can be read as a broken cross on a swastika, which is no accident, according to Levine. The artist donated the edition of this print to the Anti-Defamation League for fund-raising purposes.

53. The Daley Gesture. Alternative title: Mayor Daley's Gesture. **Date:** 1969. **Medium:** drypoint and aquatint on copper in black. **Plate size:** 8¾ x 11¾". **Sheet size:** 15 x 23½". **Paper:** Arches. **Printer:** Emiliano Sorini, N.Y. **Publisher:** A. Lublin Inc., N.Y. **Edition:** 120; ca. 10–20 A.P. **Signature:** "Artists Proof," l.l.; "J Levine," l.r., in pencil.

In a more serious vein than the candid impressions from the floor of the 1968 Democratic Convention as seen in *On the Convention Floor* (No. 51) is this telling portrayal of Richard Daley, Mayor of Chicago. Levine has caught him giving his now-famous gesture—running one finger across the throat. It was a sign to his people who ran the convention to turn off the microphone on the podium while Senator Abe Ribicoff was making a speech in which he objected to the way that the protesters, who had converged on the city, were abused by the city police. Related to this print is the 1968 painting, *Daley's Gesture* (36 x 42"). Levine used an old plate, prepared earlier with aquatint, but never worked up. Turning it on its side and incorporating the accidental markings, he "scraped and polished," as he puts it, until a trial proof came out to his satisfaction.

54. Warsaw Ghetto. Alternative Title: To an unknown German Photographer at the Warsaw Ghetto. **Date:** 1969. **Medium:** lithograph in black. **Image size:** ca. 18½ x 25". **Sheet size:** 23¼ x 29⅞". **Paper:** B. F. K. Rives. **Printer:** Atelier Mourlot, N.Y. **Publisher:** A. Lublin Inc., N.Y. **Edition:** 120; ca. 10–20 A.P. **Signature:** "To an unknown German Photographer at the Warsaw Ghetto," on the stone, l.c.; "Artists Proof," l.l.; "J Levine," l.r., in pencil.

The inspiration for this print came from a photograph that Levine had seen in a magazine, picturing fugitives pushed along by German soldiers as they fled their burning homes. In his work the artist creates his own ambience and characters; for instance, the configuration of mother and child in the middle relates to a 1941 painting, *The Passing Scene* (48 x 29¾"), in which a little boy holds on to the hand of his father. Below, Levine gave credit to the unknown photographer whose work had caught his attention. The dedication was written on transfer paper from left to right as it reads. At other times, when the writing took place directly on the stone or plate, it was done backwards in order to print in reverse on the paper. This explains the difference in this writing from other examples of Levine's hand.

55. Election Night. Date: 1969. **Medium:** etching, drypoint, mezzotint and aquatint on copper in black. **Plate size:** 19⅜ x 25⅛". **Sheet size:** 25¾ x 31¾". **Paper:** Arches. **Printer:** Emiliano Sorini, N.Y. **Publisher:** A. Lublin Inc., N.Y. **Edition:** 120; ca. 10–20 A.P. **Signature:** "19/120," l.l.; "J Levine," l.r., in pencil.

The scene, reversed in the print, first appeared in the 1954 painting *Election Night* (63⅛ x 72½"), where the same characters are also present. At about this time someone had suggested that Levine should consider wiping his own plates, thereby reaching for a richness and variance not possible with a cleanly wiped plate. Working with Sorini, Levine experimented with wiping the plate for this edition. After this attempt he decided, however, that his hand, so skilled in other areas, did not give him the sense of control he wanted, and he did not try it again.

56. The Feast of Pure Reason. Date: 1970. **Medium:** etching, mezzotint and aquatint on copper in black. **Plate size:** 19½ x 25¼". **Sheet size:** 25½ x 31⅝". **Paper:** Arches. **Printer:** Emiliano Sorini, N.Y. **Publisher:** Jack Levine. **Edition:** 100 ca. 10–20 A.P. **Signature:** "77/100," l.l.; "J Levine," l.r., in pencil.

Here Levine has referred back to one of his best-known paintings, *The Feast of Pure Reason* of 1937 (42 x 48"), done when he was 22 years of age. The familiar trio of policeman, politician and man of means, comfortably making their deals, is his reminder that youth's objection to hypocrisy in their elders did not begin with the protesters of the Sixties. The scene, executed on the plate as a faithful replica of the painting, appears in reverse on the print, a result of the printing process. By now, Levine had severed his relationship with The Alan Gallery, and his publisher, A. Lublin Inc., had suspended its activities while revising its methods of publication and distribution. Levine decided to publish the edition himself, and the successful endeavor allowed him for a moment to enjoy the fruits of publishing as well.

57. Texas Delegate. Date: 1970. **Medium:** lithograph in black. **Image size:** ca. 16 x 19½". **Sheet size:** 22 x 27¼". **Paper:** Arches. **Printer:** Atelier Mourlot, N.Y. **Publisher:** Bella Abzug Campaign Committee. **Edition:** 120; ca. 10–20 A.P. **Signature:** "Artist's Proof," l.l.; "J Levine," l.r., in pencil.

The painting *Texas Delegate* (1968–71; 56 x 64") and this print both derive from drawings made at the 1968 National Democratic Convention in Chicago. Levine remembers this man from the Texas contingent as handsome and lean but having a slightly menacing look about him.

58. Thought. Date: 1972. **Medium:** lithograph in black. **Image size:** ca. 39 x 25¾". **Sheet size:** 39⅛ x 25⅞". **Paper:** Velin d'Arches. **Printer:** Atelier Mourlot, N.Y. **Publisher:** Kennedy Graphics, N.Y. **Edition:** 100; ca. 10–20 A.P. **Signature:** "75/100," l.l.; "J Levine," l.r., in white grease crayon.

This was the first Levine print published by Kennedy Graphics, a division of Kennedy Galleries, Inc. It was printed shortly after the artist had joined the gallery. A poster edition was also issued (No. 76). The figure is related to a 1970 painting, *Opening Night—Man in Top Hat* (24 x 21") and is also seen in *For the Sake of Art—Avant-Garde*, 1969–71 (78 x 72"). Levine, slow to give titles to his works, recalls that Lawrence Fleischman, director of the gallery, had named this print. He disagrees with the interpretation of the man's state of mind as suggested by the title. Levine worked at length on the stone, "scratching" it until he was satisfied with the result. After seeing a

proof, he found the white of the paper "blinding" in its contrast to the rich black ink and insisted that a tone be laid on the stone, somewhat the color of the stone itself.

59. Hong Kong Tailor. Date: 1974. **Medium:** drypoint on copper in raw umber. **Plate size:** 6¾ x 4¾". **Sheet size:** 14⅞ x 11⅛". **Paper:** Velin d'Arches. **Printer:** Emiliano Sorini, N.Y.; ⒠, l.r. **Publisher:** Kennedy Graphics, N.Y. **Edition:** 100; ca. 10–20 A.P. **Signature:** "97/100," l.l.; "J Levine," l.r., in pencil.

In 1969 Levine went to the Orient. *Hong Kong Tailor* relates to the sketchbooks he filled during his travels. He remembers seeing this enormously fat man being fitted for a suit at Chen's in Hong Kong. The Chinese tailor, crouching behind and barely seen here, is plainly visible in the 1970 painting also named *Hong Kong Tailor* (39 x 35"). Many of the sketches of people Levine observed were incorporated in the 1970 portfolio *Facing East* (see No. 75).

60. Sacrifice of Isaac. Date: 1974. **Medium:** drypoint, etching and engraving on copper in black. **Plate size:** 13⅝ x 10⅝". **Sheet size:** 22¼ x 15". **Paper:** Velin d'Arches. **Printer:** Emiliano Sorini, N.Y.; ⒠, l.r. **Publisher:** Kennedy Graphics, N.Y. **Edition:** 100; ca. 10–20 A.P. **Signature:** "Artist's Proof," l.l.; "J Levine," l.r., in pencil.

The painted version of this subject, *Sacrifice of Isaac* (40 x 35"), dates from the same year but differs distinctly from the print both in composition and expression. Vigorous and agitated in the painting, Abraham here appears much calmer, his face set in resignation and sorrow. In both versions Levine has captured the moment when the angel's voice stays the hand of Abraham, poised to deliver the blow intended to fulfill the Lord's command.

61. Shammai. Date: 1975. **Medium:** lithograph in burnt umber. **Image size:** ca. 19¼ x 16". **Sheet size:** 27¼ x 22⅜". **Paper:** Arches. **Printer:** Deli Saccilotto, Siena Studio, N.Y. **Publisher:** Kennedy Graphics, N.Y. **Edition:** 100; ca. 10–20 A.P. **Signature:** "77/100," l.l.; "J Levine," l.r., in pencil.

This version of the scribe was done in the same vein as the 1976 painting *Shammai* (19½ x 16"), which was unfinished and in the studio when this work was executed. It is also closely related to a charcoal drawing of about 1976, *Shammai—Final Draft* (21 x 17"). This sensitive rendering of the Jewish scribe, who lived at the time of King Herod, is another in the series of Old Testament kings and sages begun in the 1940s. It was also used for a poster (No. 77).

62. Pygmalion. Date: 1977. **Medium:** lithograph in black. **Image size:** ca. 19½ x 12½". **Sheet size:** 29 x 21". **Paper:** Velin d'Arches. **Printer:** Herbert Fox Studio, Boston; ⒦, l.l. **Publisher:** Kennedy Graphics, N.Y. **Edition:** 100; ca. 10–20 A.P. **Signature:** "16/100," l.l.; "J Levine," l.r., in pencil.

Levine's fertile mind here guided his hand into creating a situation one step further than the traditional rendering of Pygmalion and the statue of Galatea coming to life. We see a sculptor with mallet in hand, wearing a cap to protect his hair from the marble dust. Before him is his live model, busying herself with her hair at the end of a posing session. At this very moment the artist's creation, Galatea, high on the sculpting stand, comes alive and, objecting to the intrusion of an imposter, is about to deliver the model a blow with her fist. Levine, not mystically inclined, has given a humorous mien to his depiction which belies a serious concern about artists' expressions of a spiritual nature: "In order for artists to have any relationship to the religious projection in art, they have to be able to free themselves from the dependence on earth-bound reality. . . . I don't know how else to put it; there has to be a projection of the mind, through the artist's material, without the intervention of incarnate reality." Levine's humor takes on another twist to anyone familiar with his disdain for the academic stress put on the importance of live models.

63. Torso of David. Alternative Title: Head of David. **Date:** 1977. **Medium:** lithograph in black. **Image size:** 17¾ x 10¾". **Sheet size:** 22⅜ x 15⅛". **Paper:** Velin d'Arches. **Printer:** Herbert Fox Studio, Boston; ⒦, l.l. **Publisher:** Kennedy Graphics, N.Y. **Edition:** 100; ca. 10–20 A.P. **Signature:** "22/100," l.l.; "J Levine," l.r., in pencil.

David, the shepherd boy who lived to become king of the Hebrews (see No. 10), is here pictured with his sling, arrested at the moment when he will let go the stone that killed the giant Goliath. Levine has

an abiding interest in this great Hebrew ruler. "I just don't feel I've done enough with David as a young hero" This portrayal of David was done quickly on the stone, and the artist is not sure that it is equal to his desire to do the subject justice. Although this print was originally published as *Head of David*, Levine wants to take this opportunity to rename it.

64. Requiem. Date: 1979. **Medium:** lithograph in sepia-brown. **Image size:** ca. 31¾ x 25½". **Sheet size:** 41½ x 29⅝". **Paper:** Velin d'Arches. **Printer:** Herbert Fox Studio, Boston. **Publisher:** Kennedy Graphics, N.Y. **Edition:** 150; ca. 10–20 A.P. **Signature:** "149/150," l.l.; "J Levine," l.r., in pencil.

This face belongs to the category of "establishment types" known to anyone familiar with Levine's characters. It relates to the 1979 painting *Old Mortality* (63 x 72"), which depicts a cemetery with a funeral service in process. When questioned about the large size of this print, Levine explained that it was no accident. He had been impressed with the size and weight of lithographic stones and here wanted to convey a sense of their boulderlike quality. Put off at first by the ease by which a drawing on the stone can be translated into a number of works of art—compared to the strenuous work that goes into preparing a metal plate—he now somewhat grudgingly admits to have warmed up to the medium: "The only real pleasure in doing lithography is the pleasure of drawing on limestone, which is the best substance to draw on I ever saw. I mean, it gives so much more sensual and beautiful a feeling than drawing on paper. I can't describe it; that's the one thing it has"

65. Sweet Bye and Bye. Date: 1980. **Medium:** etching, drypoint and mezzotint on copper in black. **Plate size:** 8 x 9¾". **Sheet size:** 15 x 20¼". **Paper:** Arches. **Printer:** Emiliano Sorini, N.Y.; ⒠, l.r. **Publisher:** Kennedy Graphics, N.Y. **Edition:** 100; ca. 10–20 A.P. **Signature:** "Artist's Proof," l.l.; "J Levine," l.r., in pencil.

Returning to the subject of a funeral (see No. 64), Levine shows the faces of three mourners emerging out of the cemetery gloom to say their last goodbyes. In the background some decorative details of the tombstones can be observed.

66. Lion of Prague. Date: 1982. **Medium:** etching and aquatint on copper in Van Dyke brown. **Plate size:** 11⅛ x 9". **Sheet size:** 20⅜ x 15". **Paper:** Arches. **Printer:** Emiliano Sorini, N.Y.; ⒠, l.r. **Edition:** 100; ca. 10–20 A.P. **Signature:** "100/100," l.l.; "J Levine," l.r., in pencil.

The lingering memory of Prague has caused Levine to return to a familiar subject (see No. 36). In the past, he has spoken of the hard work that goes into the preparation of his metal plates and of the sense of gratification he receives from the effort, but no explanation of technical means can explain the quality of serenity and peace with which this print is endowed. Levine has reverently pictured the rabbi filling an undefined space where time seems to stand still. (Have the numerals on the faces in the clock tower been obliterated to reinforce this impression?) The artist has in the past referred to himself as a physiognomist. In this old man's face he has captured a kind of character and beauty that stems from experience and wisdom gained from many years of living.

67. Untitled Fragment of Woodstock Pastoral (unpublished). Date: 1952 (printed in 1969). **Medium:** etching on copper in black. **Plate size:** 8¾ x 3½". **Sheet size:** 16 x 9¼". **Paper:** B. F. K. Rives. **Printer:** Emiliano Sorini, N.Y. **Publisher:** none. **Edition:** none; ca. 3 A.P. **Signature:** none.

The sketches for this print were made in 1952 on the same plate used for *Woodstock Pastoral* (No. 3). It was sawed off, etched and printed separately in 1969 as a trial proof.

68. Sketches for Volpone (unpublished). Date: 1964. **Medium:** etching on copper in black. **Plate size:** 10 x 7¾". **Sheet size:** 13⅞ x 10¼". **Paper:** B. F. K. Rives. **Printer:** Emiliano Sorini, N.Y. **Publisher:** none. **Edition:** none; ca. 10 proofs. **Signature:** "First State," l.l.; "J Levine" l.r., in pencil.

Although Levine signed this unpublished print, he dismisses the content "as a kind of doodling . . . sketches that didn't come off." It dates from the period of the Volpone series (see Nos. 18, 19, 20, 27

and 69). Because there are some trial proofs in circulation of this and other unpublished prints, the decision was made to include them here to clarify any confusion that may occur.

69. Study for Volpone (unpublished). Date: 1964. **Medium:** etching on copper in black. **Plate size:** 9¾ x 8″. **Sheet size:** 20⅝ x 14¾″. **Paper:** Arches. **Printer:** Emiliano Sorini; ⒺⓈ, l.r. **Publisher:** none. **Edition:** none; ca. 10–20 proofs. **Signature:** "1st State," l.l.; "J Levine," l.r., in pencil.

Like the previous work, this print dates from the Sixties, when Levine published a number of prints dealing with the characters from Ben Jonson's comedy *Volpone, or the Fox* (see Nos. 18, 19, 20, 27 and 68). Here he wanted to create "an atmosphere of daylight with the figures up against the light coming in through the window." The artist cannot remember why this print was not issued.

70. Study for Tunbridge Girl (unpublished). Date: 1967. **Medium:** etching on copper in black. **Plate size:** 11⅞ x 8⅞″. **Sheet size:** 14 x 9¾″. **Paper:** B. F. K. Rives. **Printer:** Emiliano Sorini, N.Y. **Publisher:** none. **Edition:** none; ca. 10–20 proofs. **Signature:** none.

In 1967 Touchstone Publishers, Ltd. published a suite of 25 softground etchings by Jack Levine, inspired by G. W. Pabst's film of Brecht's *Dreigroschenoper*. This study of a pensive girl smoking a cigarette relates to that series of etchings (see also Nos. 40 and 71).

71. Study for Threepenny Opera: "Look! There Goes Mack the Knife" (unpublished). Date: 1967. **Medium:** etching on copper in black. **Plate size:** 11⅜ x 9⅞″. **Sheet size:** 22 x 14⅞″. **Paper:** B. F. K. Rives. **Printer:** Emiliano Sorini, N.Y. **Publisher:** none. **Edition:** none; ca. 10–20 proofs. **Signature:** none.

This is another unpublished study relating to the *Threepenny Opera* suite as inspired by the German film (see Nos. 40 and 70). Mack the Knife (Macheath) is here making a quick exit as the ballad singer recounts his crimes to the crowd.

72. The Violinist (unpublished). Date: 1969. **Medium:** drypoint on copper in black. **Plate size:** 4⅞ x 2⅞″. **Sheet size:** 14½ x 14¼″. **Paper:** B. F. K. Rives. **Printer:** Emiliano Sorini, N.Y. **Publisher:** none. **Edition:** none; 10 proofs. **Signature:** "Third State," l.c.; "J Levine," l.r., in pencil.

Although this trial proof is signed, Levine did not like it enough to have it made into an edition or to work on the plate any further.

73. Studies for Facing East Poster (unpublished). Date: 1970. **Medium:** lithograph in black. **Image size:** ca. 12¾ x 16¾″. **Sheet size:** 14 x 19½″. **Paper:** coated. **Printer:** Atelier Mourlot, N.Y. **Publisher:** none. **Edition:** none; trial proof is a unique example. **Signature:** none.

Preliminary to doing a poster related to the publication of his 1970 portfolio *Facing East* (see No. 75), Levine made these studies based on impressions from his recent trip to the Orient. As was his habit, Levine did his "thinking" directly on the stone, without preparatory sketches. From the images that emerged, the publisher chose the wrestler for the poster.

74. Atelier Mourlot—Marianne and the Goddess of Liberty Poster. Date: 1967. **Medium:** lithograph in black, red and blue. **Image size:** ca. 26½ x 21″, including text. **Sheet size:** 28 x 21″. **Paper:** machine-made. **Printer:** Atelier Mourlot, N.Y. **Publisher:** Atelier Mourlot, N.Y. **Edition:** unknown. **Signature:** "To Ken—Affectionately J Levine Oct 13, 1978," below; "J Levine," l.r., on stone.

This poster edition is printed from the same lithographic stone as *Marianne and the Goddess of Liberty* (No. 47). To enhance the imagery's effectiveness as a poster, Levine, bowing to the patriotic colors of both France and United States, wedded the colors red and blue to the white of the sheet. He was later chagrined to discover that he had forgotten to add the red to Marianne's jaunty liberty cap.

75. The Japanese Wrestler—Facing East Poster. Date: 1970. **Medium:** lithograph in black, light umber and white. **Image size:** ca. 24½ x 18″, including text. **Sheet size:** 28¾ x 22″. **Paper:** Arches. **Printer:** Maecenas Press, N.Y. **Publisher:** Random House, N.Y. **Edi-**

tion: unknown. **Signature:** "To Emma-Stina and Ken—Jack Levine June 13 1980," in pencil, below; "J Levine," l.r., on stone.

The Japanese wrestler of this poster is from one of the studies done on the stone in *Studies for Facing East Poster* (No. 73).

76. Thought, Kennedy Galleries 1972 Poster. Date: 1972. **Medium:** lithograph in black, sienna, yellow and gold. **Image size:** 39⅛ x 25½″. **Sheet size:** 39⅛ x 25½″. **Paper:** Sunray Vellum. **Printer:** Atelier Mourlot, N.Y. **Publisher:** Kennedy Graphics, N.Y. **Edition:** 500; ca. 10–20 A.P. **Signature:** "J Levine '72," l.c., on the stone, in yellow.

This poster was printed on white stock from the same stone as the 1972 *Thought* (No. 58). A saturated sienna surrounds the black and white image. The enlarged signature, done by a paper-collage process, is Levine's own and is overprinted in yellow. The gallery's name in gold is the work of a technician.

77. Shammai, Kennedy Galleries 1975 Poster. Date: 1975. **Medium:** photo-offset in raw umber, gold, red and violet. **Image size:** 28⅝ x 17″, including text. **Sheet size:** 34½ x 22⅛″. **Paper:** machine-made. **Printer:** unknown. **Publisher:** Kennedy Graphics, N.Y. **Edition:** 2,000. **Signature:** "J Levine," l.c., reproduced from mock-up.

The basic image in this poster is that of the 1975 lithograph, *Shammai* (No. 61). To produce this commercial poster edition, Levine took a monochrome trial proof to which he added tints, as well as gold foil in the background. This mock-up was then photographed and the color photograph utilized for the photo-offset edition. The Hebrew lettering in the upper right, spelling Shammai, is by the artist's hand.

78. The Roaring Twenties 1975 Poster. Date: 1975. **Medium:** photo-offset in color. **Image size:** 29¼ x 23″. **Sheet size:** 38 x 25″. **Paper:** machine-made. **Printer:** unknown. **Publisher:** Jack O'Grady Graphics and Galleries, Chicago, Ill. **Edition:** unknown. **Signature:** "J Levine," l.l., reproduced as it appears on the painting.

This is simply a reproduction of Levine's 1975 painting *The Roaring Twenties* (46 x 36″), reduced in size. It was published in connection with the U.S. Bicentennial.

79. Jack Levine Retrospective, The Jewish Museum 1978 Poster. Date: 1978. **Medium:** photo-offset in colors. **Image size:** 34¾ x 21″. **Sheet size:** 34¾ x 21″. **Paper:** machine-made. **Printer:** unknown. **Publisher:** The Jewish Museum, N.Y. **Edition:** unknown. **Signature:** "J Levine," l.r., reproduced as it appears on the painting.

This poster was issued in connection with the major retrospective exhibition of the work of Jack Levine organized by The Jewish Museum in 1978. It is a photo reproduction of Levine's 1940 painting *King David* (10 x 8″). After the show closed in New York, it traveled to the Norton Gallery and School of Art, Brooks Memorial Art Gallery, Montgomery Museum of Fine Arts, Portland Art Museum (see No. 80) and the Minnesota Museum of Art.

80. Jack Levine Retrospective, Portland Art Museum 1979 Poster. Date: 1979. **Medium:** photo-offset in black, white, gray and burgundy. **Image size:** 21⅜ x 16⅜″, including text. **Sheet size:** 21⅜ x 16⅜″. **Paper:** machine-made. **Printer:** unknown. **Publisher:** Portland Art Museum. **Edition:** unknown. **Signature:** "75/100," l.l; "J Levine," l.r., reproduced as it appears on the original lithograph.

When the retrospective exhibition, organized by The Jewish Museum in New York (see No. 79), reached the Portland Art Museum, this poster was issued. It is a reproduction of the lithograph *Thought* (No. 58), enclosed by a dark burgundy border.

81. West '81, Minnesota Museum of Art Poster. Date: 1981. **Medium:** photo-offset in color. **Image size:** 31¾ x 20⅞″, including text. **Sheet size:** 33¾ x 22⅛″. **Paper:** machine-made. **Printer:** unknown. **Publisher:** West Publishing Company. **Edition:** unknown. **Signature:** "To Emma-Stina and Ken—love Jack Levine June 15, 1982." "J Levine," l.l., as it appears on the painting.

Taken from the 1979 painting *At the Precinct* (21 x 24″), this poster was issued in connection with an exhibition on "Art and the Law," sponsored by the West Publishing Company and presented by the Minnesota Museum of Art.

LIST OF PLATES

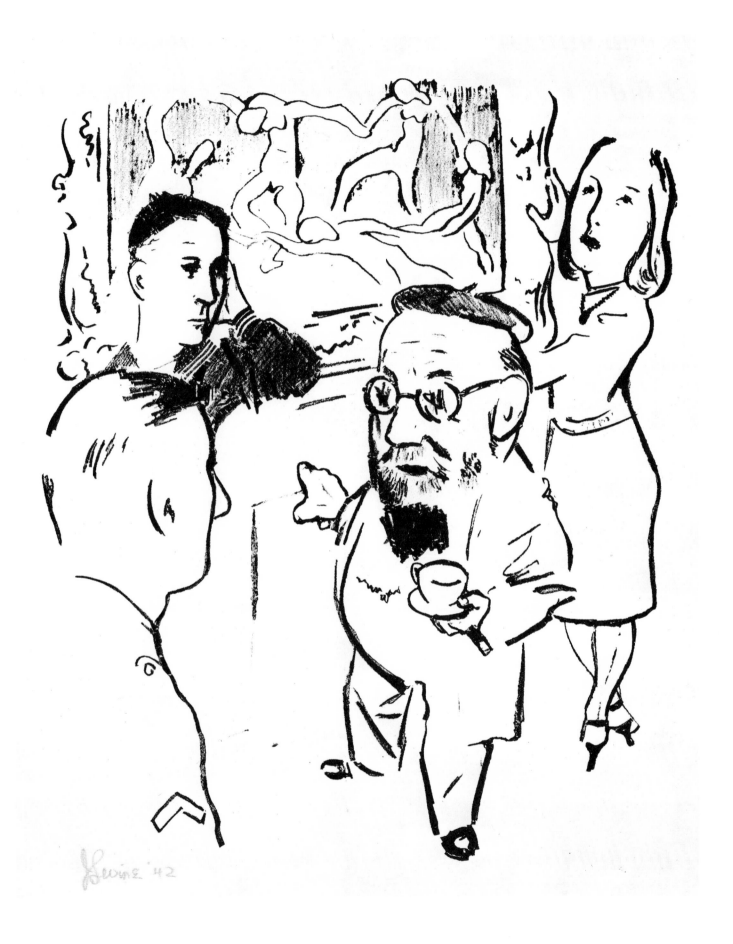

1. Matisse and U.S. Servicemen. 1942. 10¼ x 8½".

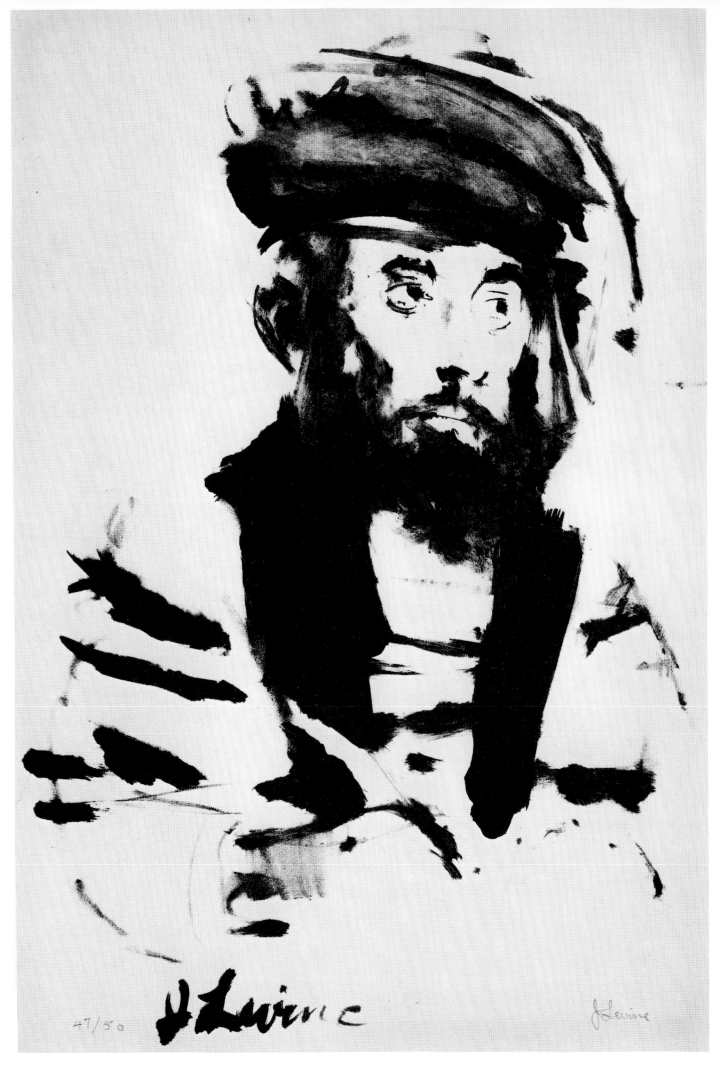

47/50

2. Hebrew King. 1949. Ca. 13¾ x 9¾".

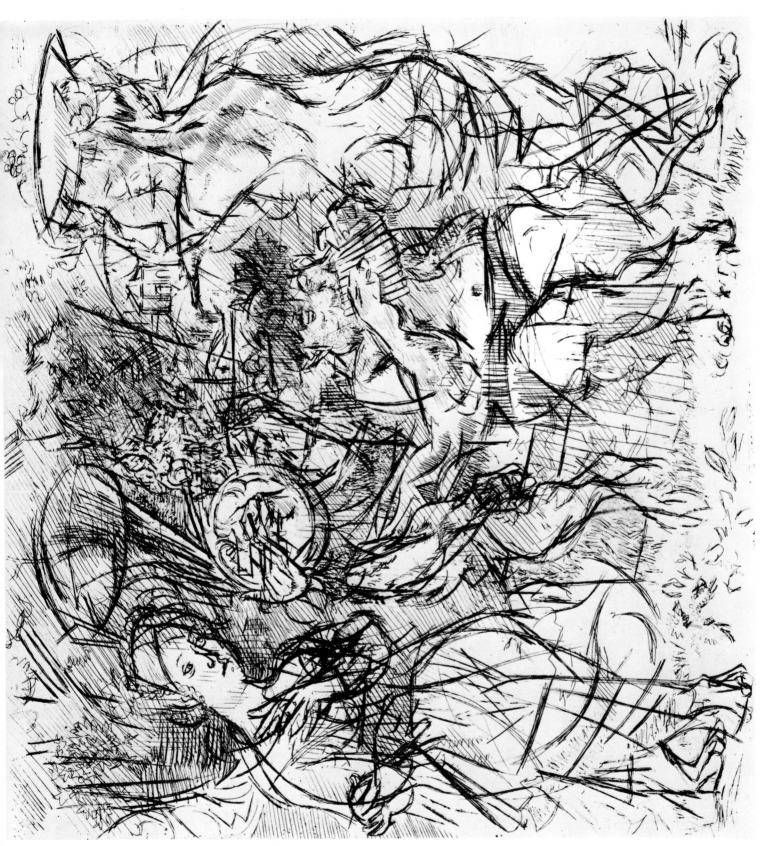

3. Woodstock Pastoral. 1952 (printed in 1969). 8¼ x 8¾".

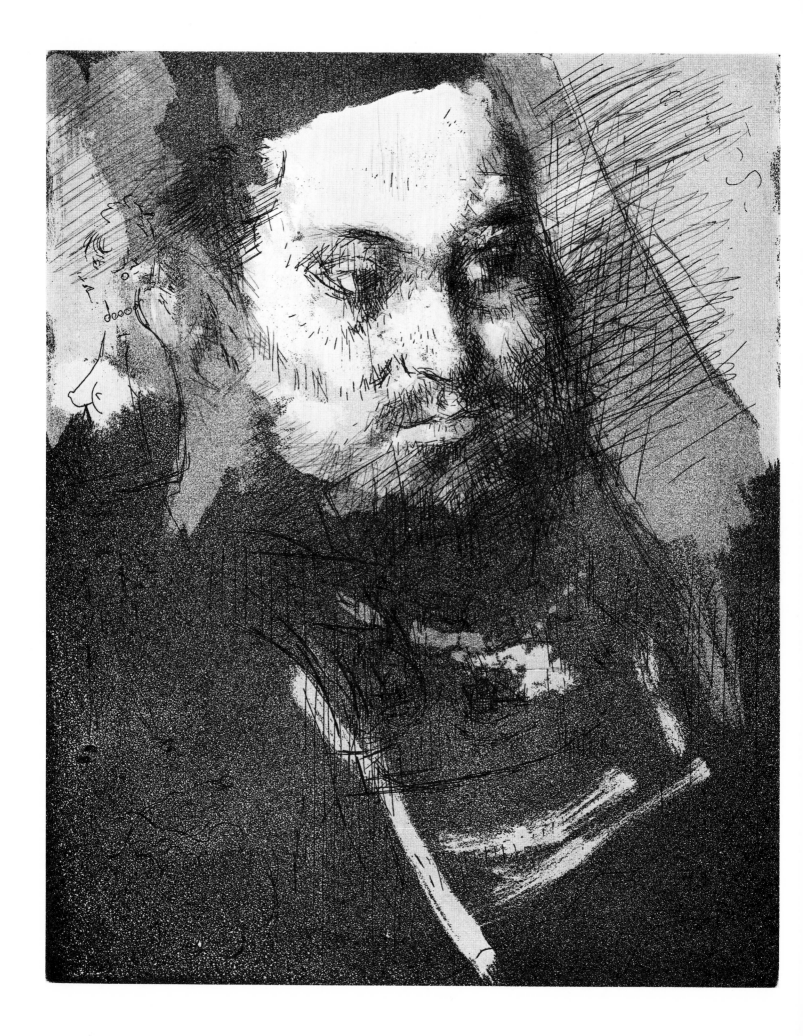

4. Bearded Head. 1962. 9¾ x 7⅞".

5. The White Horse. 1962. 7¾ x 9¾".

6. The General. 1962–63. 14¾ x 17½".

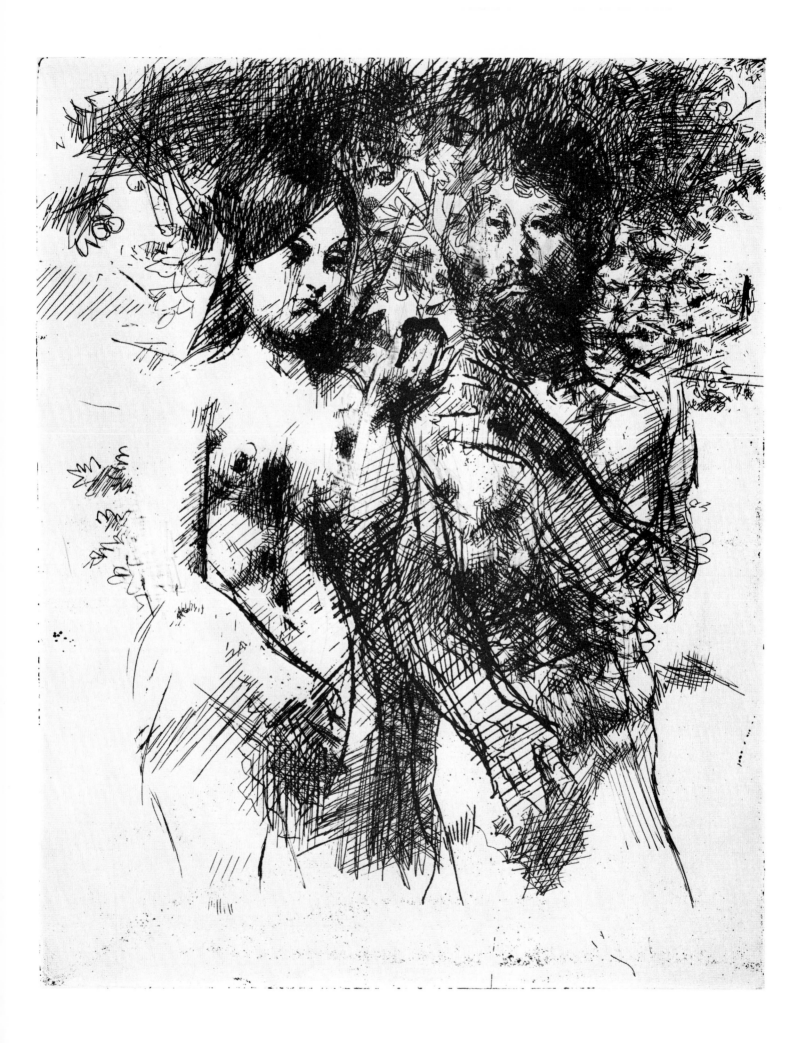

7. Adam and Eve. 1963. 9¾ x 7⅞″.

8. The Prisoner. 1963. 12¾ x 17¾".

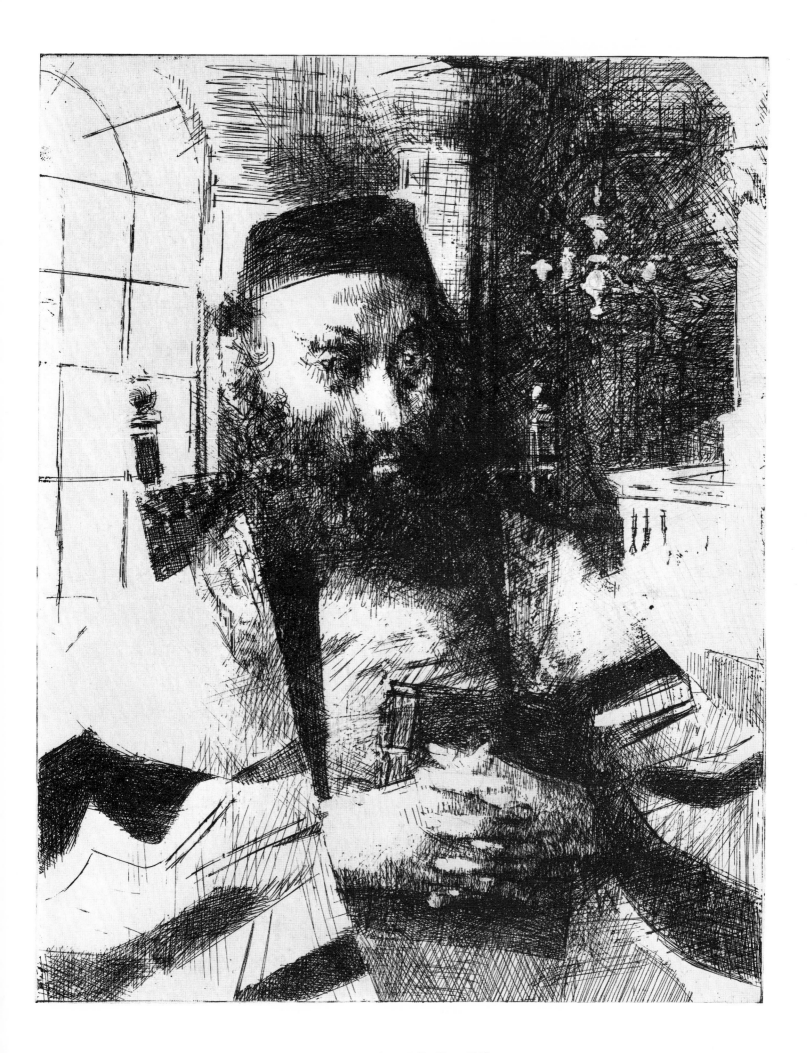

9. Ashkenazi I. 1963. 9¾ x 7¾".

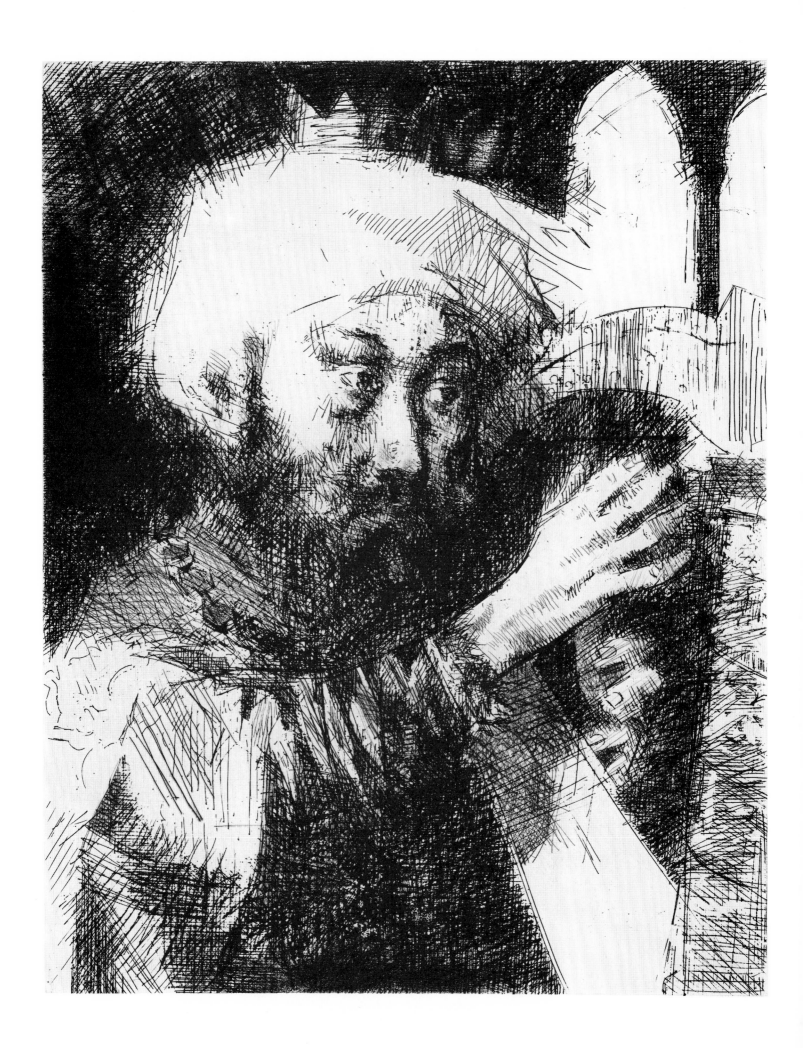

10. King David. 1963. 9¾ x 7¾″.

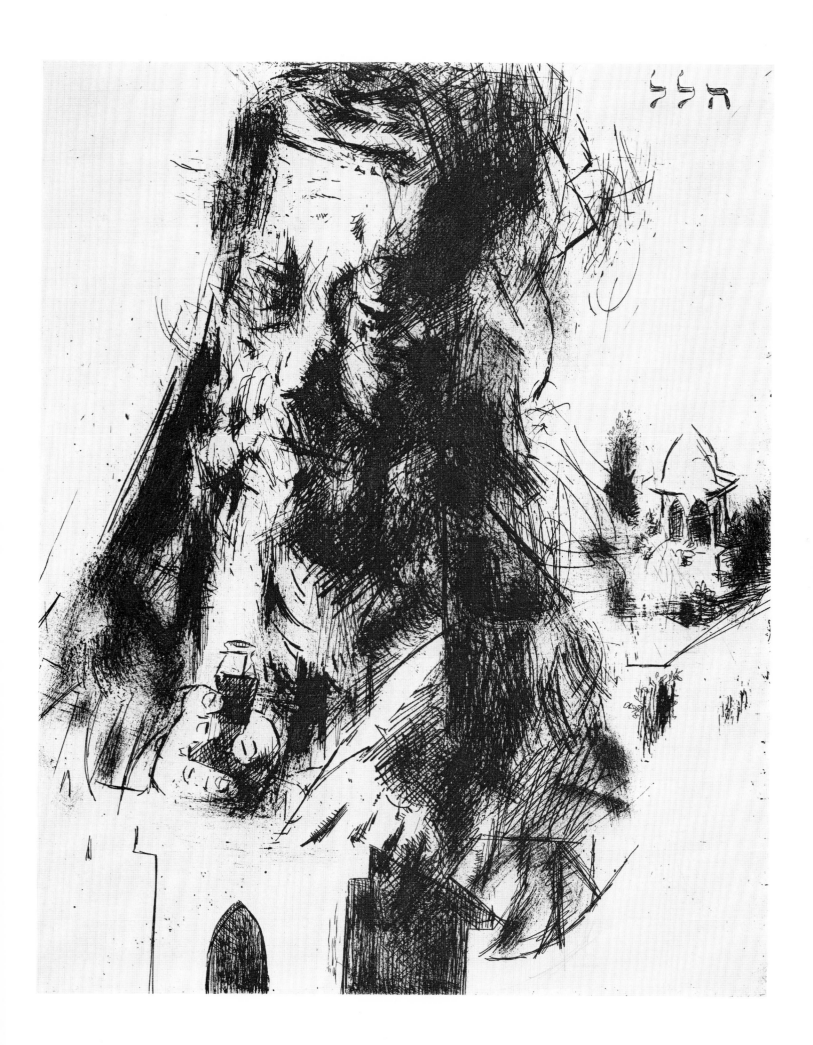

11. Hillel. 1963. 9¾ x 7⅞″.

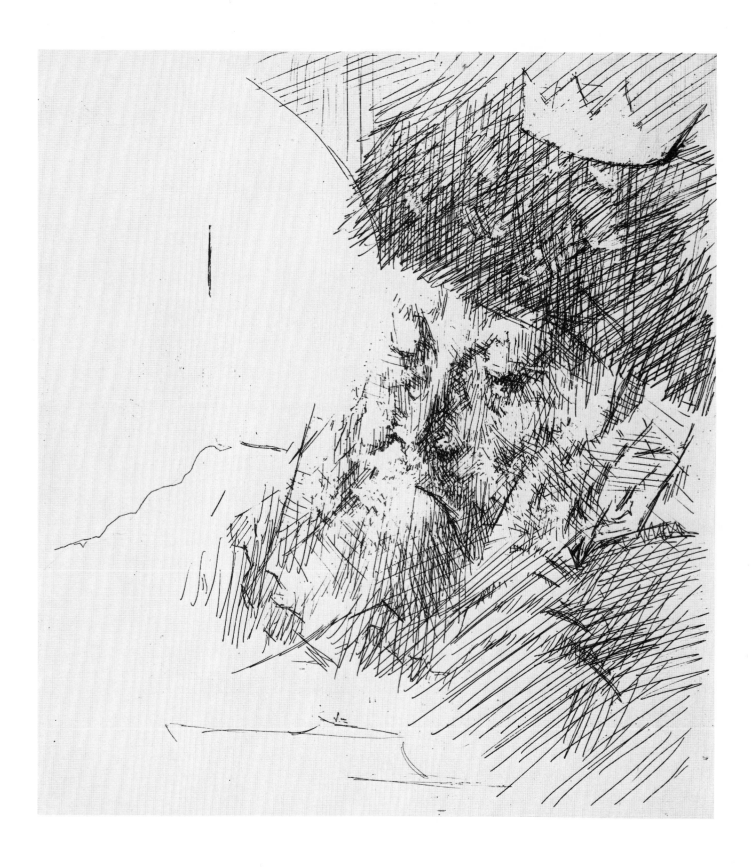

12. The King. 1963. 9½ x 7¾".

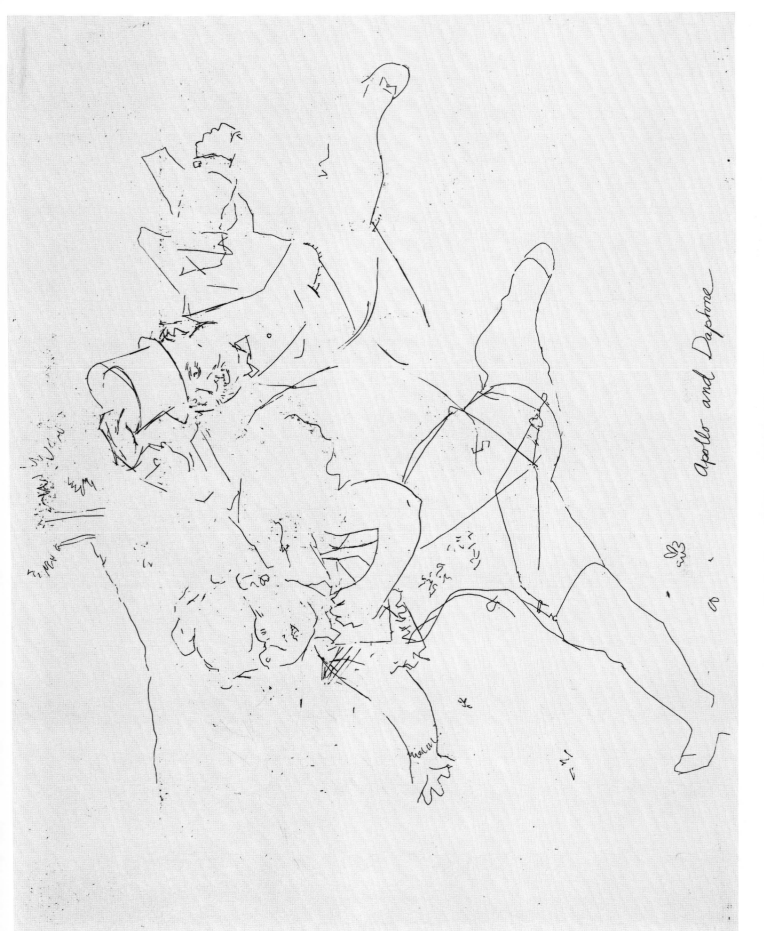

13. Apollo and Daphne. 1963–64. 7¾ x 9¾".

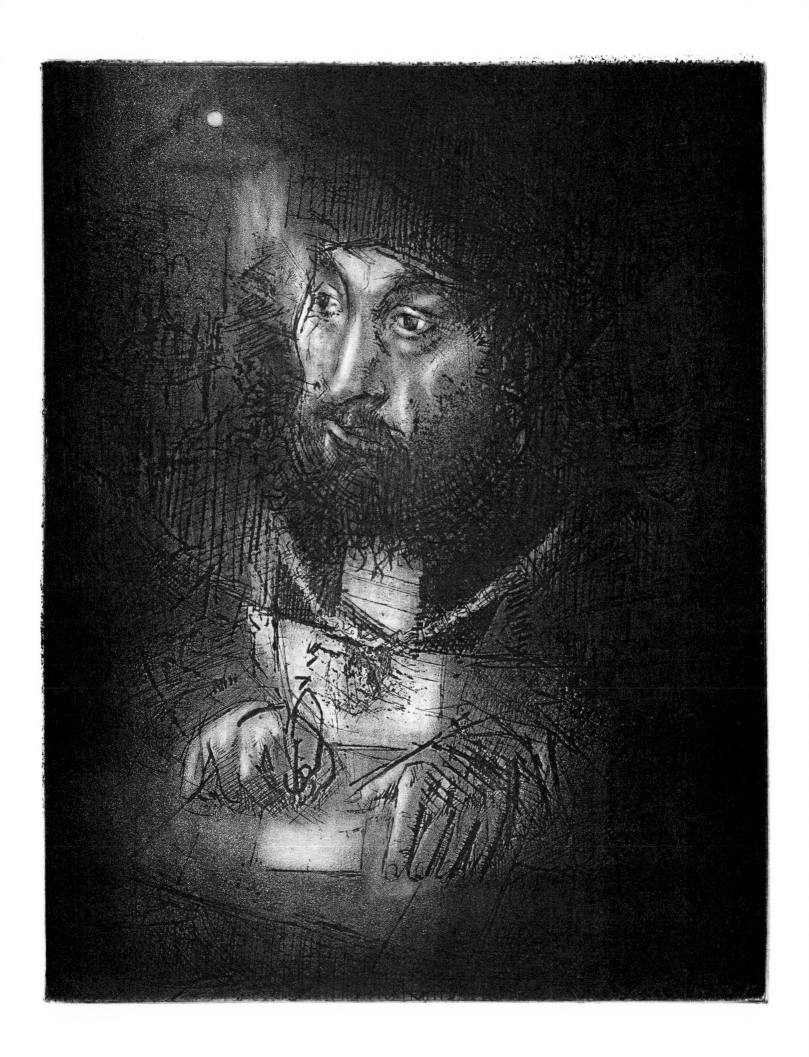

14 A. Maimonides I (State One). 1963. 9⅝ x 7¾″.

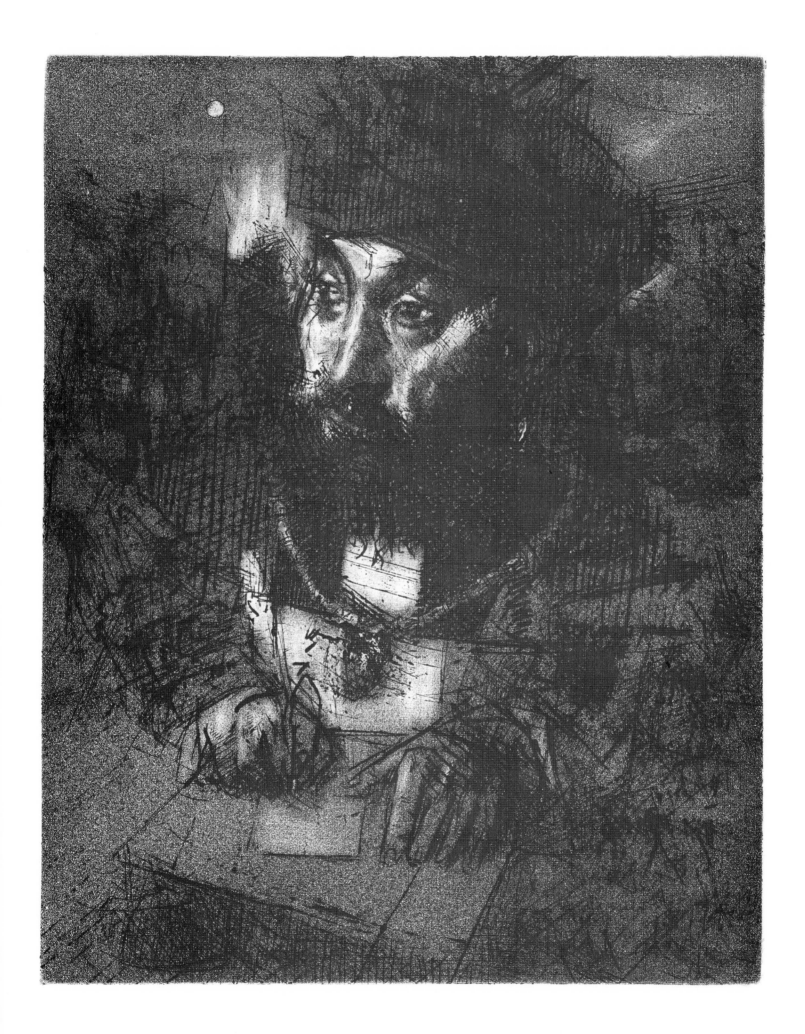

14B. Maimonides I (State Two). 1964. 9⅝ x 7¾″.

15 . Judas Maccabeus. 1963–64. 9¾ x 7¾″.

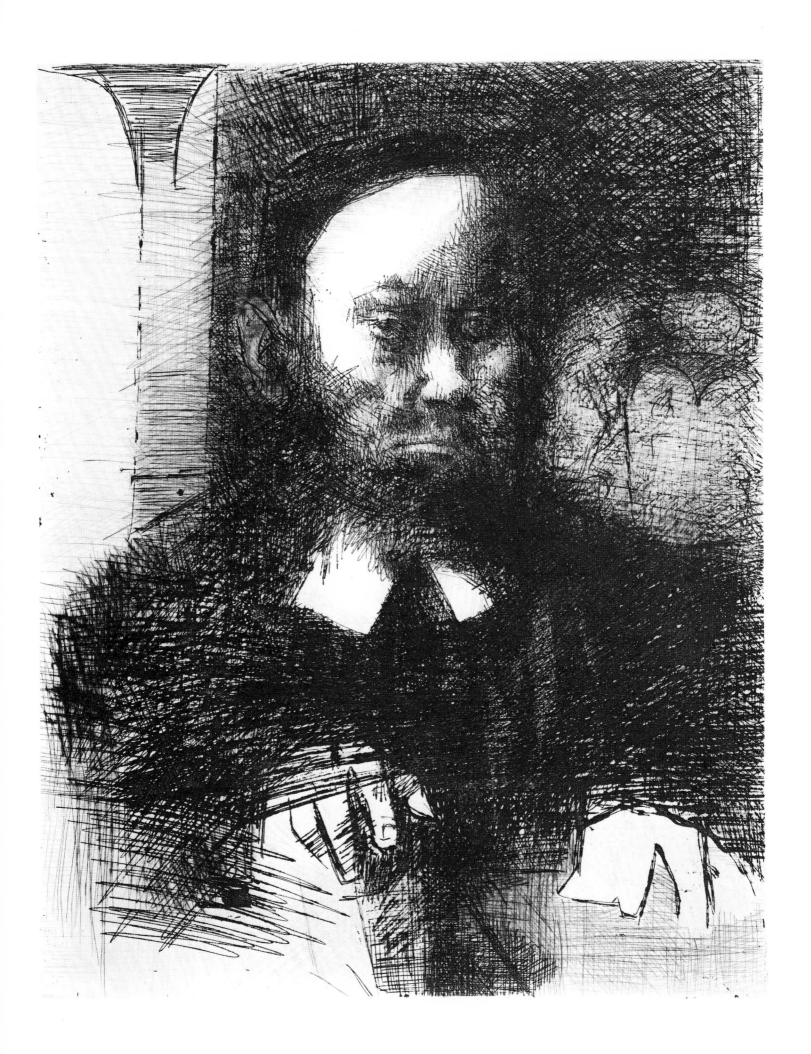

16. Ashkenazi II. 1964. 9⅝ x 7⅞″.

17. Studies of Heads. 1964. 9⅞ x 7⅞″.

18. Venetian Lady. 1964. 7¾ x 9¾".

19. Volpone II. 1964. 8 x 9¾".

20. Volpone III. 1964–65. 9¾ x 8″.

21. Cain and Abel I. 1964. 9¾ x 7¾″.

Louvre

22. Judgment of Paris. 1964. 5⅞ x 8⅞".

23. Head of a Young Girl. 1964. 3 x 1⅞″.

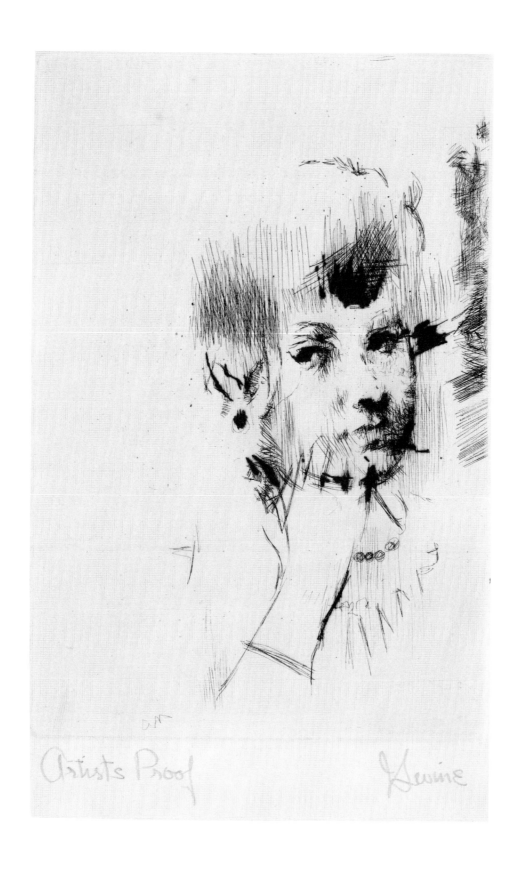

Artist's Proof

Levine

24. Meditation. 1964. 7¼ x 4⅞″.

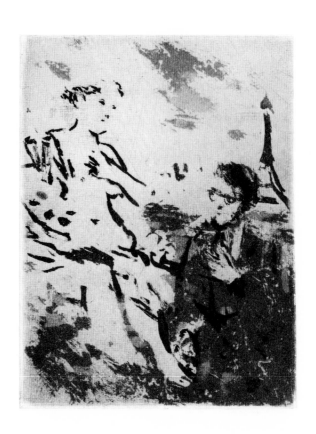

25. American in Paris. 1965. 3⅞ x 3″.

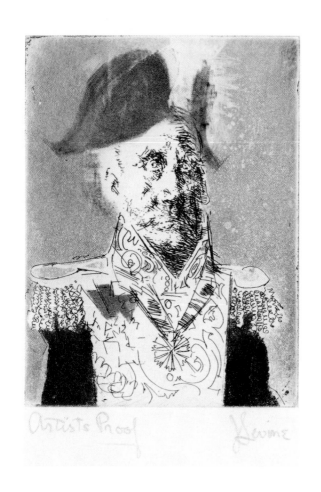

Artists Proof Levine

26. Italian General. 1965. 3⅞ x 3″.

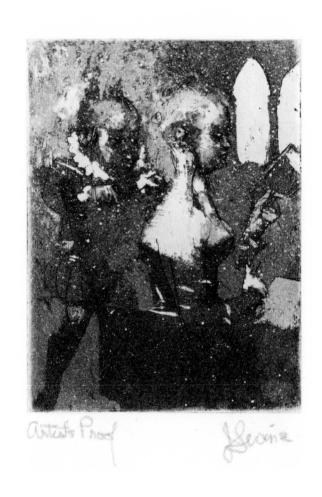

Artist's Proof Levine

27. La Toilette. 1965. 3⅞ x 2⅞″.

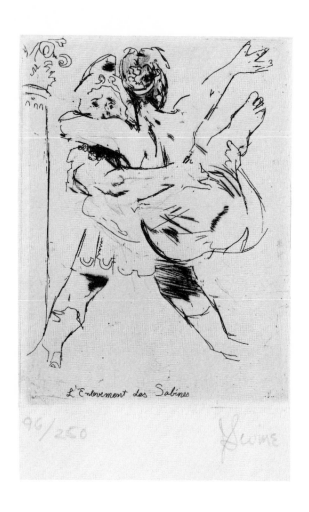

28. L'Enlevement des Sabines. 1965. 3⅞ x 2⅞".

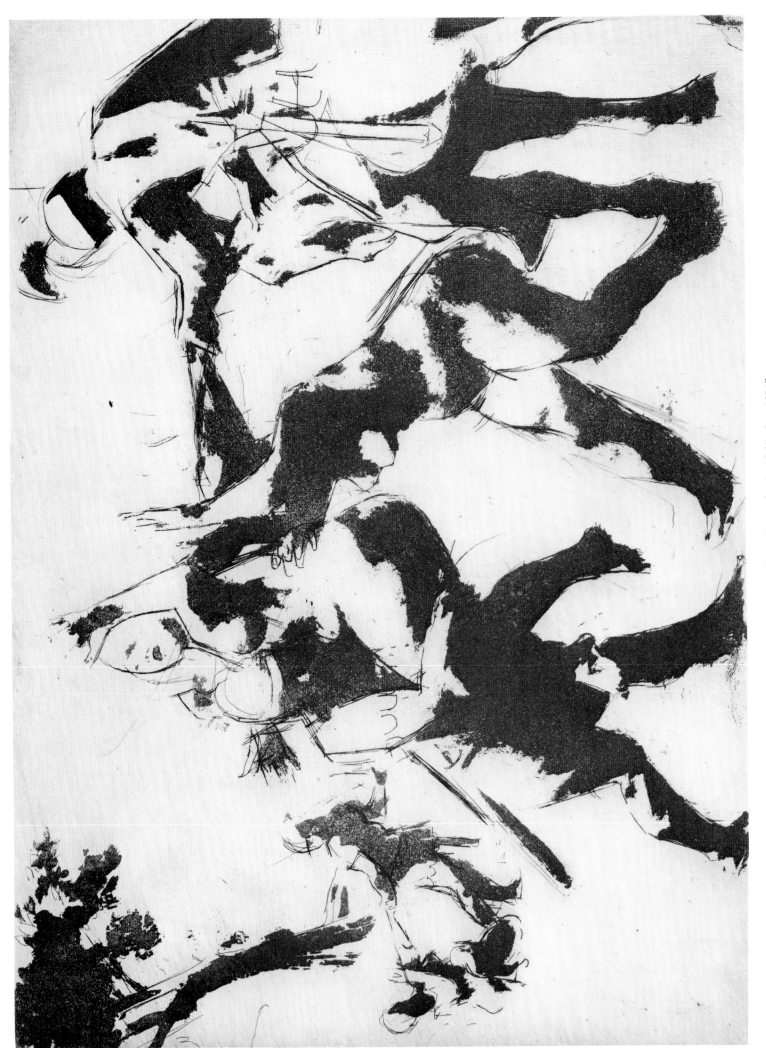

29A. Rape of the Sabines (State One). 1965. 8 x 10¾".

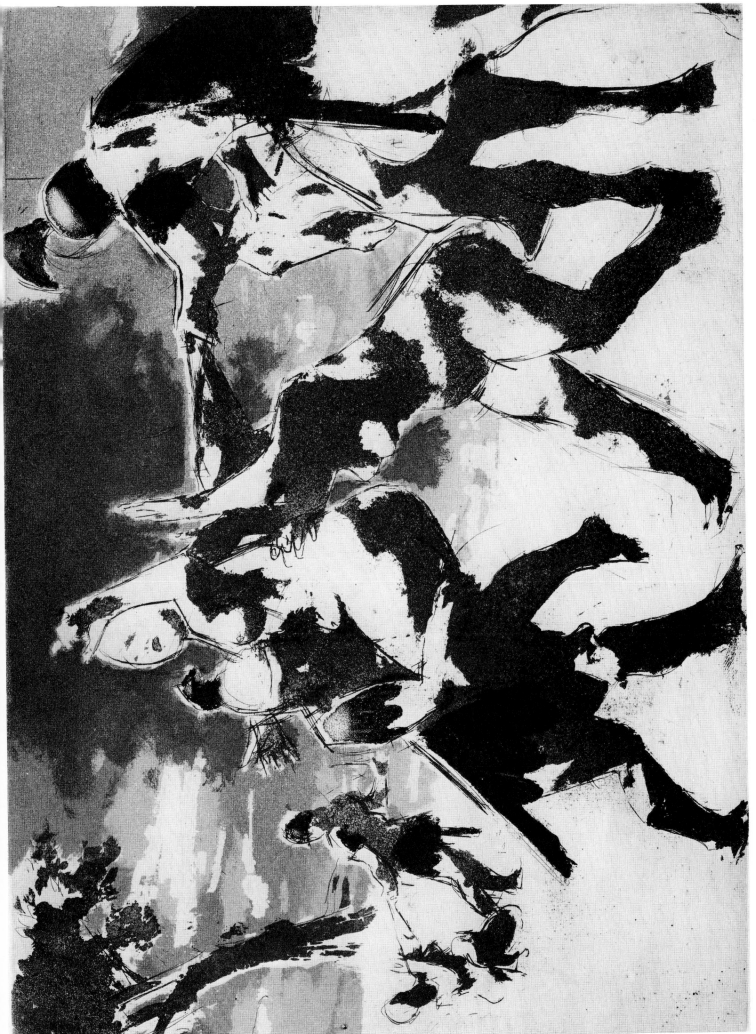

29B. Rape of the Sabines (State Two). 1965. 8 x 10¾".

30. Gangster's Funeral. 1965. 19¼ x 25⅜".

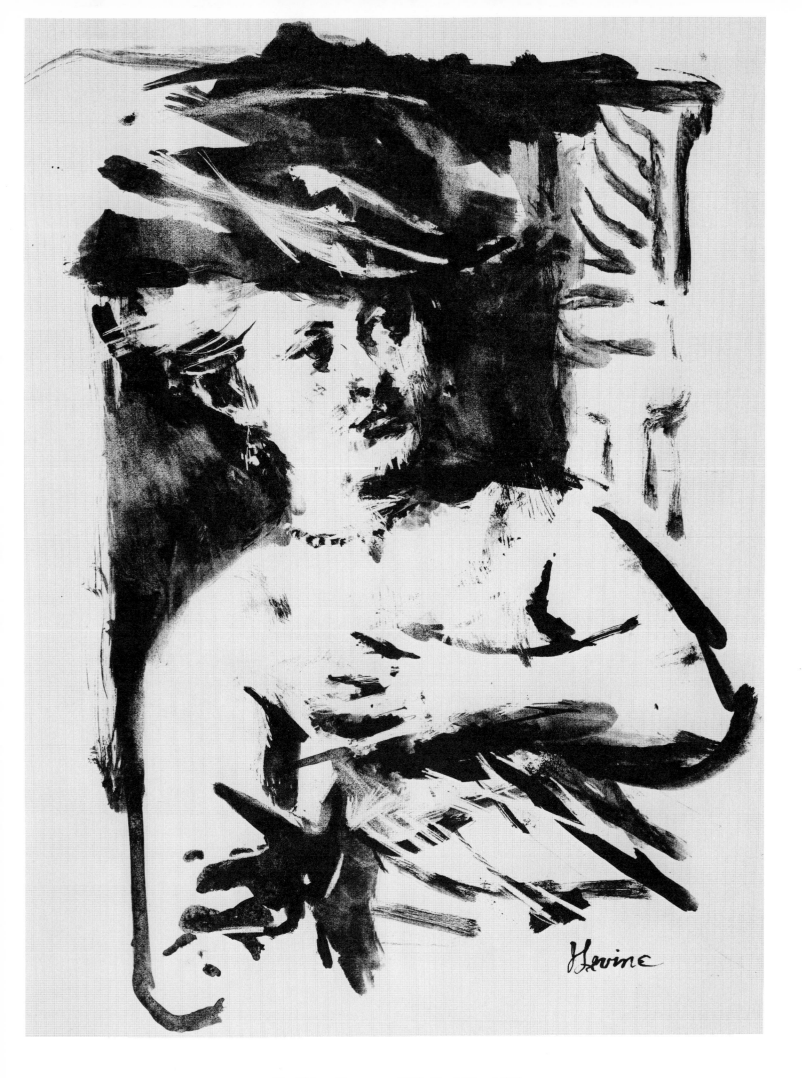

31. Helene Fourment. 1965. Ca. 15¾ x 11½".

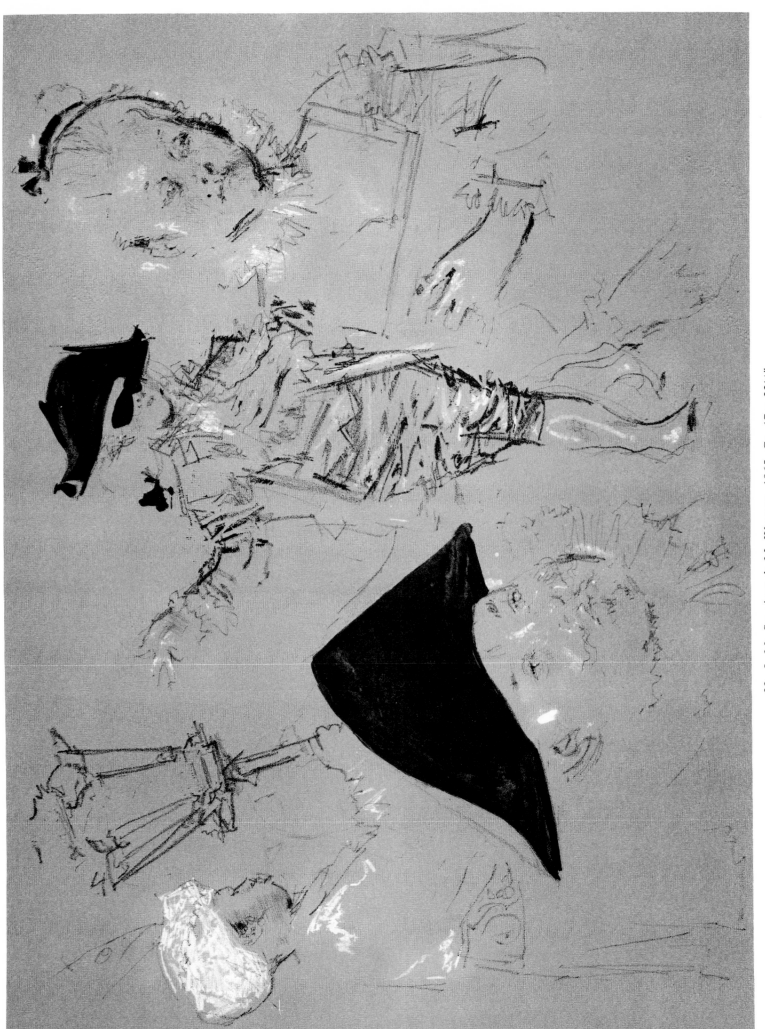

32. Je Me Souviens de M. Watteau. 1965. Ca. 17 x 22½".

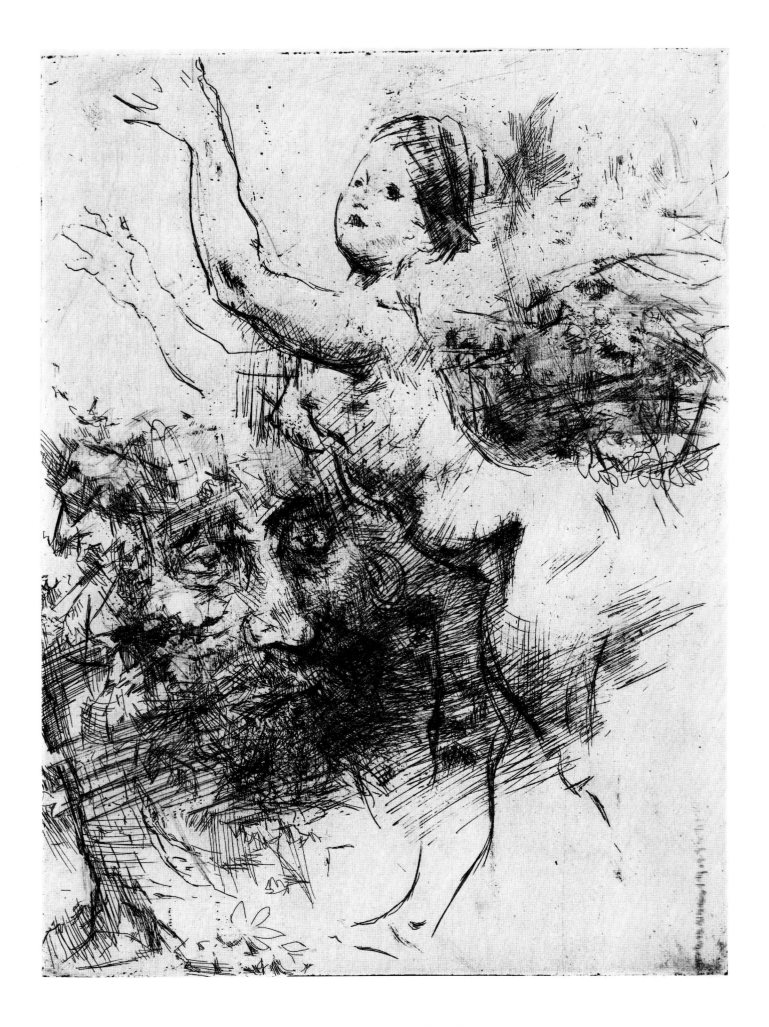

33. Nymph and Warlock. 1965. 9⅝ x 7⅜".

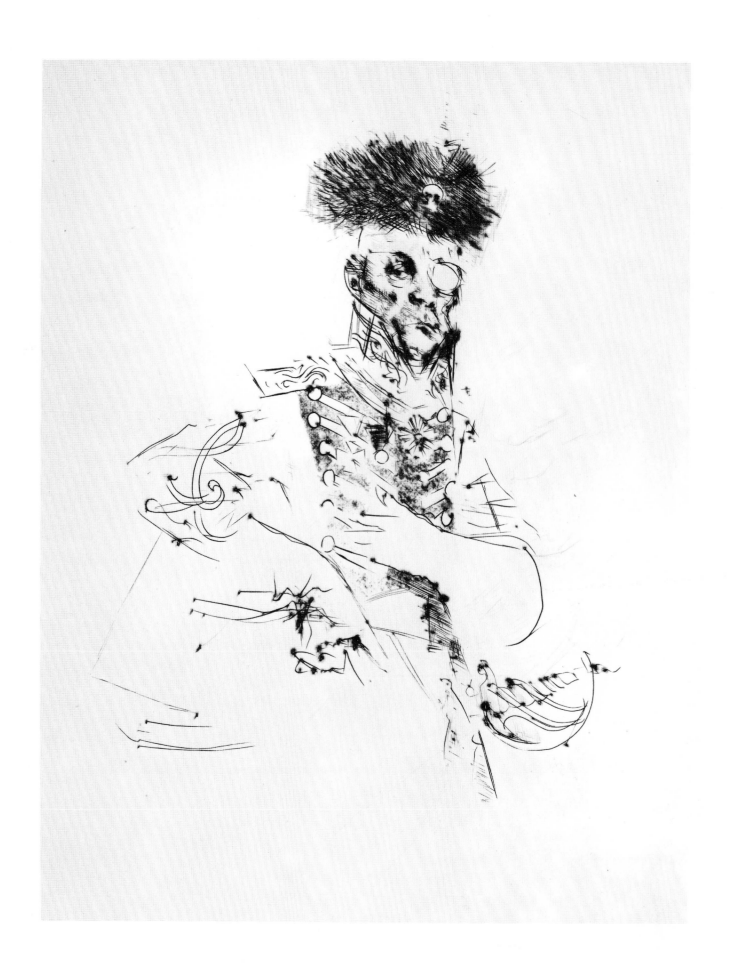

34. Death's-Head Hussar. 1965. 11⅝ x 8⅞″.

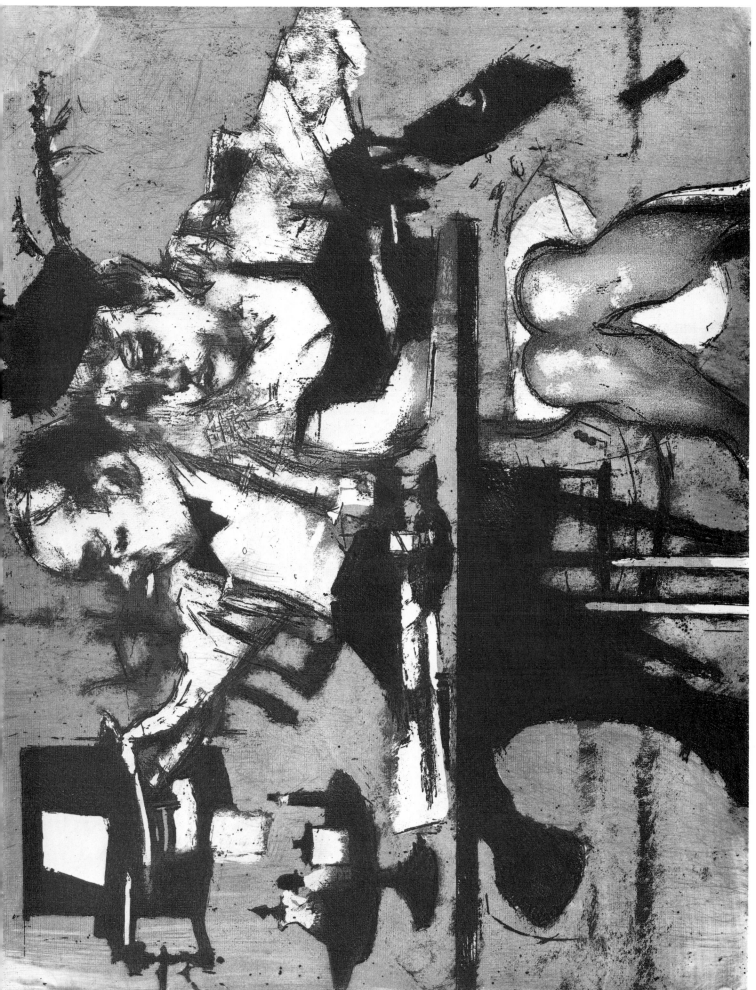

35. Careless Love. 1965. 17⅜ x 22".

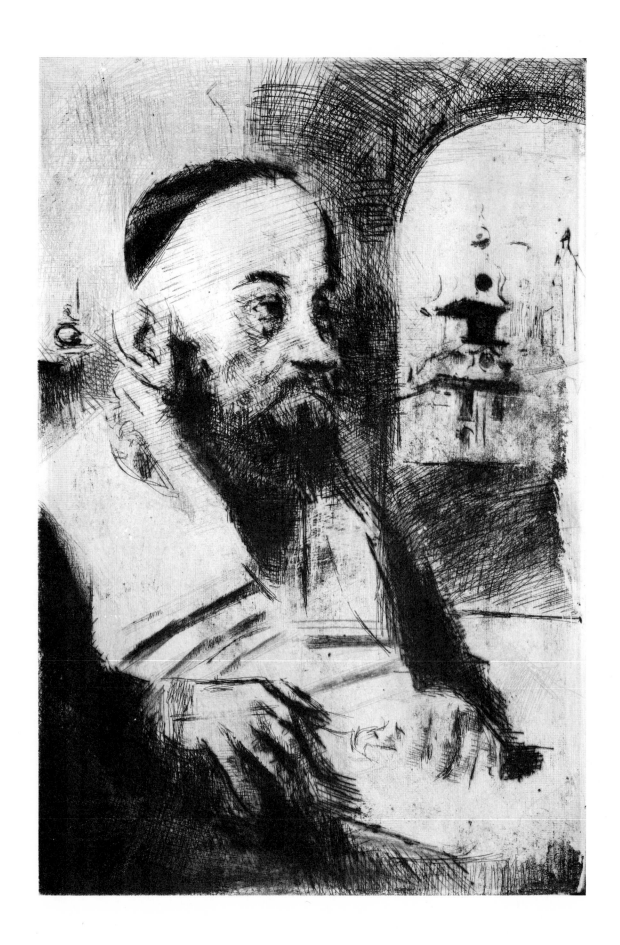

36. Rabbi of Prague. 1965–66. 8¾ x 6″.

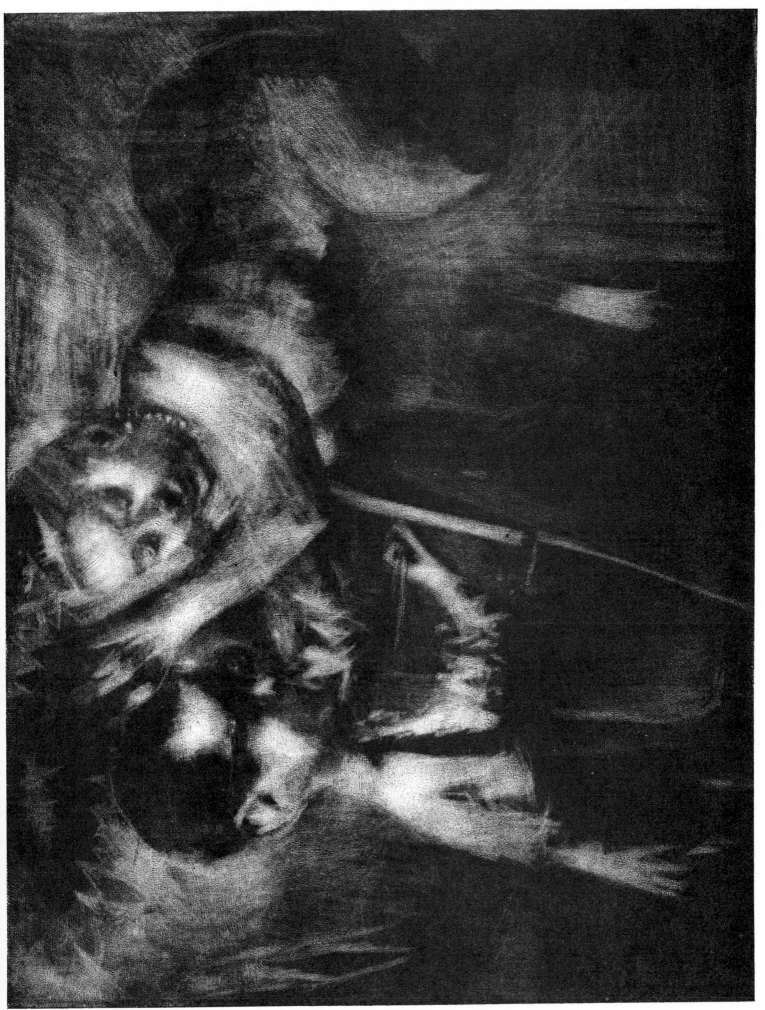

37. Self-Portrait with Muse. 1966. 9⅞ x 12⅝".

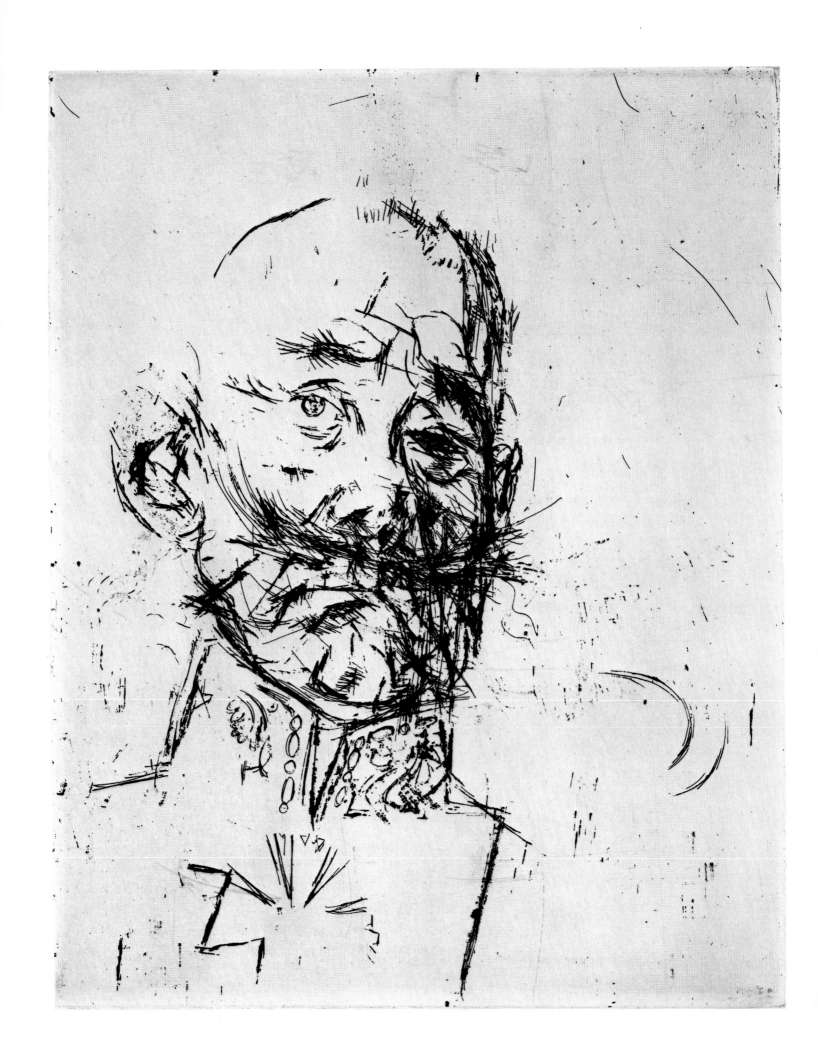

38 A. Prussian General (State One). 1966. 9¾ x 7⅝″.

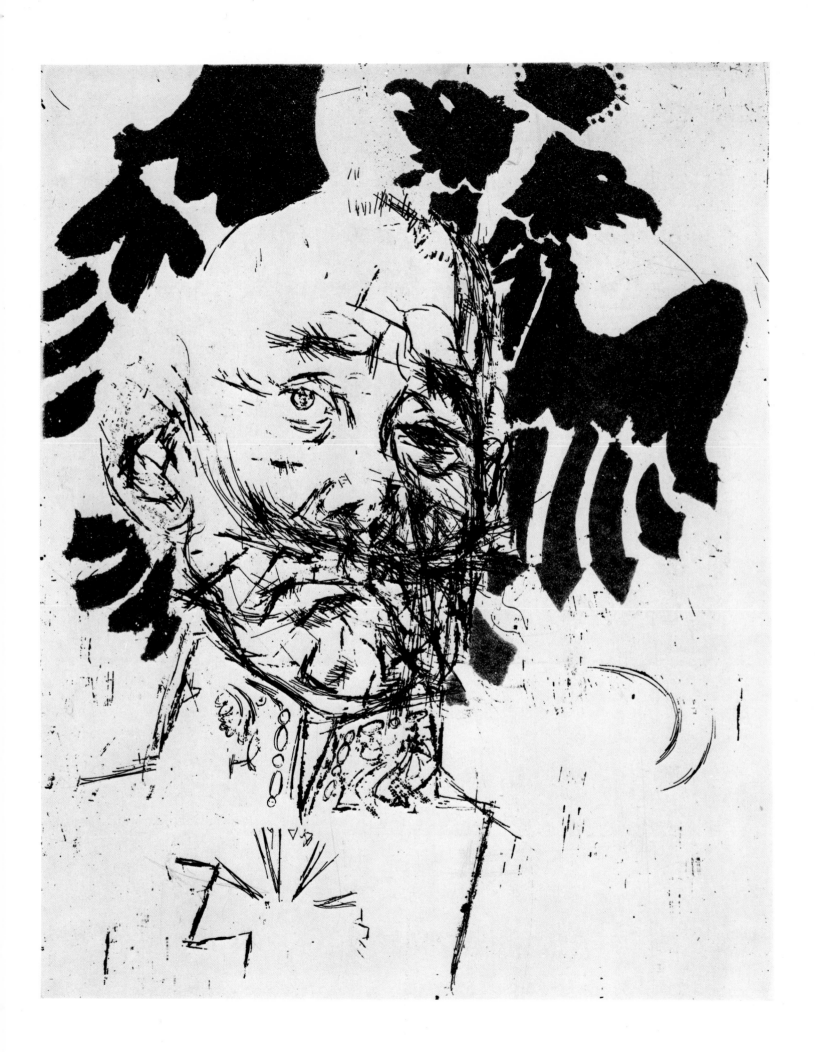

38B. Prussian General (State Two). 1966. 9¾ x 7⅝".

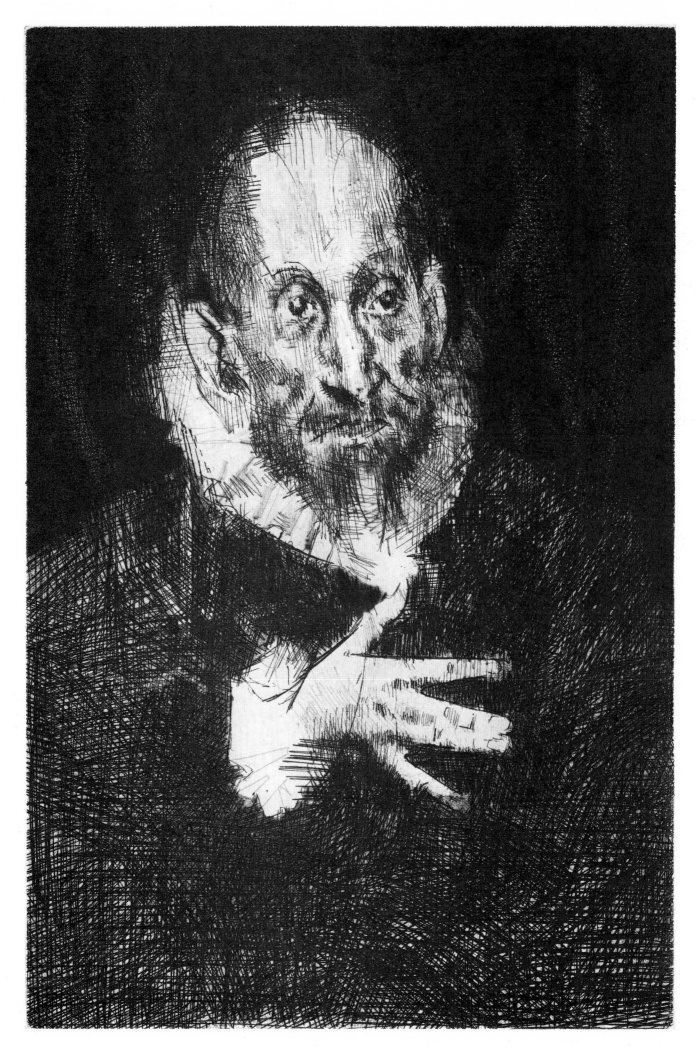

39. El Greco. 1966. 11¾ x 7⅞″.

40. Brechtiana. 1966. Ca. 14¾ x 16¾".

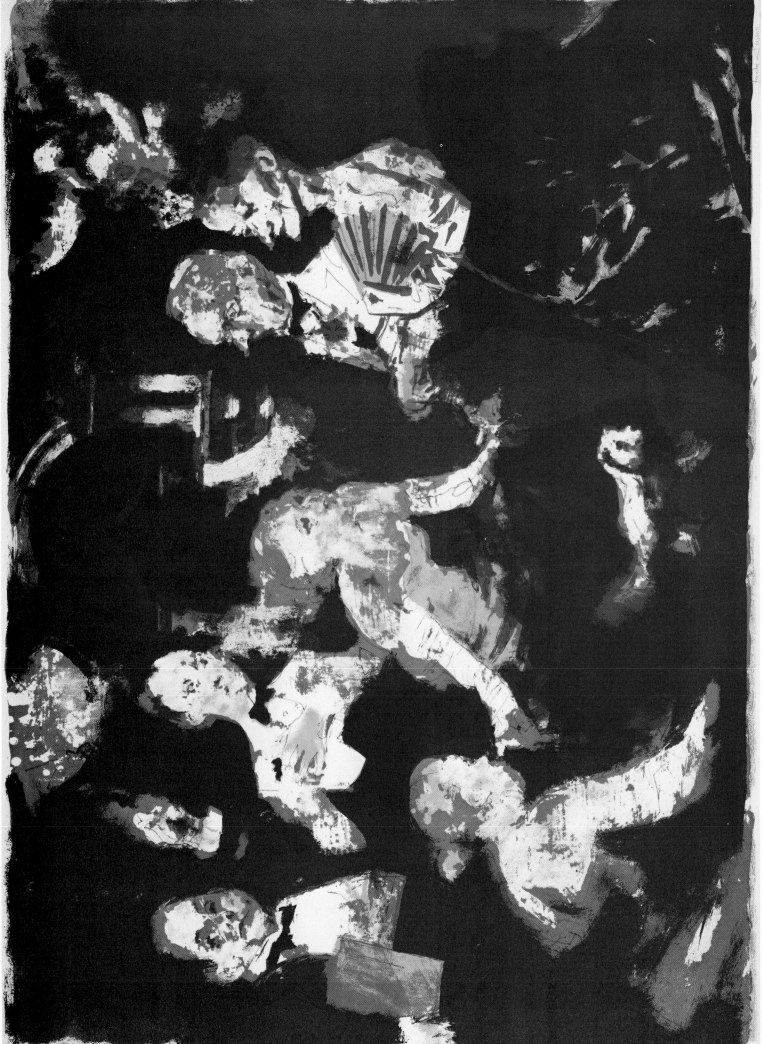

41. Reception in Miami. 1967. Ca. 21 x 28¼".

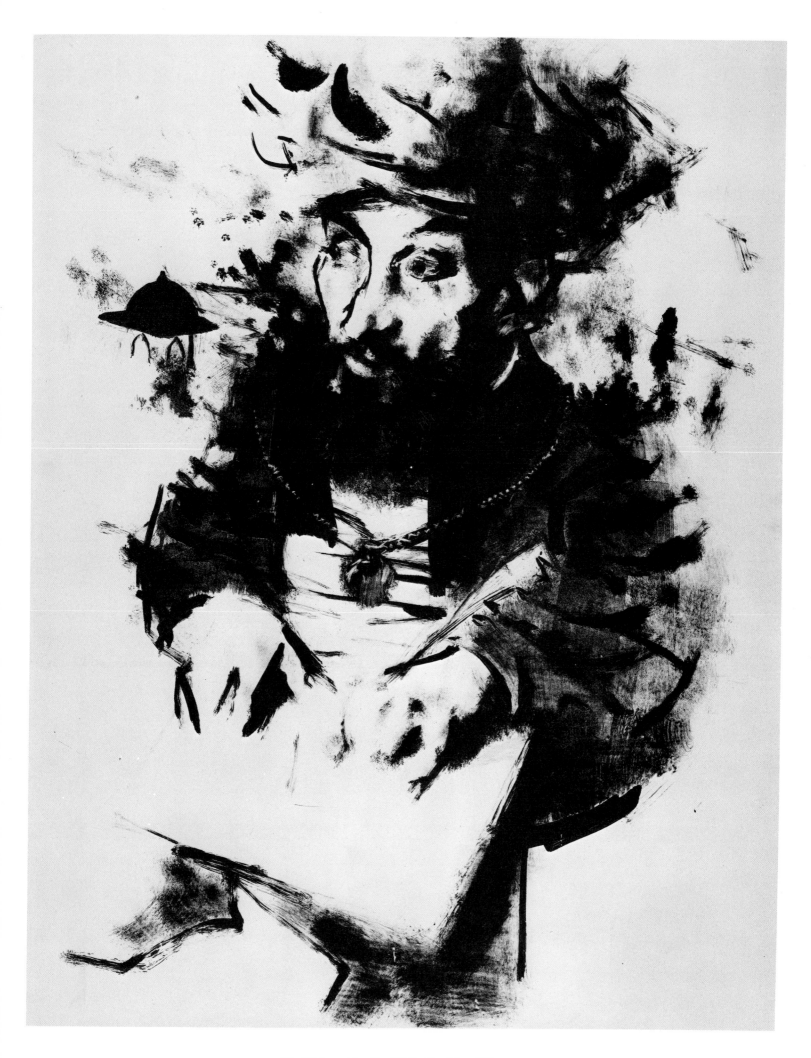

42. Maimonides II. 1967. Ca. 26 x 18".

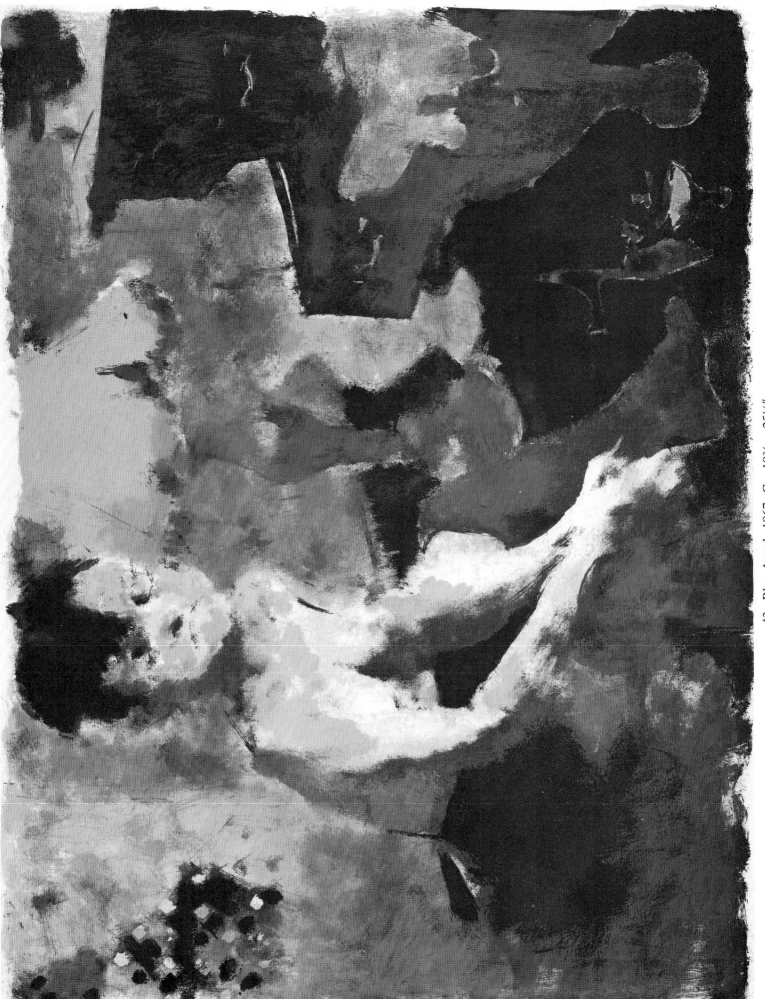

43. Blue Angel. 1967. Ca. 19¾ x 25½".

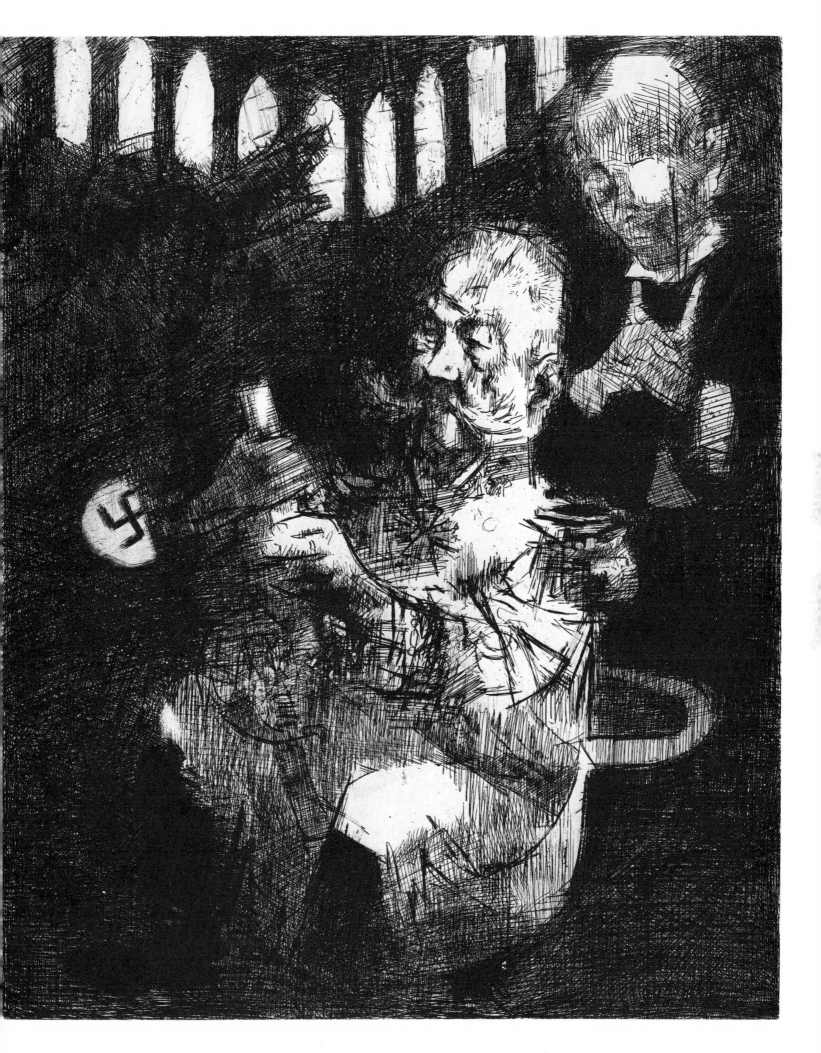

44. The End of the Weimar Republic. 1967. 17¾ x 14¾".

45. Vernissage. 1967. Ca. 16¾ x 22".

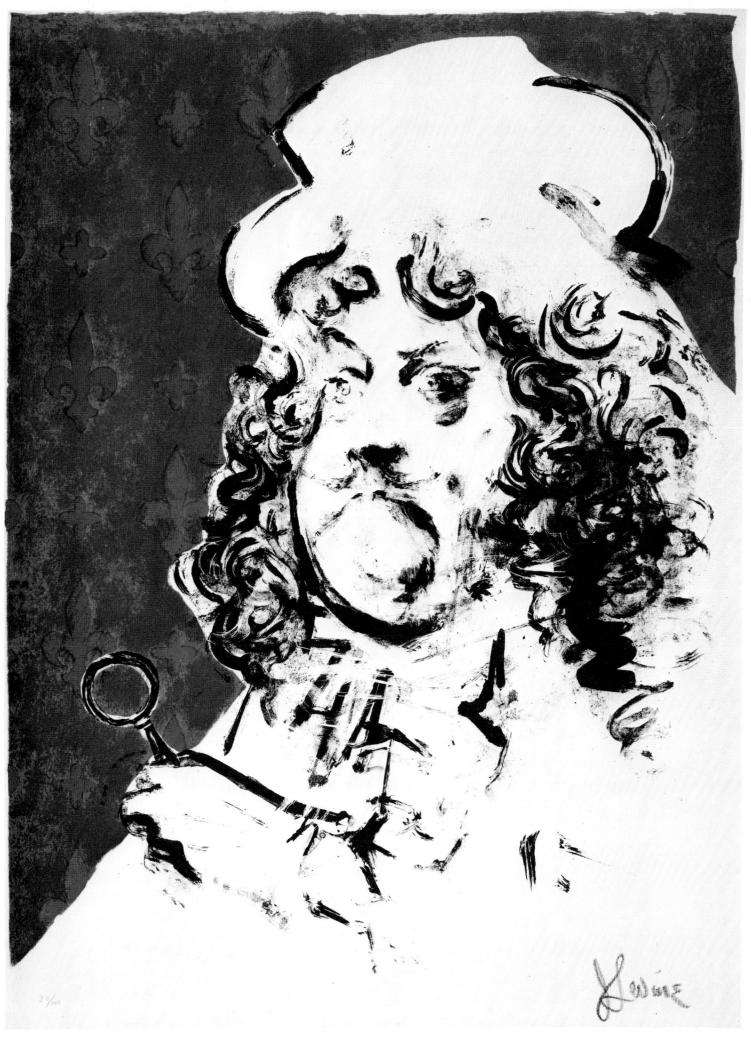

46. The Art Lover. 1967. Ca. 22 x 17½".

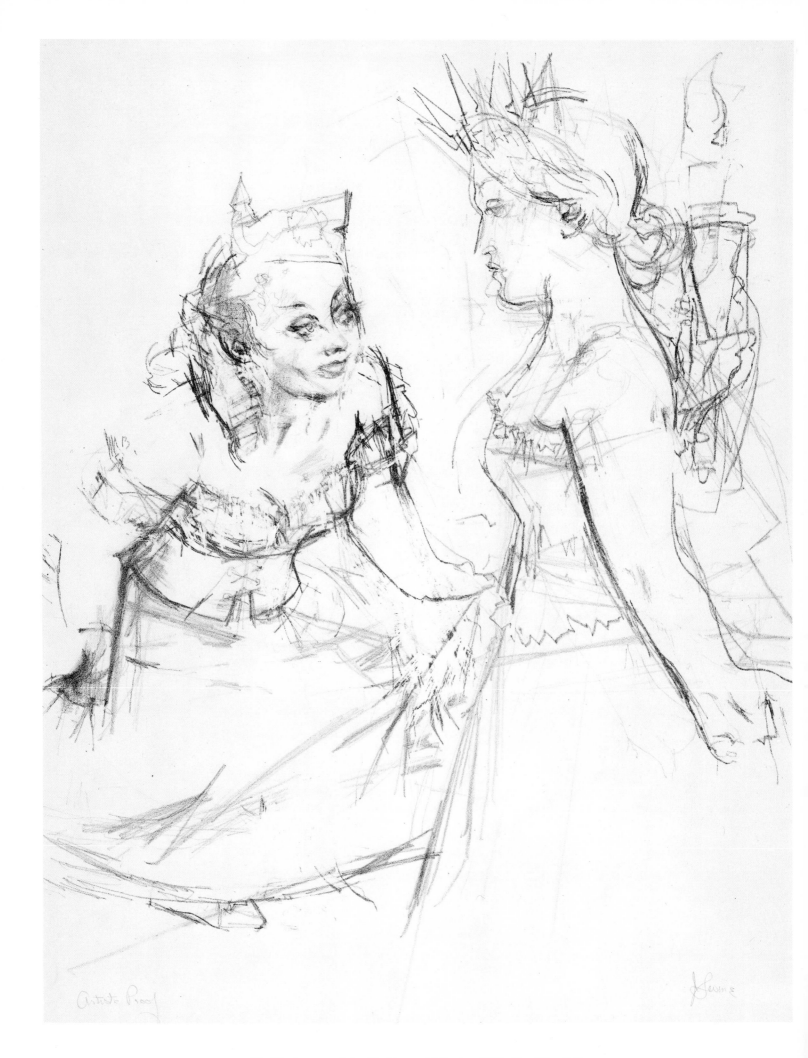

47. Marianne and the Goddess of Liberty. 1967. Ca. 27 x 21″.

48. Boudoir. 1968. 7¾ x 9¾".

49. The Great Society. 1968. 8⅞ x 11⅞".

50. At the Ball. 1968. 4⅞ x 6⅞".

51. On the Convention Floor. 1968. Ca. 18½ x 24½".

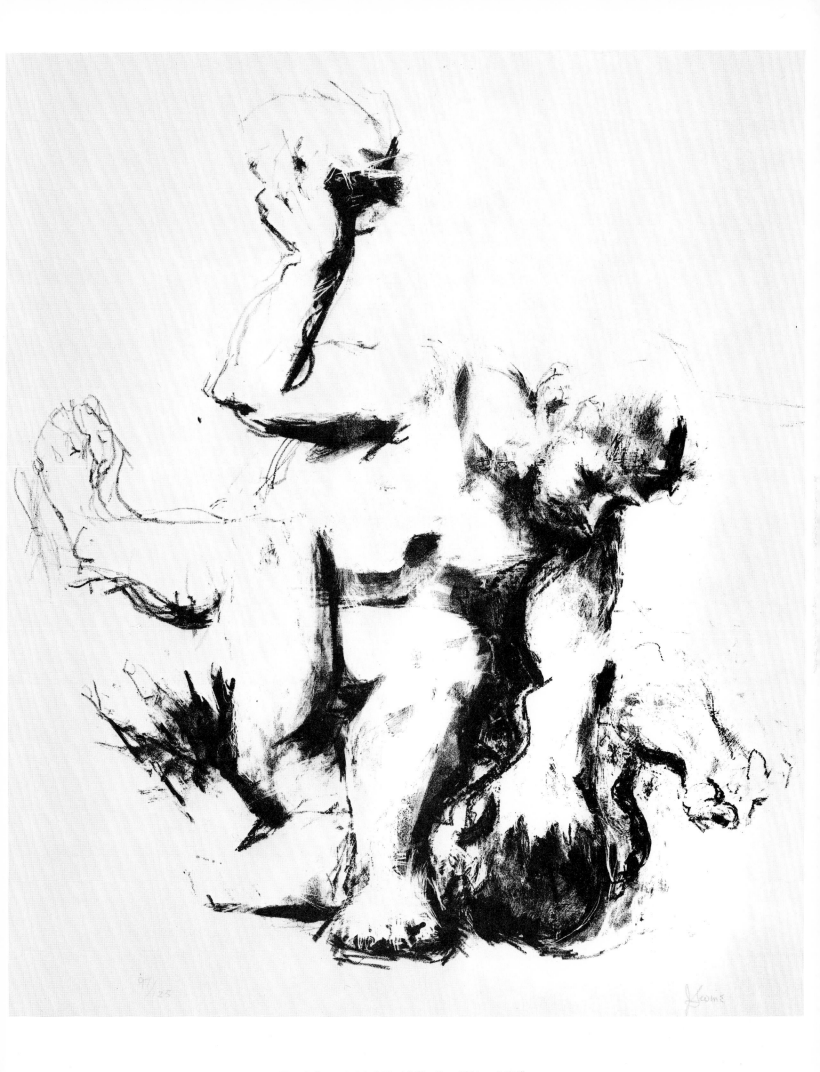

52. Cain and Abel II. 1969. Ca. 18¾ x 16¾″.

53. The Daley Gesture. 1969. 8¾ x 11¾".

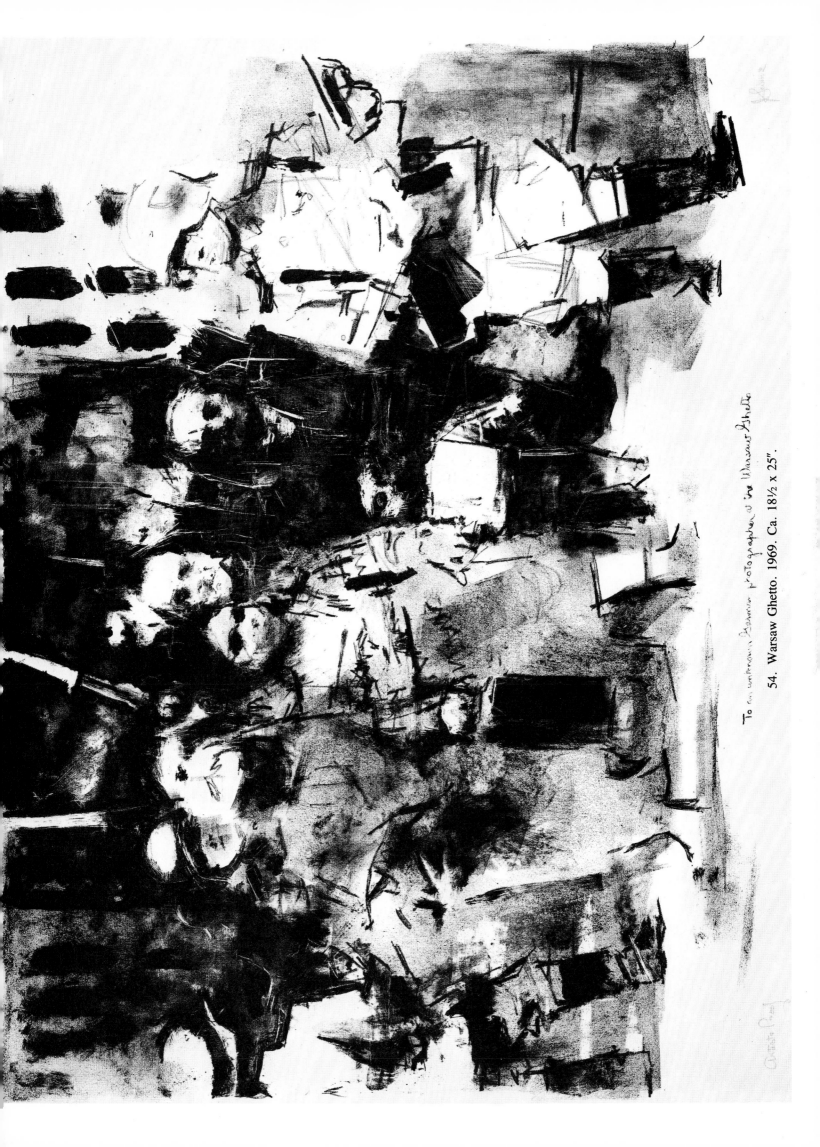

To an unknown German photographer in Warsaw Ghetto

54. Warsaw Ghetto. 1969. Ca. 18½ x 25".

Artist's Proof

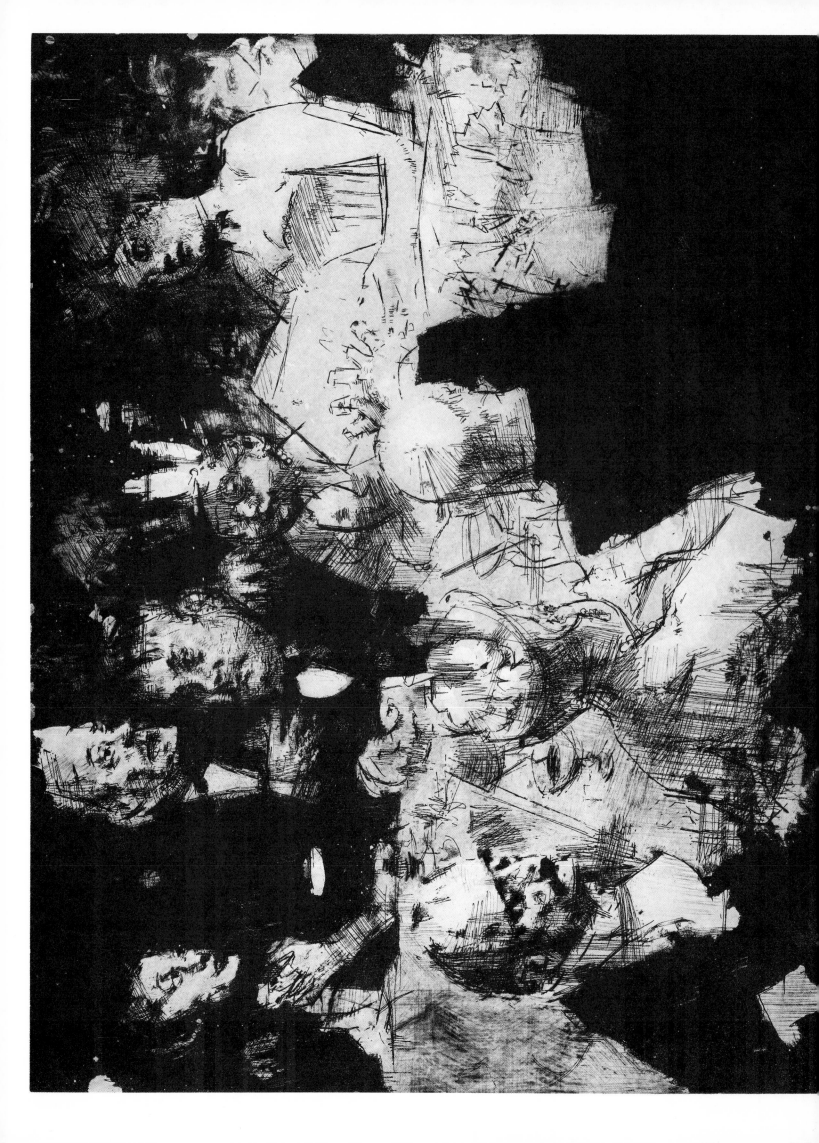

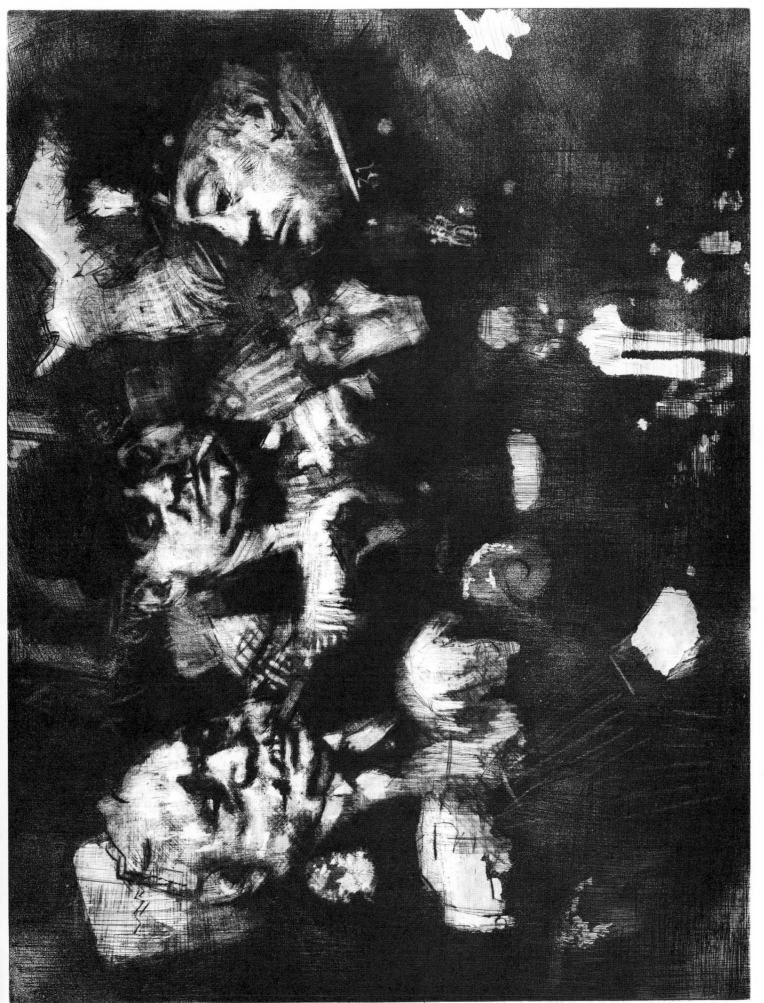

56. The Feast of Pure Reason. 1970. 19⅜ x 25⅛".

57. Texas Delegate. 1970. Ca. 16 x 19½".

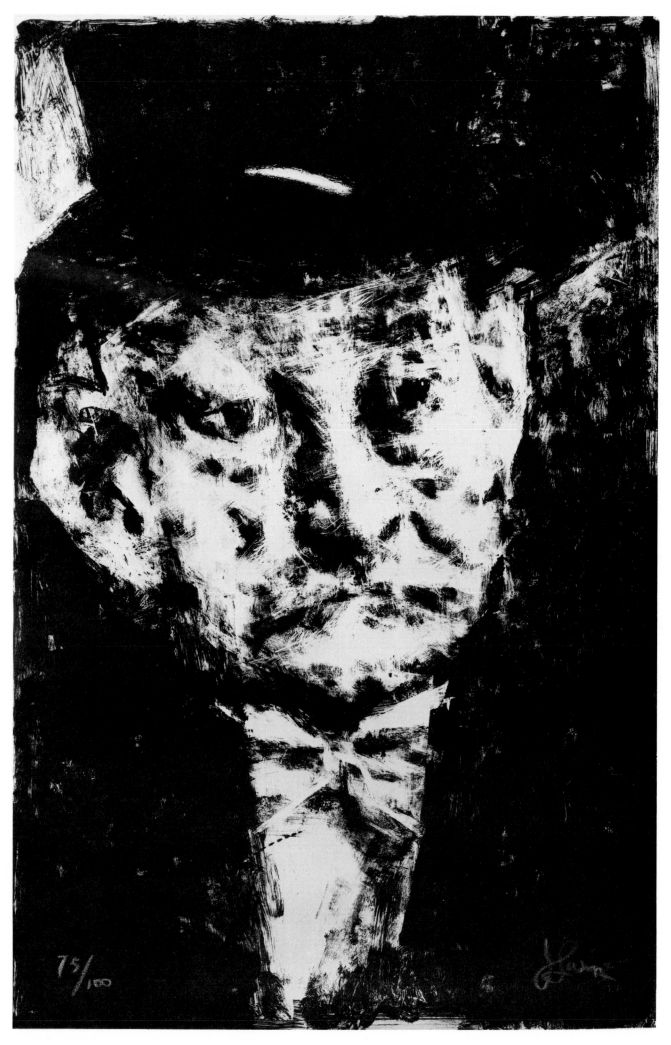

75/100

58. Thought. 1972. Ca. 39 x 25¾″.

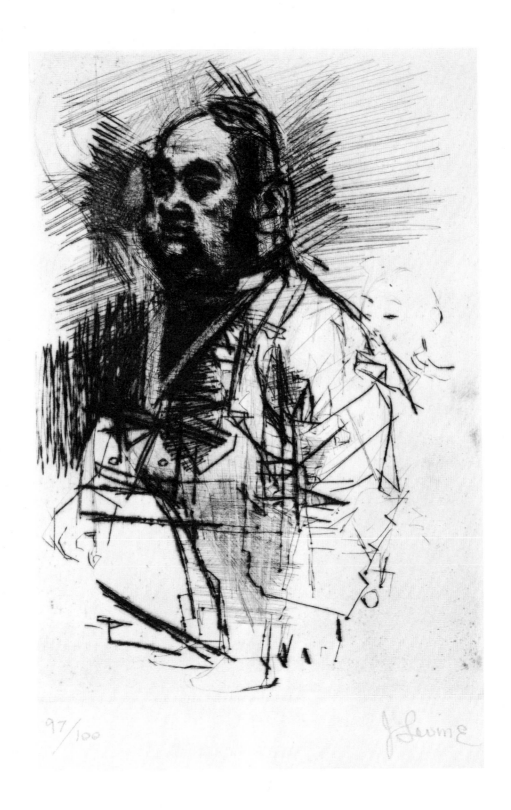

97/100

59. Hong Kong Tailor. 1974. 6¾ x 4¾".

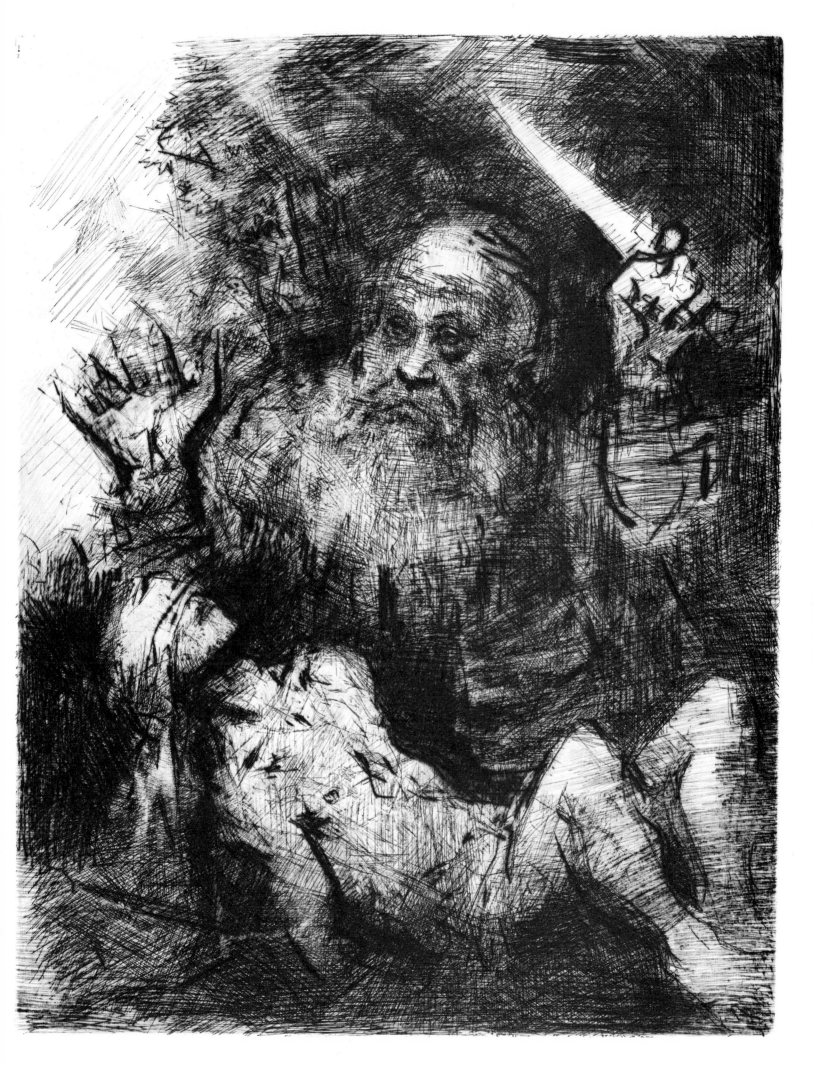

60. Sacrifice of Isaac. 1974. 13⅝ x 10⅝".

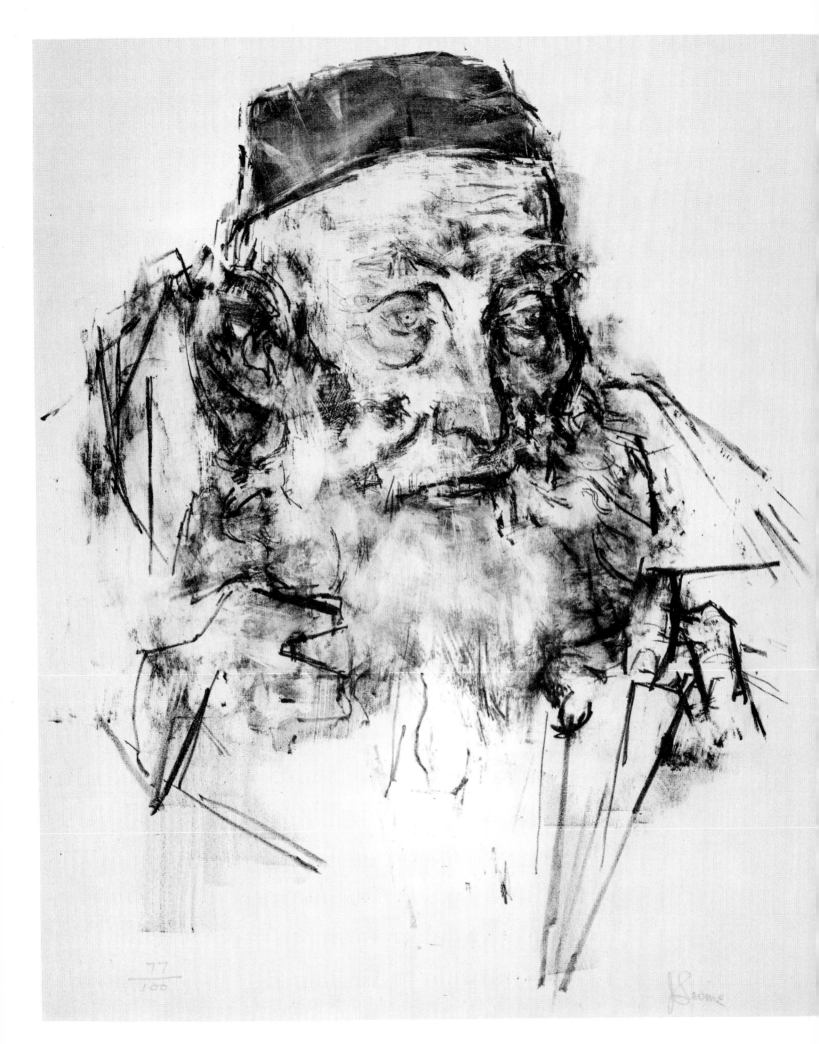

61. Shammai. 1975. Ca. 19¼ x 16″.

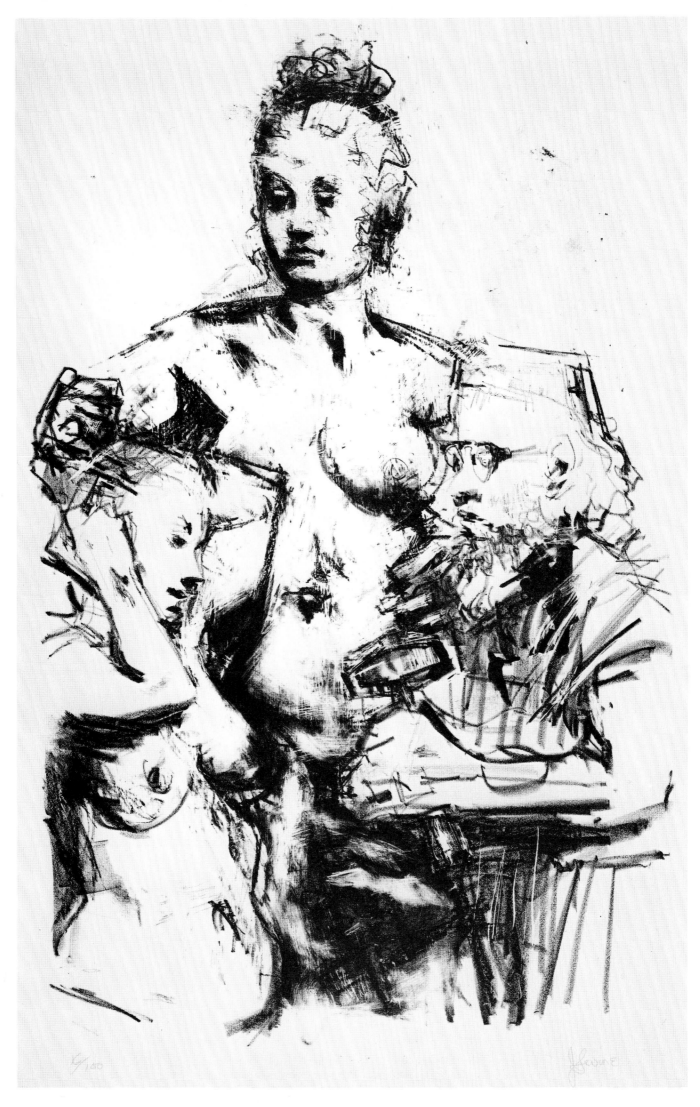

62. Pygmalion. 1977. Ca. 19½ x 12½″.

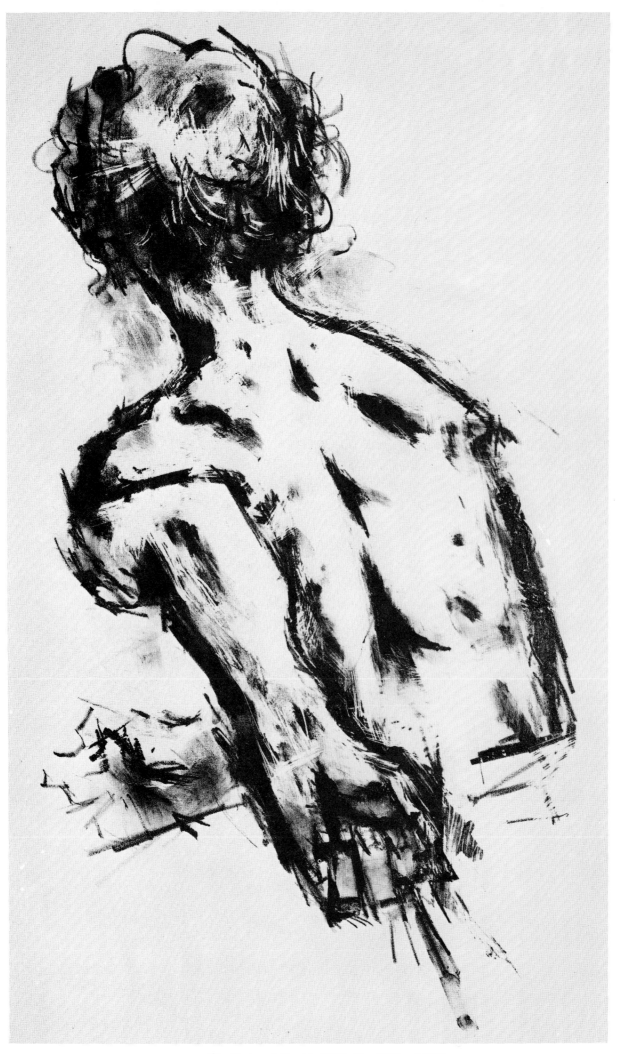

63. Torso of David. 1977. Ca. 17¾ x 10¾″.

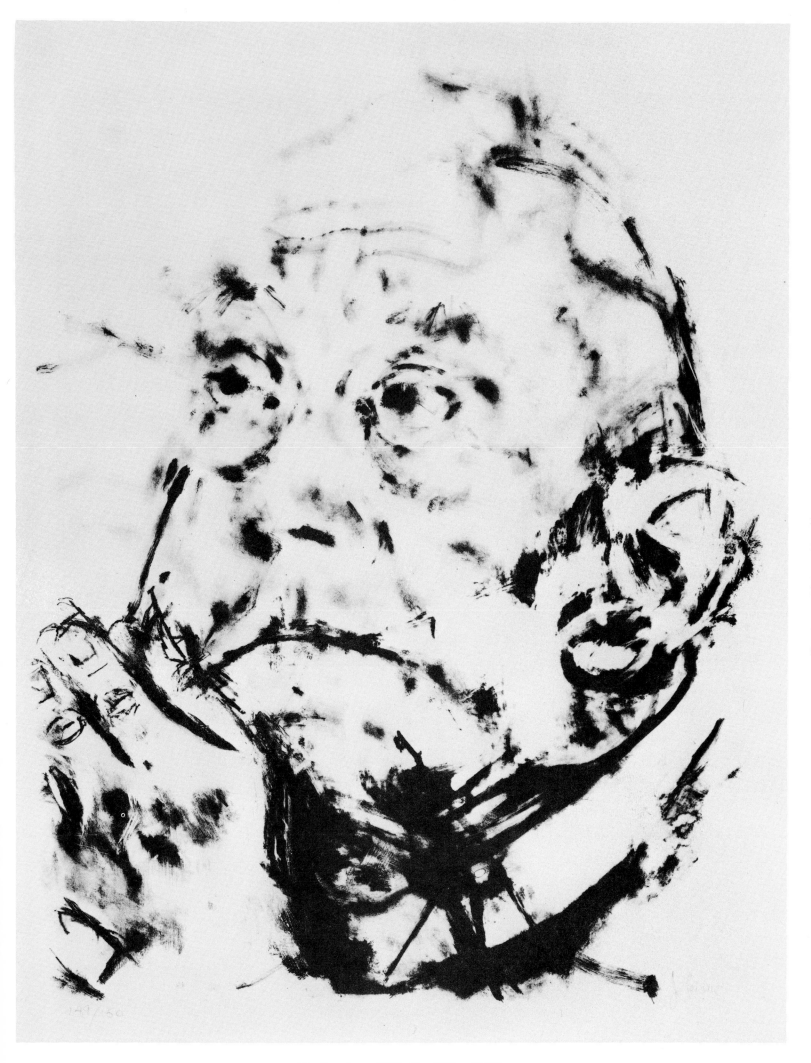

64. Requiem. 1979. Ca. 31¾ x 25½″.

65. Sweet Bye and Bye. 1980. 8 x 9¾".

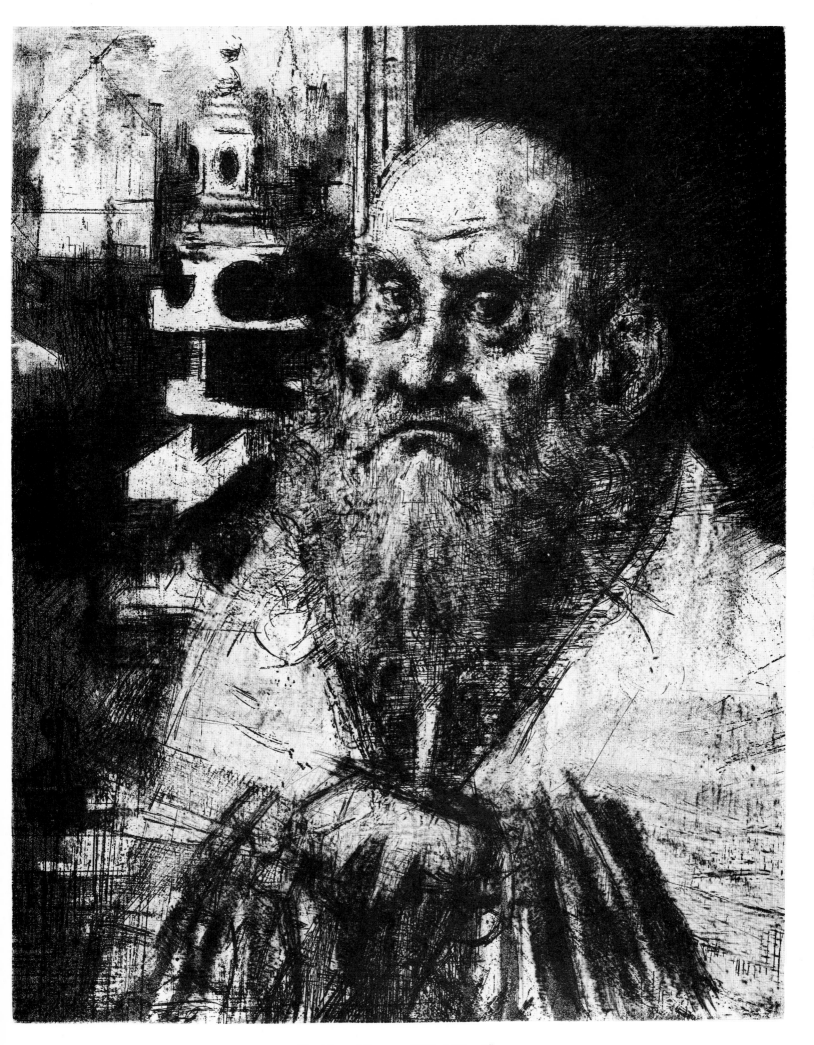

66. Lion of Prague. 1982. 11⅛ x 9″.

67. Untitled Fragment of Woodstock Pastoral (unpublished). 1952-69. 8¾ x 3½″.

68. Sketches for Volpone (unpublished). 1964. 10 x 7¾".

69. Study for Volpone (unpublished). 1964. 9¾ x 8″.

70. Study for Tunbridge Girl (unpublished). 1967. 11⅞ x 8⅞″.

71. Study for Threepenny Opera: ''Look! there goes Mack the Knife'' (unpublished). 1967. 11⅝ x 9⅞".

72. The Violinist (unpublished). 1969. 4⅞ x 2⅞".

73. Studies for Facing East Poster (unpublished). 1970. Ca. 12¾ x 16¾".

ATELIER MOURLOT

115 BANK STREET - NEW YORK - NY 10014

74. Atelier Mourlot—Marianne and the Goddess of Liberty Poster. 1967. Ca. 26½ x 21″.

FACING EAST

Jack LEVINE ~ James A. MICHENER

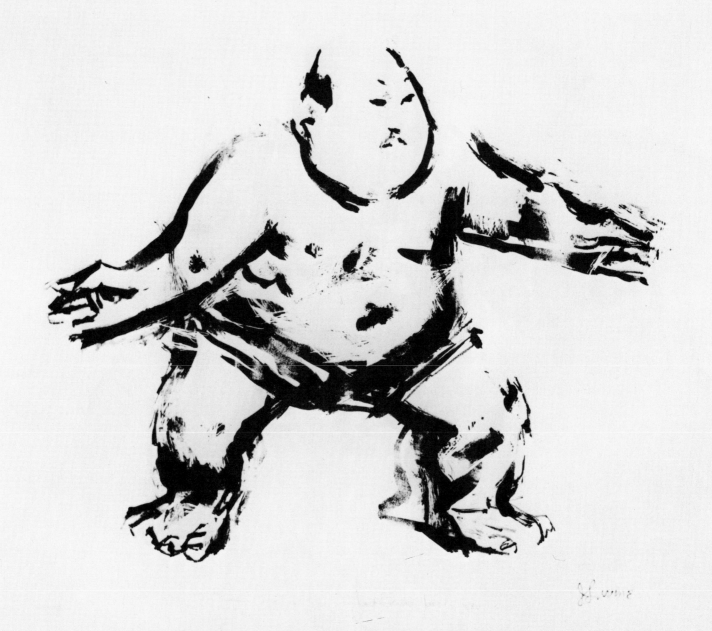

MAECENAS PRESS ~ RANDOM HOUSE

FALL 1970

75. The Japanese Wrestler—Facing East Poster. 1970. Ca. 24½ x 18″.

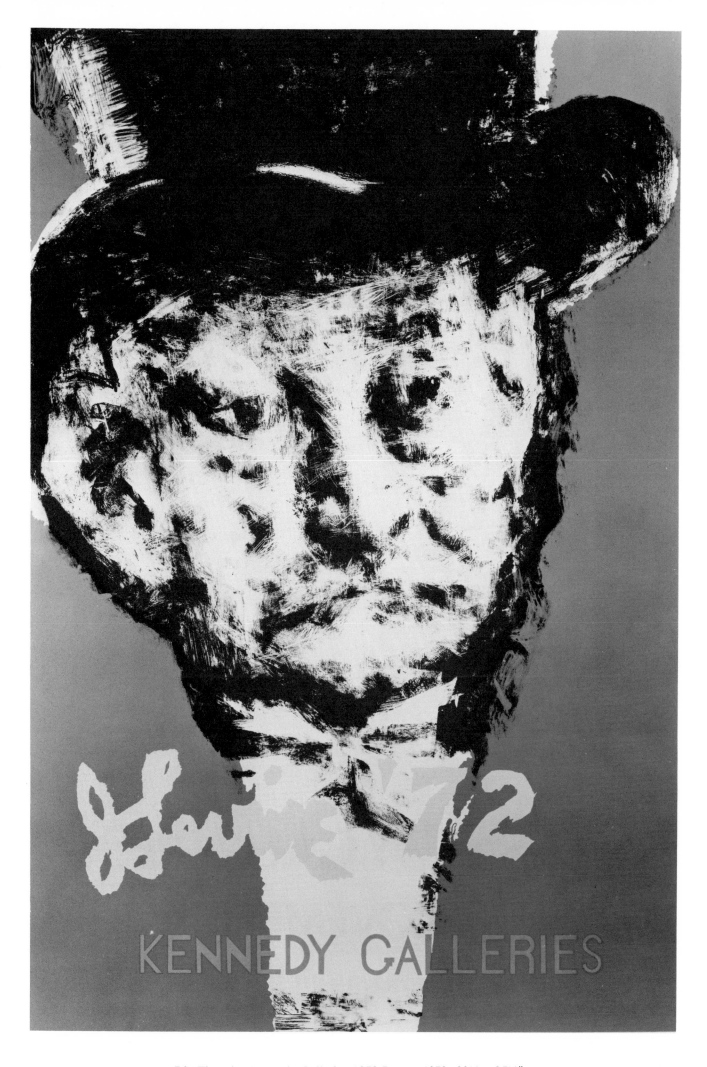

76. Thought, Kennedy Galleries 1972 Poster. 1972. 39⅛ x 25½".

JACK LEVINE

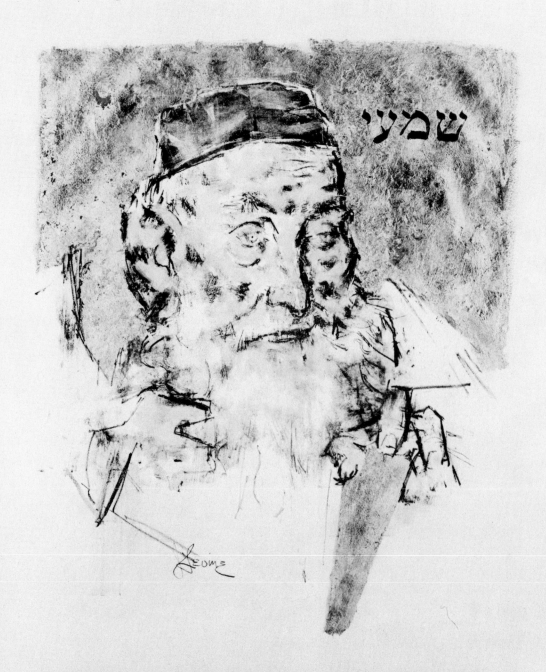

KENNEDY GALLERIES
NOVEMBER 8-29.

77. Shammai, Kennedy Galleries 1975 Poster. 1975. 28⅝ x 17″.

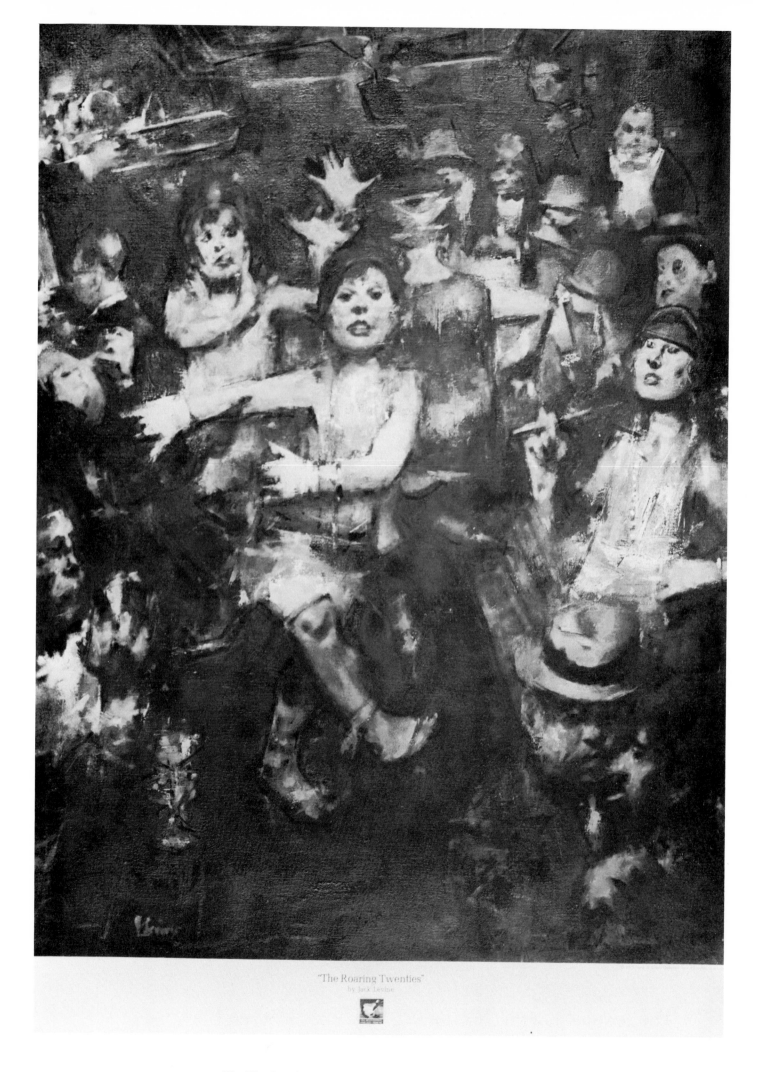

"The Roaring Twenties"
by Jack Levine

78. The Roaring Twenties 1975 Poster. 1975. 29¼ x 23″.

JACK LEVINE

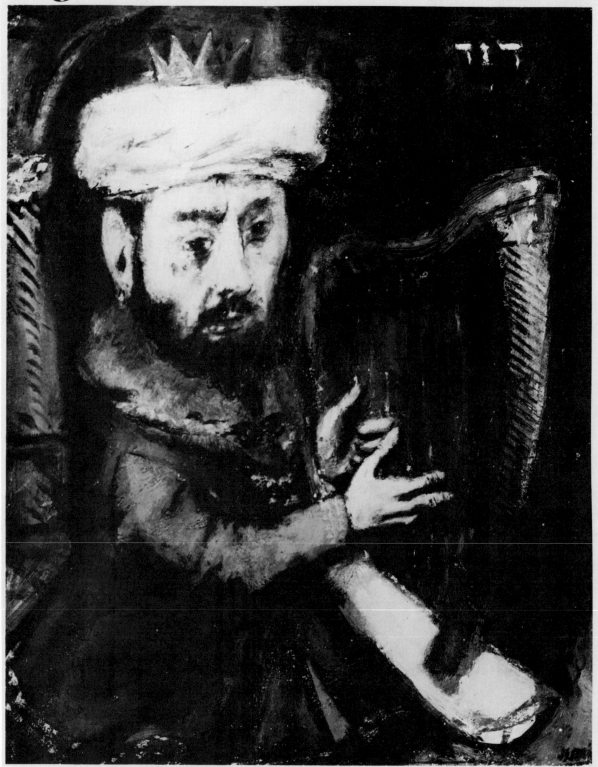

RETROSPECTIVE

PAINTINGS, DRAWINGS, GRAPHICS

The Jewish Museum, New York November 8, 1978 - January 28, 1979

79. Jack Levine Retrospective, The Jewish **Museum 1978 Poster.** 1978. 34¾ x 21″.

80. Jack Levine Retrospective, Portland Art Museum 1979 Poster. 1979. 21⅜ x 16⅜″.

DATE DUE

DEMCO 38-297